The Kurds of Iraq Michiel Hegener

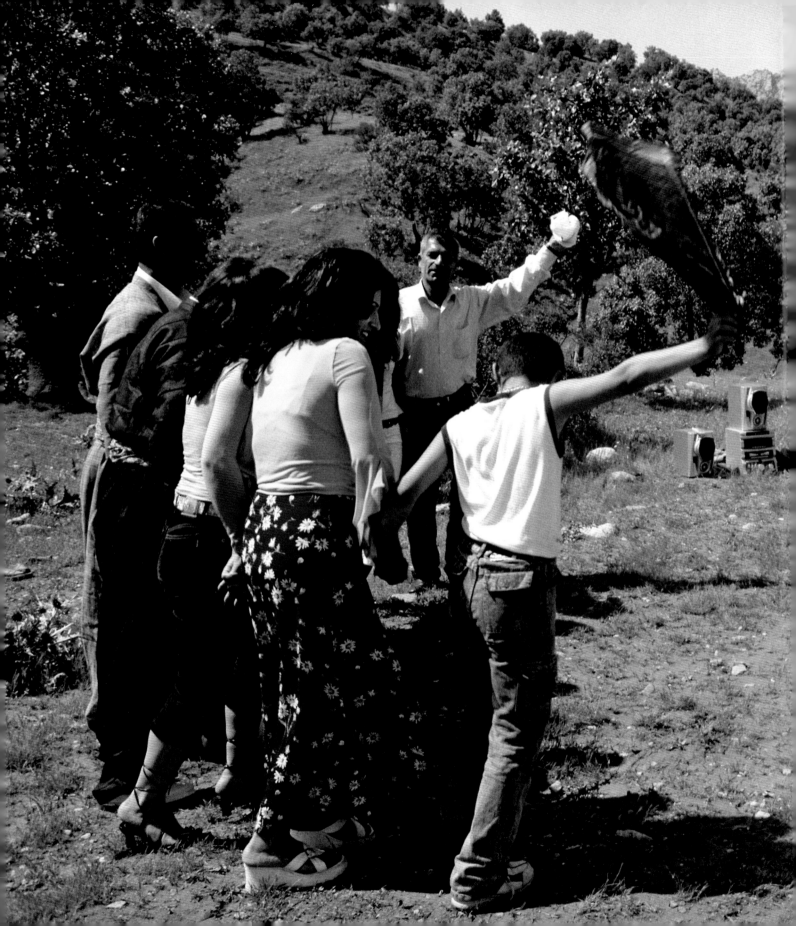

The Kurds of Iraq

Michiel Hegener

SBK
amsterdam

Mets & Schilt publishers

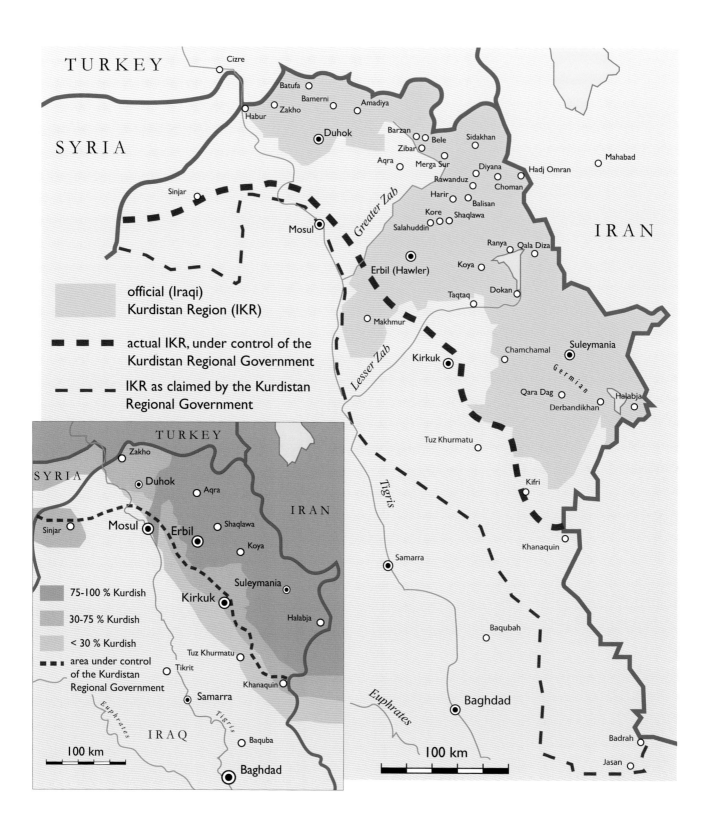

official (Iraqi)
Kurdistan Region (IKR)

actual IKR, under control of the
Kurdistan Regional Government

IKR as claimed by the Kurdistan
Regional Government

TURKEY
SYRIA
IRAN

Cizre
Batufa
Bamerni
Amadiya
Zakho
Habur
Duhok
Barzan
Bele
Sidakhan
Zibar
Aqra
Merga Sur
Diyana
Hadj Omran
Mahabad
Rawanduz
Choman
Harir
Balisan
Kore
Shaqlawa
Salahuddin
Ranya
Qala Diza
Erbil (Hawler)
Koya
Dokan
Sinjar
Mosul
Makhmur
Taqtaq
Chamchamal
Suleymania
Kirkuk
Greater Zab
Lesser Zab
Germian
Qara Dag
Halabja
Derbandikhan
Tuz Khurmatu
Tigris
Kifri
Khanaquin
Samarra
Baqubah
Euphrates
Baghdad
Badrah
Jasan
100 km

75-100 % Kurdish

30-75 % Kurdish

< 30 % Kurdish

area under control
of the Kurdistan
Regional Government

TURKEY
SYRIA
IRAN
IRAQ

Zakho
Duhok
Aqra
Shaqlawa
Mosul
Erbil
Koya
Sinjar
Suleymania
Kirkuk
Halabja
Tuz Khurmatu
Tikrit
Khanaquin
Samarra
Baquba
Baghdad
Euphrates
Tigris
100 km

Content

Introduction

During the past decades, a dramatic chain of events has shaped the fate of the inhabitants of Southern Kurdistan, known in the Western media as Iraqi Kurdistan, which – depending on who is doing the measuring – covers roughly 70,000 square kilometers. The following chapters focus on the Iraqi Kurdistan Region (IKR), known inside Iraq as the Kurdistan Region (KR). In this book IKR will be used rather than KR.

There are three IKRs: the official IKR, the actual IKR and the imagined IKR. The official IKR encompasses the governorates of Duhok, Erbil and Suleymania. The border of the actual IKR extends further, as can be seen on the map, but a small part of the official IKR – the area around Makhmur – lies outside the actual IKR. Actual in this context means: under the jurisdiction of the Kurdistan Regional Government (KRG), which is based in Erbil and has its own elections, president, no less than 44 ministries, a 200,000-strong army, borders, border patrols and even its own stamps.

And then there is the imagined IKR, which includes Kirkuk, Sinjar, Makhmur of course, and the area around the towns of Bardra and Jasan, which lie even further south than Baghdad. The imagined IKR is the area the KRG claims as being theirs, and where they already have varying degrees of influence, via indirect channels. Many of the people living there are Kurds with ties to the political parties that form the KRG. But there are also other claimants. Some Assyrians in the Mosul area would like to have autonomy just like the Kurds, rather than having to share autonomy with them under the KRG banner. In and around Kirkuk, a part of the population prefers a special status for that area, instead of

being under the KRG aegis. Tens of thousands of people with Turkish ancestry – the Turkmen – live there, and some are vociferous about their desire for a special status. A referendum to determine the future of Kirkuk has been in the works for years now. The bottom line of this section is that the following text and pictures deal almost exclusively with the actual IKR, which will be referred to as the IKR.

This book is intended as a visual introduction to what is going on in the IKR, and some of what went on during the past in the self-ruled areas in Northern Iraq that preceded the IKR. In addition to a selection of the photos I have taken during the past 35 years, maps and text should help to portray a fair image of a remarkable region and an even more remarkable people. As always, reality is more complex than even the most detailed study can reveal, and that certainly applies to a superficial introduction like this one. To mention just a few topics that are significant enough to justify entire books on their own:
● the intertwining of politics and business and the consequences of the fact that some top politicians are also avid real estate owners and developers
● the fading but still crucial influence of the agas, the landlords of old; and landownership generally, particularly as related to government planning
● the telecommunications infrastructure of the IKR, notably the overriding influence of various satellite companies
● the consequences of the worldwide broadcasting of Kurdish satellite TV, inside the IKR and in other parts of Kurdistan; the consequences of Kurdish

satellite TV on the hundreds of thousands of Iraqi Kurds living all over the world, the West in particular, and how the responses to what they see feed back into Kurdish society.

I could easily add another ten subjects but hopefully I have made my point. Kurdish society is hugely complex, drifting as it does from traditional to modern over a very short time span, subject – as all Kurds are – to Western and Middle Eastern interests beyond their control.

This book is sketchy at best as far as textual content is concerned. Readers who want to know more about the recent history and the current predicament of the Kurds of Iraq should read *Kurdistan – After Such Knowledge What Forgiveness?* (1998) by Jonathan Randal and *Invisible Nation – How the Kurd's Quest for Statehood is Shaping Iraq and the Middle East* (2008) by Quil Lawrence. However, what these two excellent books and most other books have in common, is their focus on politics, the military situation, and human rights. Among writers about the Kurds of Iraq there is a tendency to forget about such crucial subjects as culture and archaeology, the position of women, leisure, education, the economy and, the most underestimated subject of all, agriculture and life in the villages. This book addresses these subjects too, albeit briefly. One advantage of having travelled in the region for decades is that I realize how little I know and that I am aware that this book barely scratches the rugged surface of Kurdistan. Kurds – officials in particular – do not bare their souls easily: there is too much that cannot

be said, and each statement may have serious implications if taken too seriously by the wrong people at the wrong moment. Reporters rarely hear the full story. And in the absence of easily accessible written sources, a quest for truth often resembles a walk through a hall of mirrors. My preferred solution was to avoid most officials, and talk as much as possible to ordinary people and try piecing their stories together.

The Middle East is hot, as is Iraq, and the relatively small Asterix and Obelix-like ministate in the North of Iraq continues to be anathema to the surrounding dictatorships and quasi democracies alike. As such, the IKR can elicit unpredictable responses, ranging from great sympathy to the wish to annihilate the de facto independent country it is.

The present state and predicament of the four million people who live in the IKR is largely the result of external factors, most notably the actions of repressive regimes in Baghdad. Even more so, it is the outcome of how the Kurds and others in the area responded to the cruel deeds of Saddam Hussein, his cronies and his predecessors. What I have just summarized in less than a hundred words is a long, bloody tale involving the entire population and spanning decades – a tale of untold suffering, the most massive destruction of infrastructure ever recorded in history, the largest mass exodus since World War II, and, ultimately, success and a high degree of autonomy.

It was my good fortune to visit Iraqi Kurdistan as long ago as 1973, when I was 21,

together with half a dozen others from the Netherlands. We just drove in a rusty minivan from Utrecht, where most of us were studying, to Northern Iraq and back again: for the sake of it and for fun, although we also sold a few articles to magazines and newspapers upon our return, and we gave some slide presentations.
Following Saddam's occupation of Kuwait in August 1990, I went back to Kurdistan on four occasions: in March/April 1991, in May 1991, in February 1992, and in July 1992. The Kurds had realized some sort of autonomy by mid-1991 and Saddam's troops had access to only a small part of Iraqi Kurdistan. It was a period of great change, which I recorded in a book in Dutch, *De Bergen als Bondgenoot – Reizen door Vrij Koerdistan (The Mountains as Allies – Travelling Across Free Kurdistan)*, which appeared in 1993.
After 1992 my work as a journalist led me to Africa and America. Kurdistan seemed rather remote, and not just geographically: in the mid-nineties, heavy in-fighting between Kurdish factions left me almost irreparably disenchanted with the Kurds and their cause. In May 1998, in Geneva, I had a lengthy interview with Necirwan Barzani, vice-prime minister of one half of the now divided area. It was a difficult conversation, mostly about the torture centres that all factions were maintaining in the mid-nineties according to gruesome reports by Amnesty International and Human Rights Watch. It seemed beyond belief that the Kurds, after all the horrors that had been inflicted upon them in the past, were now treating each other in a similar manner. But then the skies cleared. Later in 1998, the quarrelling factions hammered out a peace

agreement, with help from the Americans, notably Foreign Secretary Madeleine Albright. Mutual distrust was plentiful but the peace lasted, till the present day in fact, and the distrust has worn off considerably.

The build-up to the Second Gulf War gave me enough reason to return to my old friends, especially if they were being friendly towards each other. So, on May 30, 2002, I experienced the sensation of crossing from Iran into Iraq and returning to a land I have loved since first setting foot there and which I hadn't seen for ten years. Just across the border lay Hadj Omran, where, on August 2, 1973, I and four fellow travellers had interviewed the legendary Mustafa Barzani (1903-1979), Necirwan's grandfather, the man who had almost single-handedly created modern Kurdish independence. Driving through Hadj Omran, seeing the snowcapped mountains all around me, and being among Kurds again quickly reawakened my Kurdish self. I was Back with a capital B! The overthrow of Saddam in 2003, following the American-led invasion of Iraq, gave new impulses to de facto Kurdish independence and spectacular economic growth. So I returned in October 2003, in November 2005, in April 2006, in October/November 2007, and in December 2008 to witness it all and to report on it for outlets in the Netherlands and Ireland. In between times I also realized an old plan, first conceived in 1992: a photo book. The result is very much Kurdistan as I saw it – and in fact this is the photo album of my travels among the Kurds of Iraq.

Michiel Hegener
Spring 2009

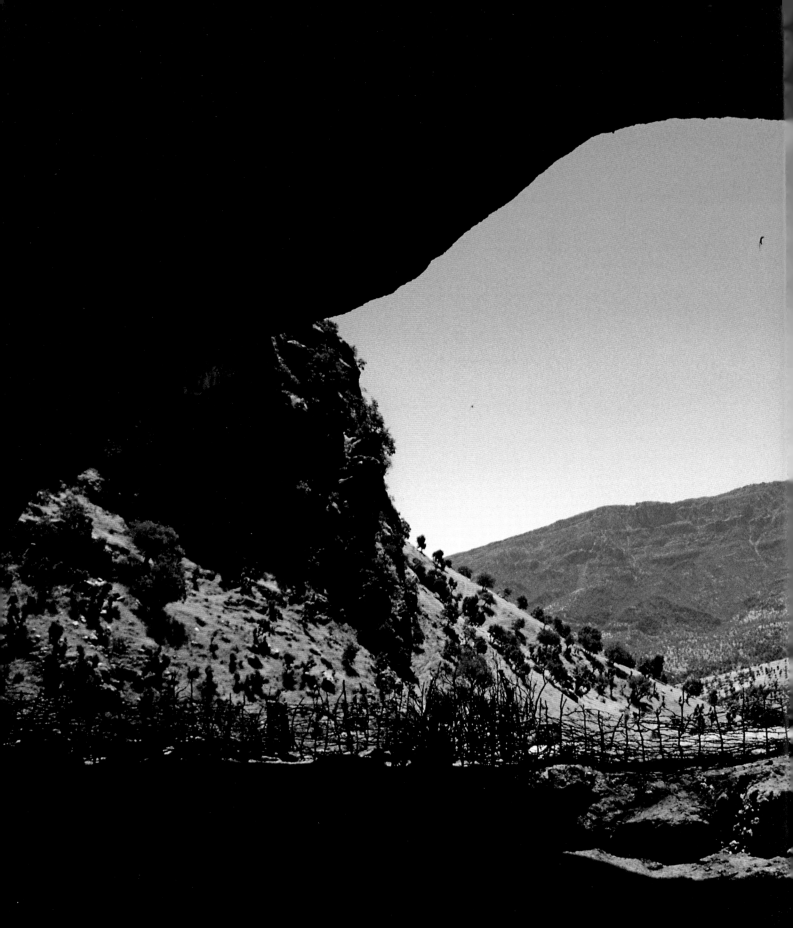

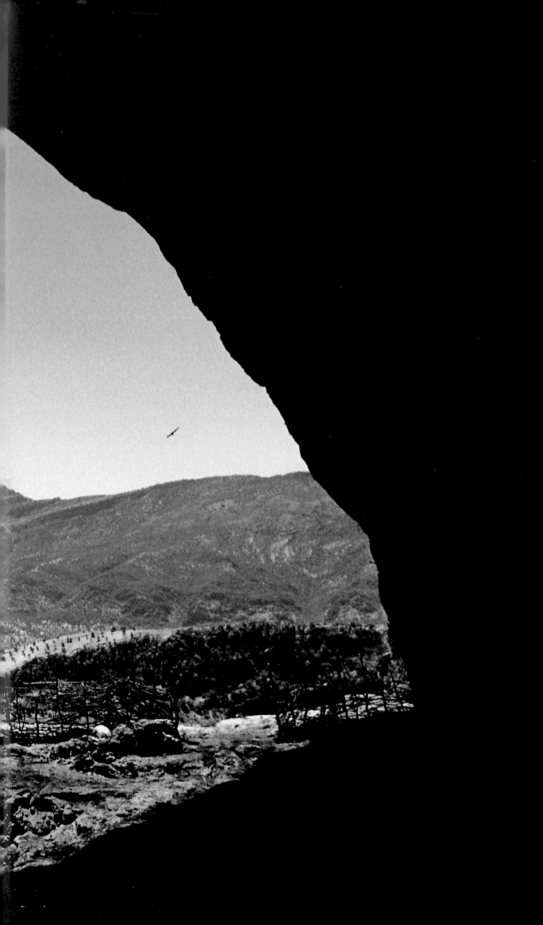

Ancestors Some of the earliest
inhabitants of Southern
Kurdistan enjoyed this view
from their home. Neanderthal
people lived in this cave and
were buried in it between
70,000 and 46,000 years ago,
leaving us the remains of nine
individuals. One of the dead
had been buried with flowers.
Another one had an amputated
arm while alive.
The Shanidar Cave was
excavated between 1957 and
1961 by an American team from
Columbia University, led by
paleontologist Ralph Solecki.
Neanderthal people had been
found at various sites in Europe
from 1829 onwards, as well as in
Israel. Shanidar yielded the first
remains of Iraqi Neanderthalers.

Ancestors

The inhabitants of Southern Kurdistan appear in the media far more often than you might expect for a group of some four million people, 0.06 percent of the world's population. Their fame and, occasionally, notoriety may seem new, but that is because the media as we know them are new too. In their homeland and surroundings, the inhabitants of these lands have been making news all along. If newspapers had existed in the past 5,000 years, reports about Kurds, Assyrians, Gutians, Akkadians, Sassanids and a host of others in the countries drained by the Greater and Lesser Zab rivers would have hit the front pages on a fairly regular basis.

Why? The two Zabs and their myriad tributaries attest to one of the basin's greatest assets: water – lots and lots of it, flowing from the mountain slopes, disappearing underground, emerging from sand deposits and rock faces in hundreds of unexpected places. Combined with a warm climate and fertile soils, the abundance of water accounts for the eternal appeal this area has for human beings and wildlife. About 70,000 years ago, Neanderthal people settled in mountain caves just south of the present Iraqi-Turkish border and some of the well-preserved skulls and bones from the Shanidar Cave have become icons in the world of paleontology.

Sedentary agriculture changed the status of today's Iraqi Kurdistan dramatically. In fact, sedentary agriculture, man's greatest invention, began here and in adjoining areas like Anatolia in around 8000 BC. Excavation results show that it started in Southern Kurdistan at Jarmo, near Chamchamal, and in places like Çatal Hüyük in what is now Turkey.

Agriculture proved a hit in Southern Kurdistan. At around three or five thousand years BC, when farmers in Europe would have considered themselves lucky to have survived the winter, their colleagues in Kurdistan lived lives well above subsistence levels. They could spend significant amounts of their time making and/or trading luxury products made of metal, stone, leather, wood, wool, flax, meat, grain, honey, nuts, milk and anything else their rich land provided them with.

These successes permeated through entire societies. Trading led to roads being built. And the road networks resulted in crossroads, which developed into settlements and later into towns. The accumulation of wealth allowed increasing numbers of people to do things other than farming. Like creating beautiful artefacts. Like writing. Like studying the heavens (astrology is an Iraqi invention, though not Kurdish). Like soldiering: conquering lands, capturing slaves and stealing the wealth of other societies. And so, complex, dynamic and sometimes cruel societies were built, especially from 3000 BC onwards, on a solid agricultural foundation. The oldest permanently inhabited town in the world is Erbil, the capital of Iraqi Kurdistan (although some claim that Jericho, in what is now Israel, is even older). Erbil is certainly 7,500 years old, since sherds from the lowest layer, Tell Halaf pottery, demonstrate this.

Let's flash forward to the present... Archaeologists in Iraqi Kurdistan are in despair as the number of sites is overwhelming. In 2006, Kanan il Mufti, head of antiquities at the Ministry of Culture, told me that he and his small staff had 3,125 archaeological sites to look after – and those were just the known sites. The archaeologists of the Iraqi Kurdistan Region (IKR) should not complain as their work is now gaining much more attention than it ever did in the past. Some new students enrol at Salahuddin University in Erbil every year to study archaeology. Towns are improving their archaeological museums. There are full-time archaeologists on the government's payroll. Cooperation schemes with foreign archaeologists and universities are in full swing, including traineeships for Kurdish antiquarians in labs in Western countries.

However, all these strides forward are being largely annihilated by the immense amount of building taking place in Iraqi Kurdistan today, as well as the wholesale destruction of buried artefacts, buildings, burial sites and more subtle records like pollen that haven't been disturbed for millennia. There are few places in Southern Kurdistan – or indeed Western Asia – where you can dig without hitting upon antiquities. Unfortunately, the diggers are almost invariably construction workers, focused on getting their job done rather than on calling the local archaeologist. If the latter does occur, settlements that are thousands of years old must be investigated in a few weeks or less by just a few under-equipped archaeologists before the bulldozers start roaring again. More often however, the bulldozing isn't interrupted at all when old walls or artefacts are revealed.

Better laws would be helpful, and so would better control by the police, as well

as more knowledge generally. But what would help most, and what is already helping, is an increased understanding of the unique archaeological values of the IKR and how they could foster tourism in the not so distant future.

There is an awful lot to be seen already! Intrepid readers of the book should realize that a tour along the IKR's monuments is much more fun and exciting today than it will be in five or ten years time, when air-conditioned touring cars may well ply the routes between the monuments and adjoining luxury hotels.

The Erbil archaeological museum and the foundations of a village. What can be seen here dates from the Uruk period (3500-3000 BC) while lower strata are from the Halaf period (5500-4500 BC).

Dutch archaeologist Diederik Meijer, right, of the University of Leiden, talking to locals about a small tell on the outskirts of Erbil. Meijer, who spent many years excavating tells in Syria, needed just ten minutes and a handful of pottery sherds to date this one. According to him, this tell probably began its dusty life some 2,800 years ago, in Early Neo-Assyrian times. The rounded stones in the foreground, apparently taken from a riverbed, may once have served as a floor.

Excavating a place like this might be interesting, according to Meijer, insofar as written sources, like clay tablets, reveal the tell's relation to the far more powerful, nearby town, which is now the citadel of Erbil. Just digging for artefacts like cylinder seals, coins or jewellery is yesterday's archaeology – today the focus is on uncovering social and political structures.

A tell, or city mound, near Duhok. Tells in all sizes can be found all over the Middle East. Typically, they are a couple of thousand years old. Their origin is quickly explained. In olden times, most houses were made of dried, unbaked clay, which would collapse after some decades. The owners must have thought: Why clean up the rubble first before building a new house? Good thinking. They just levelled the debris and started again, bringing in mud bricks from outside the settlement. And that's what all citizens did, century after century. The result: a town that rose slowly, and a hill left over once the last inhabitants had gone. The slopes used to be steeper in the days of habitation, the typical cone shape is the work of wind and rain.

On top of these tells, and to a lesser extent on the slopes, lots of pottery sherds can be found. The reason is simple: rain has washed away the loose particles, and the remains of baked pottery are left.

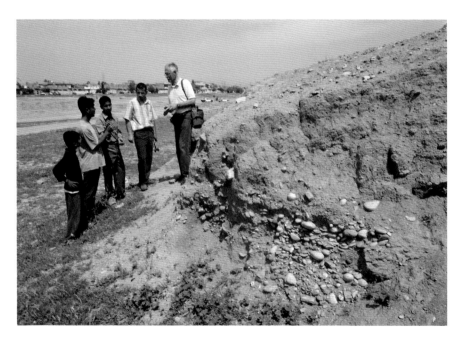

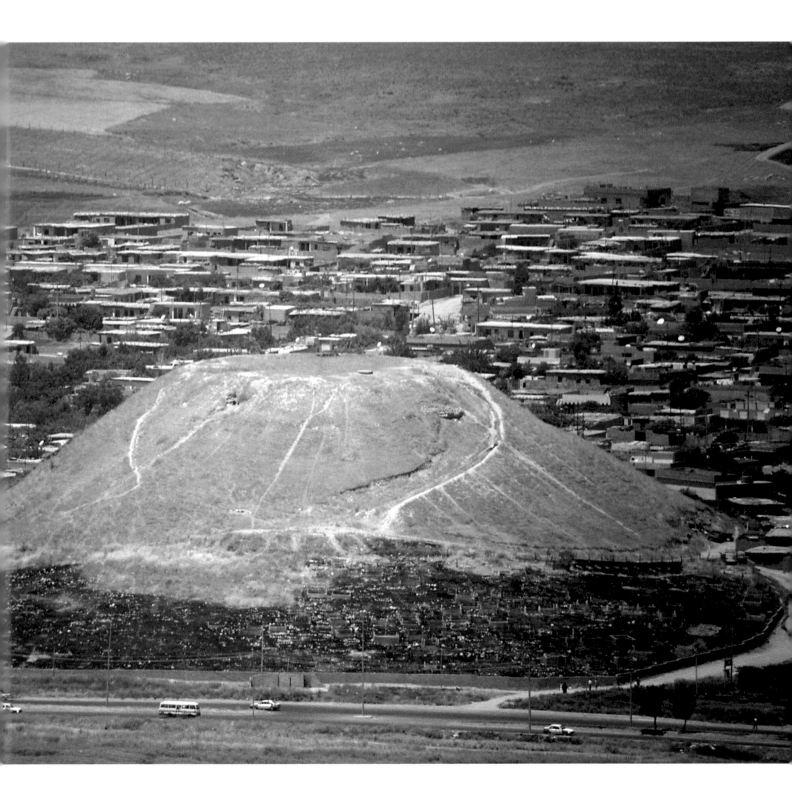

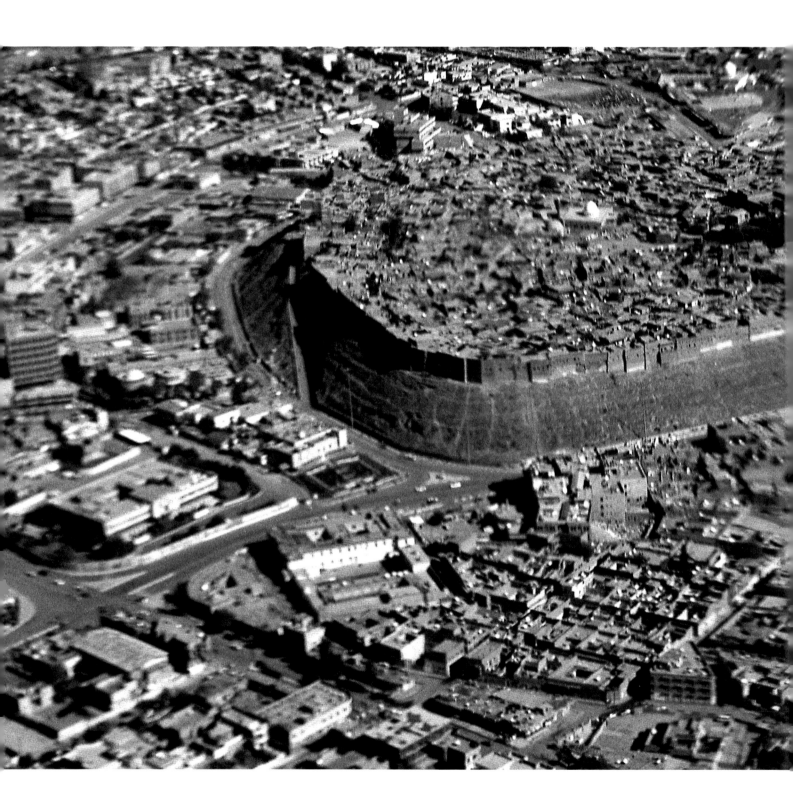

The oldest tell of them all: the citadel of Erbil, three million cubic metres of archaeological records. The tell of Erbil rises thirty metres above the plain, where the modern town of Erbil was built. The surface measures ten hectares. All but a few families were moved out of the citadel in 2007 in order to make room for major repair works. But it was essential to keep just a couple of houses inhabited in order not to lose the claim of being the oldest permanently inhabited place in the world.

The IKR government has made multimillion-dollar plans to turn the citadel into a tourist attraction, as was done successfully with the citadel of Aleppo, Syria. Many of the current houses, most of them dating back to the period between the 17th and 19th centuries, are in bad shape. In many places, the walls around the edge are in danger of coming down.

When the walls are stable once again, international teams may start excavating – in fact, UNESCO has been lobbying for years to find funding for excavations. The Erbil citadel will also be nominated for inclusion on the UNESCO World Heritage List. As in Aleppo, permanent structures (maybe just glass roofs) may cover the open excavation sites, in order to allow tourists to savour some of the archaeological riches that the mount is concealing. The lowest layers, dating back to the 6th millennium BC, are the oldest and, in a way, the most fascinating. Of course they are the most difficult ones to access and to display. That's a pity but, on the other hand, the upper layers date back to later times, which may well have been more affluent. A palace and clay tablets with cuneiform inscriptions would be expected to be found in the upper strata and hardly at the bottom.

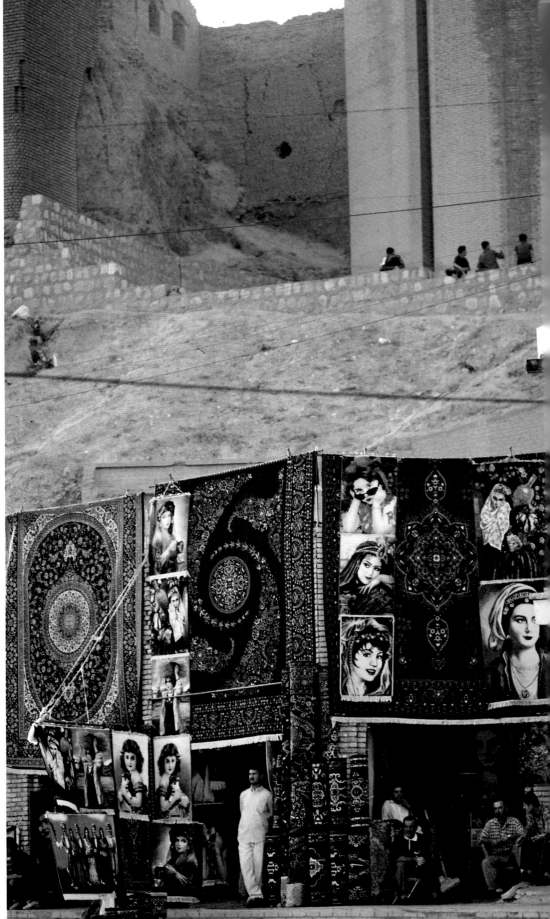

16 The citadel seen from ground level. Note the crumbling walls on the left. Landslides, mainly caused by rain, are responsible for a continuous deterioration of the citadel. That is one reason for the recent ambitious rescue plans – the other two being tourism and scientific interest. On the right, some repair/restoration work carried out in the nineteen-eighties during Saddam's rule can be seen. For all his faults, Saddam did care about the archaeological heritage of Iraq. Restorations were carried out. Many historic sites were well protected, till the UN trade embargo in 1990, following Iraq's invasion of Kuwait. Wages for guards could no longer be paid and massive pillaging began. It has been going on ever since. As Saddam's motives were nationalistic rather than scientific, the repair work was often bombastic and ostentatious. The newly-built South Gate of the Citadel, rebuilt in 1980, is an example of this. Part of it can be seen to the right.

A 17th century bath house and an 18th century minaret and mosque on the citadel. The mosque stands on the site of a lost synagogue.

In the foreground is Burhan Qaradagi, the local archaeologist of Qara Dag Valley, an hour's drive from Suleymania. The identity of the other man, four metres tall on the yellow rock face, is a bit more vague. For sure he is a ruler, holding a symbol of power in his right hand, and more significantly crushing two enemies under his feet. Were they Kurds? Victims of a Saddam of old? For a long time the view commonly held by archaeologists was that we are looking at Naramsin (2254-2219 BC), grandson of Sargon, ruler of the short-lived but otherwise successful empire of Akkad, which had its centre of power in Akkad, a place which has yet to be identified.

The problem is that there is no inscription, while Naramsin might have been keen to add some words to inform future passers-by about his crushing victory. According to research by Kurdish archaeologist Kozad Ahmed, working at Leiden University in Holland, this is not Naramsin but more probably Erridupizir, a Gutian ruler in 2141-2138 BC. About seven years after Naramsin's death, the Guthians had overrun and destroyed the Akkadian empire. "And the Gutians didn't like inscriptions," explains Kozad Ahmed. As far as the written sources of their neighbours go, the Gutians were pure barbarians.

At any rate, the bas relief in Qara Dag is worth a visit. And as tourism is slowly becoming popular in the IKR, a new road to the site has reduced the required walking time from some hours in 1992, when the first picture was taken, to a mere five minutes from the parking lot today. For the benefit of visitors, rather than of the scientific interest of the bas relief itself, it was thoroughly restored in early 2006. Here, Carwen Omer, chief chemist of the Suleymania archaeological museum, inspects a work in progress. He was responsible for mixing and composing the epoxy that was used to repair the image.

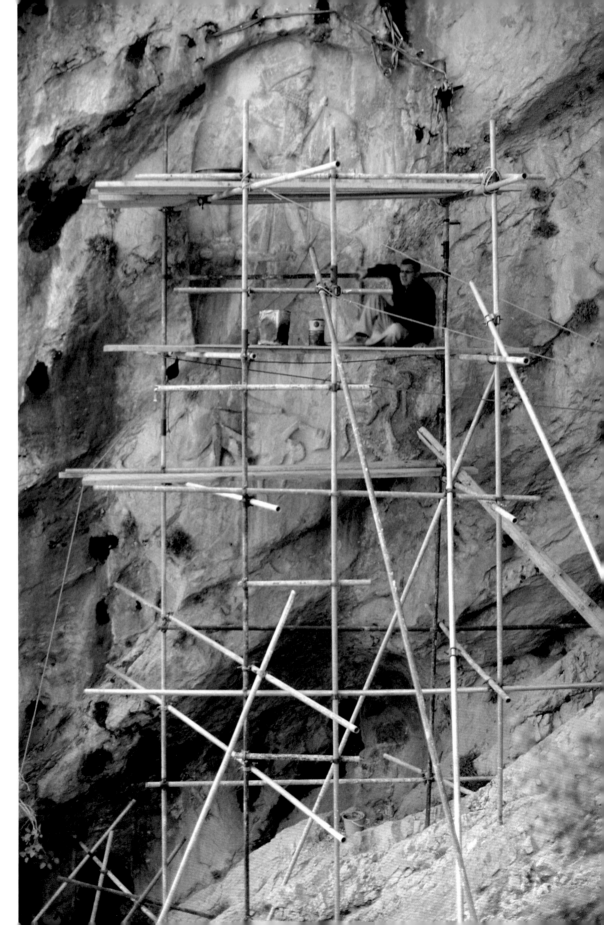

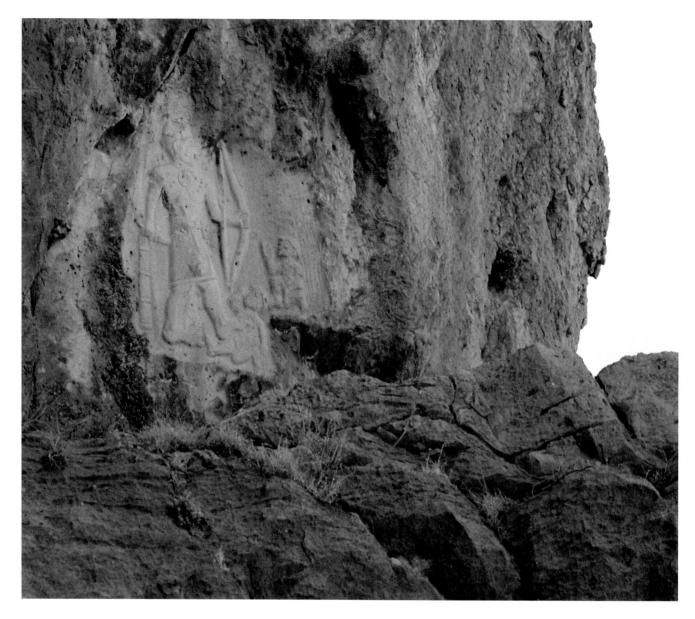

No repairs are needed at the Derband Belulah bas relief, 500 metres from the Iranian border, well south of Suleymania. Once again we see a ruler, this one flanked by an inscription, while he is trampling an enemy and getting admiring looks from a subject. The man is either Leshir Pir'anni or Tar-dunni, ruler of the Lullubi people, at around 2200 BC. Anni or Dunni is certain, the rest of the name can't be deciphered. That is not due to erosion but because the writing on the mountain wall is amateurish. It was probably done by an illiterate sculptor who copied the text from a clay tablet, thinks Kurdish archaeologist Kozad Ahmed. What can be read is a curse, saying that anyone damaging this relief will be struck down. That prospect may have kept barbarians at bay because the whole display is still in mint condition. No doubt its inaccessibility also helped: this picture was taken from about a hundred metres with a powerful telephoto lens. Only a skilled mountaineer with ropes could have reached the site.

Not far from Suleymania, just off the main road to Erbil, this amazing picture was carved out in the rock, about ten metres above the floor of a valley, some 2500 years ago. There are at least two conflicting interpretations of what we see here.

Some say these two men are kings, apparently in a friendly mood, and above them is the moon god, seated on a crescent moon. Or is it the sun god, seated on a crescent sun, a reminder of a solar eclipse? If the latter, the two men may well be Alyattes the Second, king of Lydia, and Cyaxares, king of Media. The Greek historian Herodotus (485-420 BC) describes (in his Book I, 73-74) how the armies of these two kings were engaged in yet another clash as part of a prolonged war, when a solar eclipse darkened the battlefield: "... it happened, when the fight had begun, that suddenly the day became night [...]. The Lydians and the Medes [...] ceased from their fighting and were much more eager both of them that peace should be made between them," according to Herodotus. Modern astronomers have calculated that an eclipse occurred in the early evening hours of 28 May 585 BC, at the time of the war. And at the place of the battle, in present-day Anatolia near the river Halys, the eclipse was complete. If this interpretation is correct, the peace deal depicted here followed the first event in world history that can be dated exactly. One problem with this explanation is the distance between the monument and the battlefield. Furthermore, commemorative monuments were usually, and logically, constructed at the border of the parties involved, which is not the case here. And behind the dark entrance there are three cube-shaped holes in the ground which may very well have been graves. The priest-like appearance of the man on the right further reinforces the idea that this is a royal tomb. Maybe one day more advanced techniques will reveal traces of human remains in the holes.

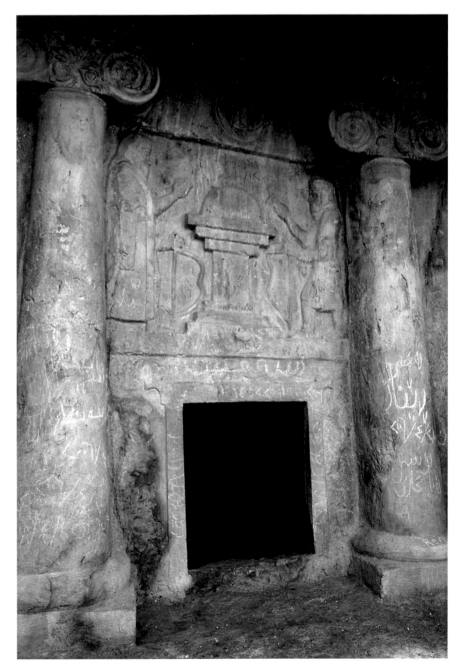

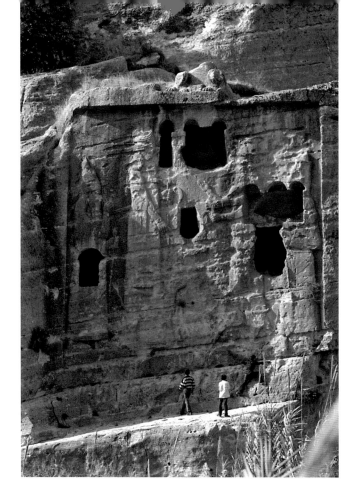

Just a hundred metres downstream from the fallen lamassu is this remarkable display of Assyrian belief, prestige and humility. Sennacherib, at the left, shows respect for the two gods in the middle by bending his right arm, as in the Duhok bas reliefs (see page 25). On the right we see Sennacherib again. Maybe he was thinking: if you are a king, why not twice? As at Duhok, the gods are standing on animals (heavily eroded). The king must have visited this place himself, watching over processions or rituals while seated on a throne, carved out of the rock, which has partly survived. The lower part, in particular two lion's feet, can be seen on top of the relief. The keyhole-shaped openings in the rock are certainly of a later date. Most experts think these are cells, carved out and inhabited by early Christian monks in search of solitude and meditation and preferring to do so at a place of ancient worship. One such hole can also be seen at the Duhok bas relief.

For anyone who has ever visited the British Museum or the Louvre, this is a familiar sight: a bull with a human head and wings, except that this one has remained where it was made. This bull is 2,40 metres high and 3 metres long. On the rock right above the bull, two eroded figures can be seen in bas relief: the one on the right may be Sennacherib, on the left is a god. Maybe the builders decided that this lamassu – as such a statue is called in Assyrian – wasn't up to scratch and abandoned it. Alternatively, the lamassu may have had a function at this very site, now known as Bavian or Khenis, not far from the village of Qasrok near Aqra. A lot must have been going on here some 2700 years ago...

A picture of the same lamassu, taken from the opposite bank of the river. Two more figures can be seen, on the rock and reflected in the water.

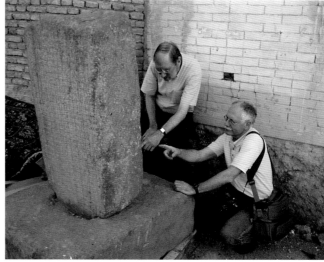

In November 2008 a family in Erbil, living a few hundred metres from the foot of the citadel, proceeded to dig a hole for a new toilet in their small garden. At a depth of three metres, the diggers hit a stone slab and they quickly realized it was man-made and probably quite old. They notified municipal archaeologist Mr. Haider, who had to be persuaded several times before he agreed to inspect the find. The slab was lifted and this burial room, dated around 1500 BC, was found. Human remains from the sarcophagus, seen in the picture, were taken away, as were some statues. Even the governor of the governorate of Erbil, Nawzad Hadi Mawlood, made the tricky descent to see for himself. The family was left with the empty grave. It is quite likely that there are more graves nearby, maybe many more.

A stèle full of cuneiform writing on top of the citadel of Erbil. Here Dutch Assyriologist professor Wilfred van Soldt (left) and archaeologist Dr. Diederik Meijer, both working at Leiden University, are trying to decode it. Van Soldt: "Lu ... itur ... Is this Assyrian? Hmmm. Dingir ... ip. No, my! This is Urartian! Lu lui ni ... i ni, that is certainly Urartian. Lu lu i ni li means barbarians." On the side facing the camera the writing is Assyrian, but written by people with little command of that language – Urartians, according to Van Soldt. The stone was erected by King Rusa, 735-713 BC, and its original location was probably on a road to Mutsatsir, a sacred town to the Urartians, which was destroyed around 700 BC by the Neo-Assyrian King Sargon II. Mutsatsir probably lies in Turkish Kurdistan, but it has yet to be found.

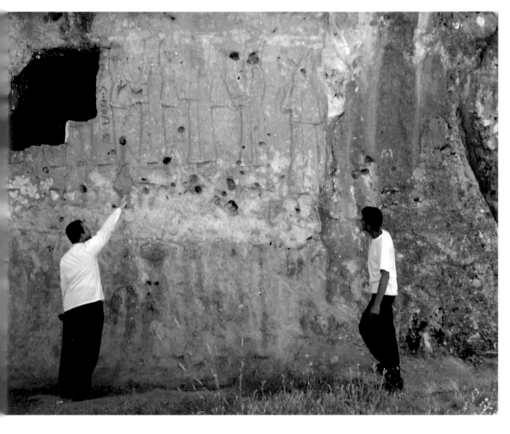

The identity of these figures is beyond scientific doubt. On the right is Sennacherib, king of Assyria from 704-681 BC, son of Sargon II. In 701 he tried to conquer Judea, as recorded in the Bible, Kings 18-19 and Chronicles 32 of the Old Testament. According to the Bible, after some initial successes by Sennacherib, God intervened by sending down an angel, who managed to kill 185,000 of his men in just one night. Here we see the king in happier days. He is lining up with seven gods, while making a sign of respect with his right arm. Note the various animals the gods are standing on: had it not been for the ethereal lightness of the gods, their weight would of course have broken the backs of the poor creatures. This panel, one of four, can de found on the South flank of Duhok. The place is known in literature as Maltai. At the time the effigies were made, this was right on the main road from Assur to the Upper Zab Valley.

On this panel at Maltai the gods are slightly more damaged but the animals they are standing on have survived a few millennia of erosion pretty well. As in the other panels, we see a procession of seven gods, flanked on each side by an image of Sennacherib. The tall god on the far left is Assur, the upper god of the Assyrians, standing on a dragon and on a horned lion. Behind him is his wife Ninlil, seated on a throne, which in turn is resting on a lion. Further to the right are the old Sumerian god Enlil, the moon god Sin, the sun god Shamash, the god of storm and weather Adad, and finally Ishtar, the goddess of fertility and love.

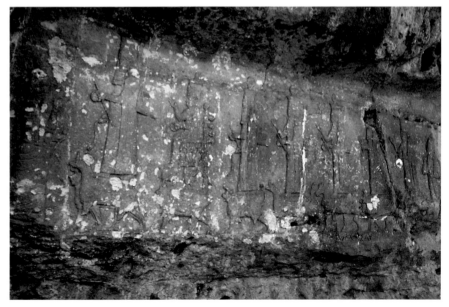

At a site named Paikuli, near Darbandikhan, the surroundings of a ruined Sassanid fortress are littered with inscribed stones and a few effigies. The writing is both in the Parthian and Middle Persian languages, commemorating the return to the throne – after an interruption by a usurper – of Narseh, who, from 293-302 AD was the 7th King of the Sassanid Empire.
An English translation of *The Sassanian Inscription of Paikuli* can be found on the internet – of the blocks that remain, that is, since some 130 out of an estimated total of 235 have survived. This picture was taken in 1992. Around 2005, this stone and all the others were taken to the Suleymania archaeological museum in order to preserve them better, to protect them against theft, and to display them in the original arrangement – a project of the Task Force Iraq of the Italian Ministry of Foreign Affairs and led by linguist and archaeologist Carlo Cereti.

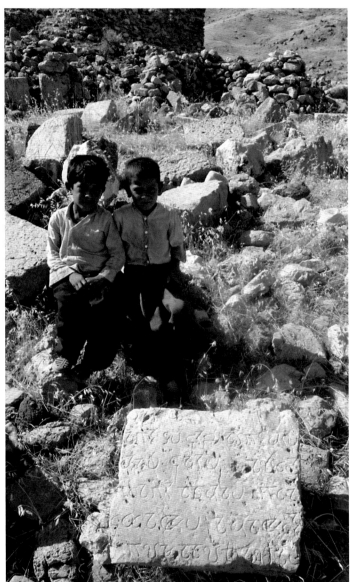

Paikuli. One of four statues of, presumably, the Sassanid King Narseh, which originally decorated the now crumbled tower to commemorate his 299 AD victory. One of the 130 remaining text slabs from the tower can be seen on the left. Like the slabs, the remains of the effigies have now been moved to the Suleymania archaeological museum.

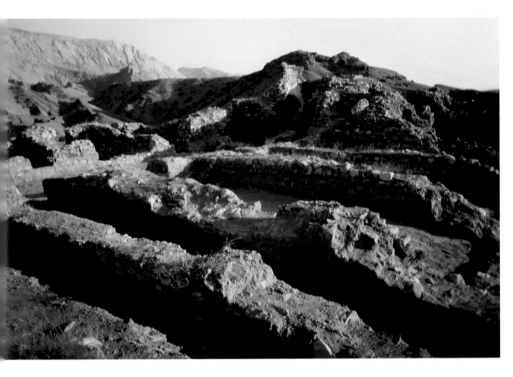

Remains of a Sassanid town near Darbandikhan
The Sassanid Empire lasted from 224 till 651 AD.
In Iraq and Kurdistan it ended in 637, the year
of the Arab Muslim invasion. During its last
200 to 300 years, the Empire included all of Iraqi
Kurdistan. The main religion was Zoroastrianism,
but Judaism, Buddhism and Christianity flourished
as well and there was religious freedom. From
633 onwards, Khalid ibn Waleed, a close companion
of Mohammed, led Arab armies to conquer the
Sassanid empire. After eighteen years of struggle,
the last Sassanids were subjugated by the Arabs.
The victors were largely driven by religious zeal.
They introduced massive forced conversion to
Islam, their brand new creed, and the death
penalty for those who dared to leave Islam.
Children of Muslims were automatically Muslims
themselves for the rest of their lives. As a result
of this formula, Islam largely wiped out the other
religions and is now the dominant religion in the
former Sassanid empire, including Kurdistan, Iran,
Afghanistan and Pakistan.

After 600, the Sassanid Empire was weakened
by two policies during the reign of King
Khosrau II (590-628): centralisation of the
government (a departure from the federal
structure the empire used to have) and huge
territorial expansion to the east and west, and
the south-west. As a result of these policies,
the empire was weakened considerably.
Sassanid gains in present day Anatolia were
reconquered by the Byzantine Empire between
622 and 627. And in 632, invading Arab Muslims
started their conquest of what was to become
the entire Sassanid Empire including Kurdistan.

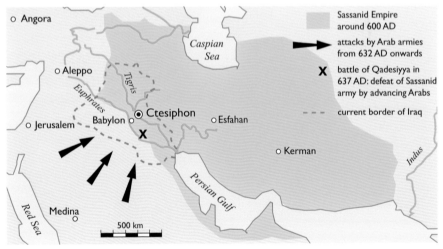

Sassanid Empire
around 600 AD

attacks by Arab armies
from 632 AD onwards

X battle of Qadesiyya in
637 AD: defeat of Sassanid
army by advancing Arabs

- - - current border of Iraq

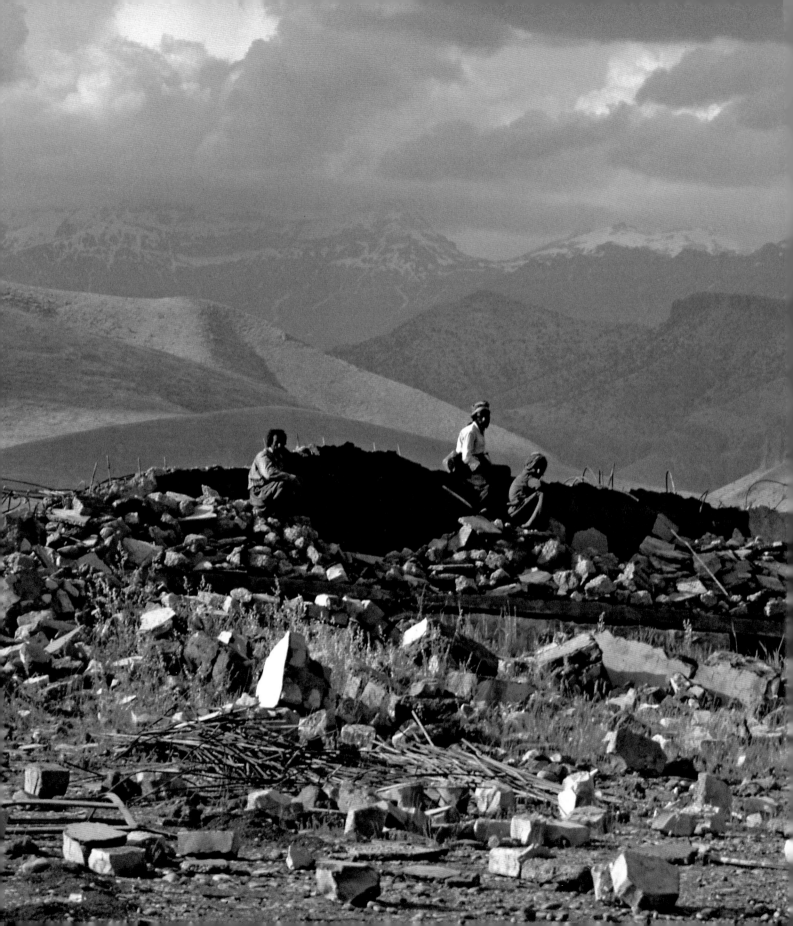

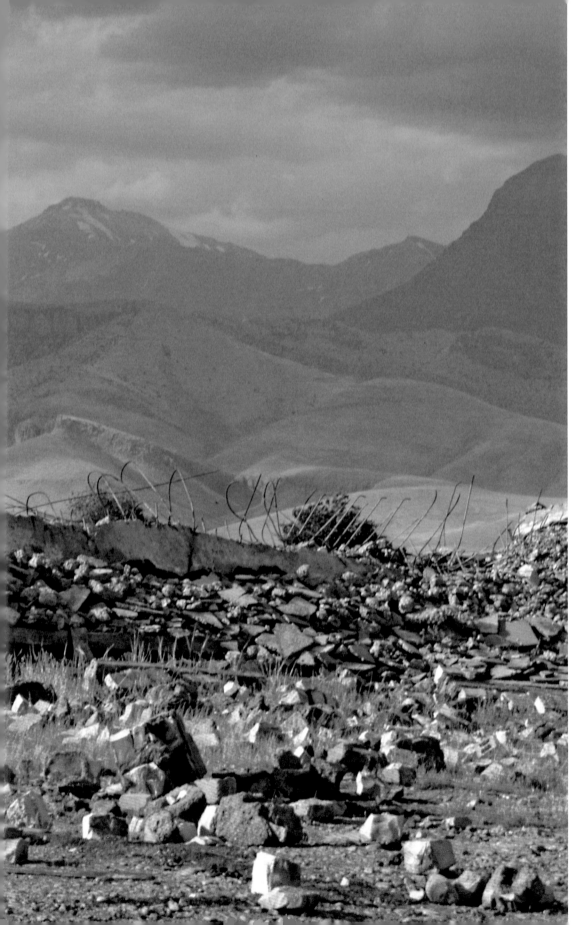

Victims It hardly matters where this is (it is between Ranya and Qala Diza, with the Kandil mountains in the background), because this is what the entire Kurdish countryside looked like in May 1991.

Victims

For decades, the Kurds of Iraq have been synonymous with suffering: poisoned gas attacks, large-scale deportations, mass executions, torturing, destruction of thousands of settlements. Millions of Kurds endured this, and hundreds of thousands perished. Of the survivors, few were able to tell foreigners what had happened, as Saddam's army was smart enough to completely seal off the areas when the worst crimes were being committed. Dozens of Srebrenicas took place in Southern Kurdistan and the world's media never paid any attention to them, except once, when the town of Halabja was attacked with poisoned gas in 1988.

Most of the atrocities occurred under Saddam Hussein's rule of Iraqi Kurdistan, from 1968-1991, and in particular during the 1987-1989 period. The events of the late eighties are known as the Anfal Campaign, when the regime in Baghdad took its revenge for the lack of loyalty on the part of the Kurds during the war with Iran. Most Kurdish villages, as well as some Assyrian and Turkmen villages, were destroyed by Saddam's forces. Of course, no journalists or photographers were allowed to witness them being laid waste. So there were no stories or pictures. And so the media largely ignored the plight of the Kurds. There were only rumours. A case in point was the destruction of the largest settlement that was levelled, the town of Qala Diza with its 120,000 inhabitants, in the spring of 1989. Western media were told about Qala Diza by Kurds living in the West. But how true were these stories? Maybe the refugees were just grinding their axes. Some journalists duly asked Ira-

qi embassies, who duly denied it, and these denials were quoted in newspapers alongside what was being rumoured.
That is how the Anfal campaign trickled down in the media outside Iraq – or rather how it didn't. I was part of that conspiracy of silence, both as a newspaper reader and as a journalist.

In mid-August 1990, one memorable, lengthy conversation put an end to my ignorance. It was a fortnight after Saddam's invasion of Kuwait and I was in London for NRC Handelsblad to interview members of Iraq's opposition in exile. I spoke to a member of the prominent Shiite Al Hakim family about the attacks on his relatives. I met ex-Baathist Hani al Fekaiki, who played a prominent role during the 1963 Baath rule of Iraq, and who told me how the Baathists started murdering opponents the first night after seizing power in July 1968. For two hours or so I listened to Hosyar Zebari, the then Kurdish representative in London, and now Iraq's Foreign Secretary. He told me about a talk he had just given to employees of the British Ministry of Foreign Affairs. "I told them: most of what has happened in Iraqi Kurdistan during the past few years is beyond imagination, you simply would not believe it if I told you. So I will only tell you about what you can understand." Zebari was candid to me as I listened in amazement. But I hardly understood. The message that all villages in an area of about 40,000 square kilometers had been levelled, was beyond my grasp. Only seeing for myself would lift my veil of disbelief.

I first saw the results of the Anfal on 14 April 1991, the first day of my return to Iraq since 1973. I and a cheerful American journalist,

Gary, who worked for a Spanish newspaper El Sol, decided we had done enough reporting about the plight of the refugees in Turkey (chapter 3). They were getting large amounts of aid, and in fact small numbers of Kurds started walking back to Iraq. Gary and I followed in their footsteps, crossing the poorly-guarded Turkish-Iraqi border at a 2000-metre high mountain ridge and then descending into a lush green valley via mud tracks full of abandoned vehicles that had been used for the escape two weeks earlier.
After some hours, we reached a small fortress of Saddam's army, occupied by pesh mergas, i.e. Kurdish military. They indicated that we were welcome and that we could stay for the night. A US helicopter had just dropped supplies: brand new sleeping bags, chocolate nut cakes, ready to eat tuna & noodle meals, lemonade powder, chewing gum and perfumed tissues for wiping one's hands.

After we had had our fill, the commander of the fort took us by car some miles further inside Iraq, mainly to show us the Iraqi forces milling around on the surrounding hilltops. They could have fired at us, but having just lost a war they kept quiet. What amazed me more than the distant soldiers were the ruins along the road. I was watching evidence of Zebari's exposé, but at first I failed to understand that. I just wondered: why have all these houses been demolished? Of course, here, high up in the mountains, villages were small and so were the piles of rubble.

Our stay in the fortress was quite memorable. As soon as night fell, petrol lamps were

lit. The dozen or so pesh mergas engaged in hefty debates about their predicament, the refugees and what to do next. After a night in the fortress, Gary and I walked back to Turkey and our hotel in Cizre in order to file our stories. A week later I was back in Holland, and after taking two weeks rest, I went back to Kurdistan. That was when I first saw how immense the results of the Anfal really were. More about that trip in the chapter "Survivors", page 48 and further – I'll first describe the Anfal itself.

Towards the end of the Iran-Iraq War, in March 1987, the Anfal began, led by Saddam's nephew Ali Hassan al-Majid. And when the Iran-Iraq War ended in the summer of 1988, the Anfal campaign was stepped up because more Iraqi soldiers were available to assist. Roughly 4000 out of 4600 villages and some towns in Iraqi Kurdistan were destroyed, usually with bulldozers, if necessary with dynamite. Water wells were poisoned or filled with concrete, orchards were cut down, grave-

This girl in Germian, not far from Suleymania, was one of the few survivors of a family that had been executed by Saddam's forces during the Anfal. My translator had been well-acquainted with the family, and he told me: "I just don't know what to say to her." At any rate, she was very shy and silent, here seen making tea for the unexpected visitors.

yards levelled. Only villages on the outskirts of towns remained intact. Of the inhabitants, some 182,000 were killed according to Kurdish counts. Human Rights Watch maintained for a long time that between 60,000 and 110,000 people had been executed. In 2003 Kenneth Roth, director of Human Rights Watch, said that "100,000 Kurdish men and boys were machine-gunned to death during the 1988 Anfal genocide." Add to these the victims of 1987 and 1989, and the women, and the total number might well be close to 182,000.

Many were loaded onto trucks and brought to large pits in the desert. A couple of hundred at a time, they were commanded to stand in the bottom of the pit. Then they would be machine-gunned and the pit closed by bulldozers. Sometimes people were shot individually and then thrown into a mass grave.
A few who were only wounded managed to escape under the cover of darkness before the pits were filled up. The most famous of these is Taymur Abdallah Achmad from the Kalar region. He was twelve when Saddam's men murdered his family and dozens of others, in September 1988 in Southern Iraq, close to the Saudi border. Taymur, only wounded, climbed out of the pit unseen and stumbled into a Bedouin camp hours later. The Bedu treated his shot wounds and hid him for two and a half years, till the liberation of Iraqi Kurdistan began, in March 1991, and Taymur was smuggled to the North. Then he was able to tell his story – and he told it to dozens of journalists, lifting the shroud of silence that had covered the Anfal. On 27 November 2006, Taymur was a witness during the Anfal Trial, against Saddam and Saddam's nephew Ali Hassan al Majid, the chief architect of the Anfal. Facing both defendants directly, Taymur said: "Even if they gave me all the riches of the world, that

would not compensate for my father's fingers." He also said that he had seen tears in the eyes of the soldier who had been ordered to shoot him.
During the demolition of the villages, poisoned gas was used at times. Not to kill – firing squads are more effective – but to instil fear. In all, about thirty poisoned gas attacks were carried out in those two years. About a million villagers were spared. They were brought together in large "resettlement camps" near the towns, where the army could easily control them. In many cases they had to build their own houses, while some did not even receive the building materials needed.

According to Human Rights Watch, during the Anfal campaign 1,754 schools, 270 hospitals, 2,450 mosques and 27 churches were demolished. And it wasn't only the Kurds who were targeted, but also minorities in the area like Assyrians, Chaldeans, Turkomen and Shabaks.
The reasoning behind the Anfal was that the villagers had provided all sorts of support for the Kurdish guerrilla fighters through the years: shelter, food, medical care, and indeed personnel as tens of thousands of young men enlisted to become pesh mergas themselves. Therefore, according to Saddam, all villages had to be wiped out.
Ironically, only one event out of the entire Anfal campaign got any serious attention in the world's media. On 16 and 17 March 1988, the Iraqi air force launched a massive poisoned gas attack on the Kurdish town of Halabja, near the Iranian border, then held by Kurds who cooperated with Iran. A few days later, Iran brought in Western journalists and NGO representatives, because Iran realised the great anti-Saddam PR potential of streets and houses full of dead bodies. Many of the victims had embraced each other while dying, parents had been trying to protect their children. It was horrendous

to the extreme, it could easily be photographed, and it was proof beyond doubt that Iraq was using chemical weapons. Exposing Halabja would be disastrous for Saddam, who was until then a friend of the West because he was acting so firmly against Islamic fundamentalism, Iran's ayatolla regime in particular. And so, pictures of the Pompeii-like bodies appeared all over the world and Kurdish suffering became synonymous with Halabja and vice versa.

Although Halabja was by far the most serious poisoned gas attack on the Kurds, its 5,000 dead (the maximum count) constituted 2,5 percent of all the victims of the Anfal. The other 97,5 percent were largely ignored by the West. That changed in May 1991, when Saddam was ousted from Iraqi Kurdistan, first from the Safe Haven in the north west, later that summer from most of the rest of the Kurdish areas.
As will be seen in chapter 4, many Kurdish villagers started rebuilding as soon as they could reach the rubble of their former dwellings, from May 1991 onwards. The first effects of their efforts became visible very soon: the piles of loose bricks disappeared, everywhere houses arose from their dusty ashes. The UNHCR helped a lot by bringing in hundreds of thousands of doors and windows together with frames. The Kurds didn't need much more, they could build walls and roofs surprisingly well themselves – see chapter 4.
As a result of this, there was only a short time frame, lasting just a couple of weeks, during which the destruction of the Anfal was able to be inspected and photographed by anyone who travelled through the Kurdish countryside.

Please note: This chapter deals with the 1987-1989 period, when no journalist had access to Iraqi Kurdistan. So all pictures were taken in 1991-1992.

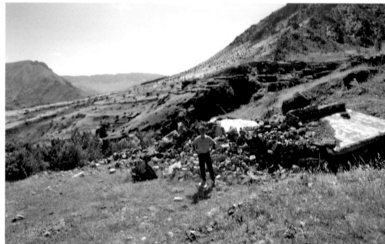

The house where I and my fellow travellers stayed for a week, in Jalala, in 1973 – and me standing in front of the same house after the Anfal, in May 1991 (Photo: Burhan Jaf).

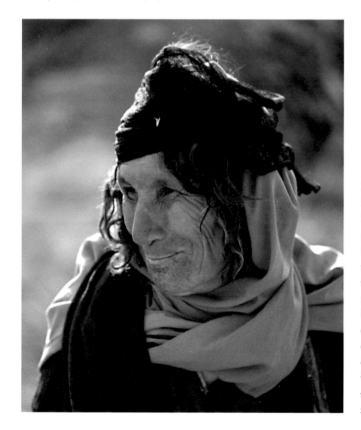

Between the Anfal and the liberation of Kurdistan in 1991, this woman from Hashi Zeni in Germian was locked up in the Nugra Selma prison camp, 300 kilometers south of Baghdad. She told: "When we were rounded up I got separated from one of my daughters. I haven't seen her since. There were 2500 Kurds in the prison. About a dozen a day died. They were buried right outside the fence surrounding the camp, where dogs used to dig them up and eat them before our eyes." The tattoos on her chin are not really Kurdish. They used to be fashionable among Arab women in Iraq, and some Kurdish women in Kurdish-Arab border zones copied them.

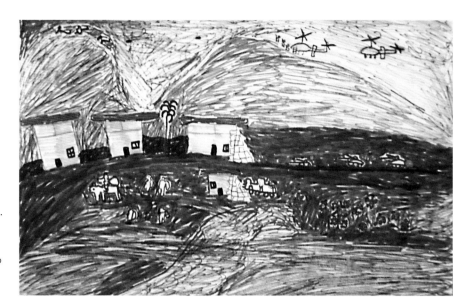

This drawing was made in 1992 by a child in
an orphanage in Suleymania whose parents
had been killed during the Anfal. On the right
and in the foreground: roses and a river
symbolize the good life that came to an and.
In the middle on the right, tanks approach.
In the meantime bulldozers are pulling down
houses, two piles of rubble can already be seen.
On the foreground, left, villagers are preparing
to leave. And on the hilltops in the background
to the left, pesh mergas make a vain attempt to
withstand the might of Saddam's men and
their supporting helicopter gunships.

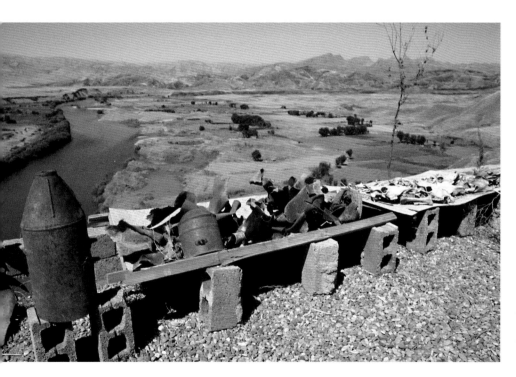

One of the thirty poisoned gas attacks that
never made it to the media took place in
Goktapa on 3 May 1988. Between 154 and 300
people were killed. In 1992 returning survivors
made this makeshift monument, with shells of
gas grenades and skulls of perished animals.
A graveyard for the victims lay nearby. Some
people died near the riverbank, where they
were working on the fields and where the gas,
heavier than air, accumulated.

Such was the need for building materials when people started flocking back to their demolished villages that some used poisoned gas bombs – which do not explode, they just open – as roof supports.

Pesh mergas of the PUK in one of Saddam's many torture rooms, in Kifri. Note the hook on the ceiling.

Roughly one million people were concentrated in resettlement camps after their villages had been razed to the ground during the Anfal. This is a resettlement camp near Diyana, pictured in May 1991 when the mood was no longer that gloomy.

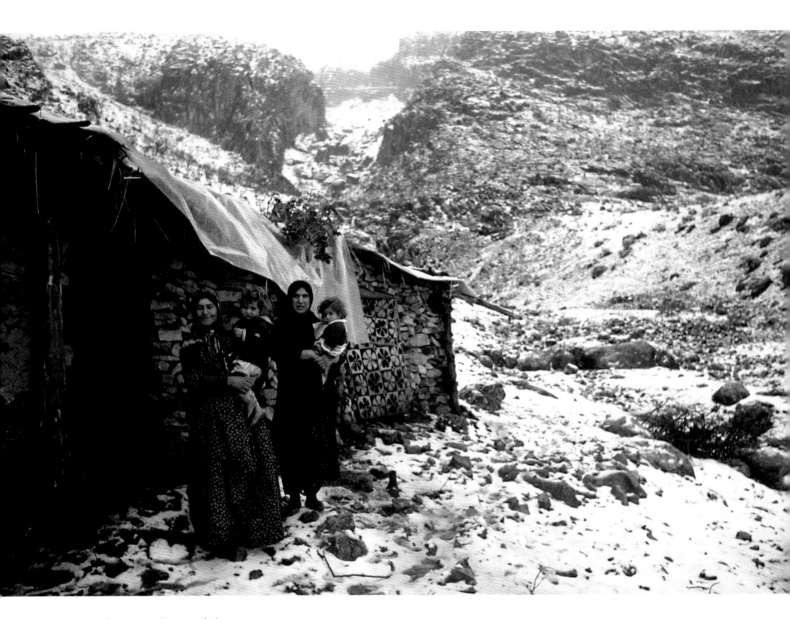

Yet another poisoned gas attack that went
unnoticed outside Kurdistan took place in the
Balisan Valley on 16 April 1987, killing between
225 and 400 people. Those living on this spot,
on a slope just above the village, were lucky. When
there is no wind, the gas drifts to the lower areas.
That is why this family survived, though some
members were still having serious throat problems
when this picture was taken, in February 1992.

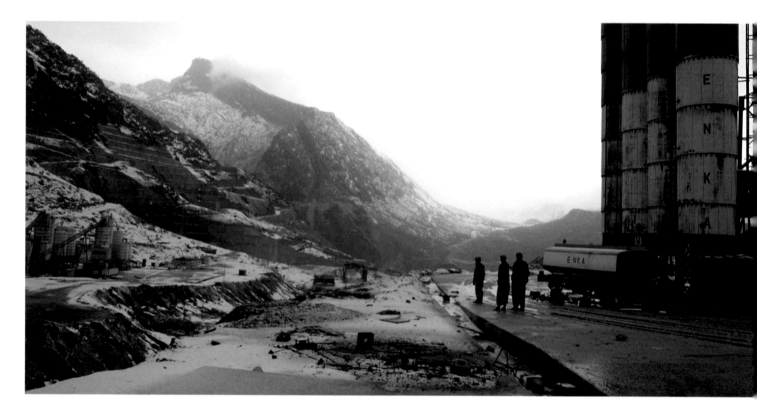

There was more involved in the campaigns against the Kurds than killing and demolishing. This is the site of the Bekme hydroelectric dam. Saddam needed electricity for the towns in Kurdistan and the rest of Iraq. The lake would inundate the entire Barzan Valley (and a few adjacent valleys), the homeland of the Barzanis. It would destroy huge, unknown archaeological riches still waiting to be excavated. In other words, it would destroy a key area of Kurdistan. The Turkish building company Enka and America's largest engineering group Bechtel were happy to accept Saddam's order. Work started in 1983. At the time of the uprising, March 1991, angry Kurds destroyed all they could at the Bekme site, including many precious vehicles. Later, Masoud Barzani allowed Aga Omar Surchi, a powerful Kurdish landlord, to sell whatever was still usable.

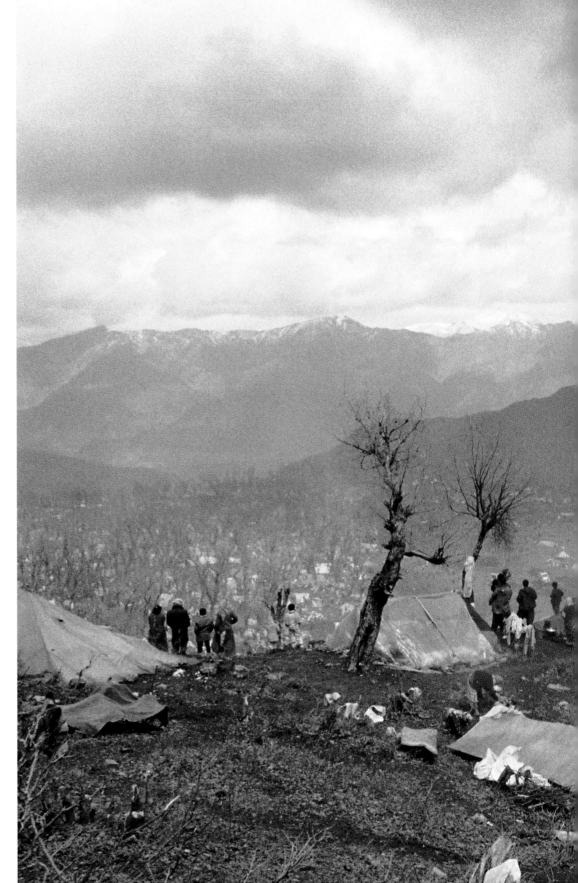

Refugees The "refugee camp" north of Zakho, just inside Turkey, was in fact a mountain slope packed with people. The big tent in the right-hand corner was the home of a family of 23. I spent one night there while it was raining hard, also inside the tent.

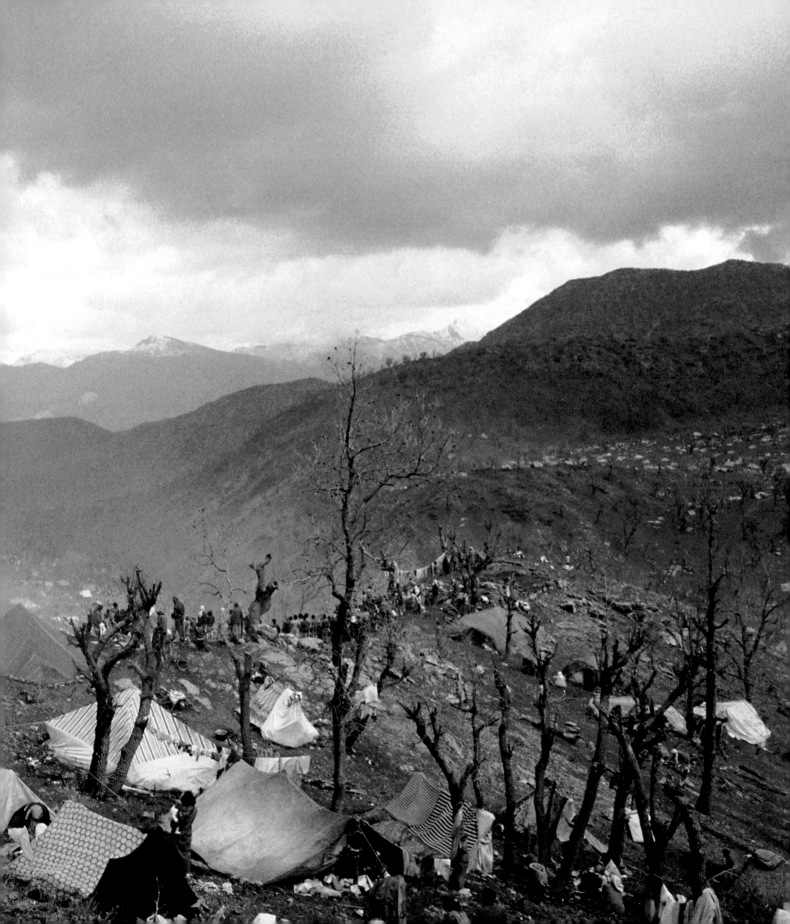

Refugees

At the end of March and the beginning of April 1991, some two to three million Iraqi Kurds, Assyrians, Chaldeans and Turkmen fled to the mountainous borders of Iran and Turkey. It was the largest mass exodus ever recorded by the UN High Commissioner for Refugees. More than that, it marked the beginning of a completely new era in the history of the inhabitants of Iraqi Kurdistan. 1991 became the year when everything changed for the better, after several horrendous weeks on icy mountain slopes, just across the Iraqi border.

Why the flight? Five weeks earlier, Saddam's army had been soundly defeated by the US-led coalition that had launched an assault on Iraq starting January 17. The *casus belli* was Iraq's occupation of Kuwait in August 1990 and Saddam's subsequent refusal to comply with resolutions of the UN Security Council. Iraq didn't pull out of Kuwait and was therefore thrown out, by the Americans, on February 26. The victors moved on, pushing towards Baghdad and chasing the remnants of Saddam's men, many of whom seemed more than happy to surrender.

On February 15, President Bush added an improvised paragraph to a speech from the White House: "There is another way for the bloodshed to stop, and that is for the Iraqi military and the Iraqi people to take matters into their own hands and force Saddam Hussein, the dictator, to step aside." That message wasn't lost on the Kurds who heard these words via *The Voice of America*, the BBC *World Service* and CIA broadcastings. A fortnight on, Saddam's defeat wasn't lost on the Kurds either. Together with the call to arms from their new friend in Wash-

ington, this clearly was their window of opportunity. The uprising began around March 5, in the town of Ranya, and it soon spread like a prairie fire over the entire Kurdish region. And what a success it was! The defeat had demoralized Saddam's forces, both military and civilian, and fortified the hearts of their victims. Erbil fell, Kirkuk fell, Suleymania fell and so did all other towns in the space of some two weeks. For the first time in decades, Kurds had the almost other-worldly experience of walking around their own houses in freedom. On the whole, it was fairly bloodless. There were victims, though relatively few. In Suleymania, some of Saddam's people tried to hide in the wide tubes of the air conditioning system in their headquarters, where many Kurds had been tortured in the most heinous ways and many women had been raped. When Saddam was still in power, the townspeople didn't even dare to look at that building when passing by. Now the state-employed terrorists were at the mercy of the Kurds, and those who were dragged by their feet out of the ventilation system were killed as soon as they hit the ground.

By the end of March, very suddenly and unexpectedly, and not in accordance with American estimates and predictions, the army of Saddam managed to regroup and reorganize itself and launched successful counter-attacks in the South against the Shiites and in the North against the Kurds. By March 31, most of the liberated area in Kurdistan was under Saddam's boot once again.
Iraqi citizens could end up in jail or worse if they spilled some tea on a picture of

Saddam in a newspaper. During the uprising, the countless pictures and statues of Saddam in streets, squares and public buildings had been smashed without exception. What punishments those acts might solicit was beyond imagination. And as everybody had joined the revolution in some way or another, with or without partaking in the smashing of Saddam's images, almost everybody fled at the return of Saddam's men. About half a million ended up in Turkey, just across the border; about a million in Iran, somewhat further inland; and about half a million inside Iraq, near the Turkish or the Iranian border.

In Turkey, the refugees only had what they had carried with them while crossing the snow-capped mountain ridges on foot: almost nothing plus lots of goats and sheep, food that could transport itself. At first there weren't even any journalists. In the Turkish border town of Cizre, Paul Castella from Switzerland and I were the only foreign journalists present when the refugees arrived. We first saw them on TV on April 3 in Cizre's Kadooglu Hotel, a popular hangout for Kurdistan reporters throughout the '90s. On April 4, Castella and I tried to reach the refugee concentration nearest Cizre, on the mountains south of Uludere, 70 kilometers to the east. Sometimes in taxis, sometimes hitchhiking, we got quite near but we were turned back by soldiers at one of the last checkpoints.

The Turkish authorities felt that they, rather than the refugees, had a problem: hundreds of thousands of strangers without proper visas were sitting on their mountain slopes. How to get rid of them?

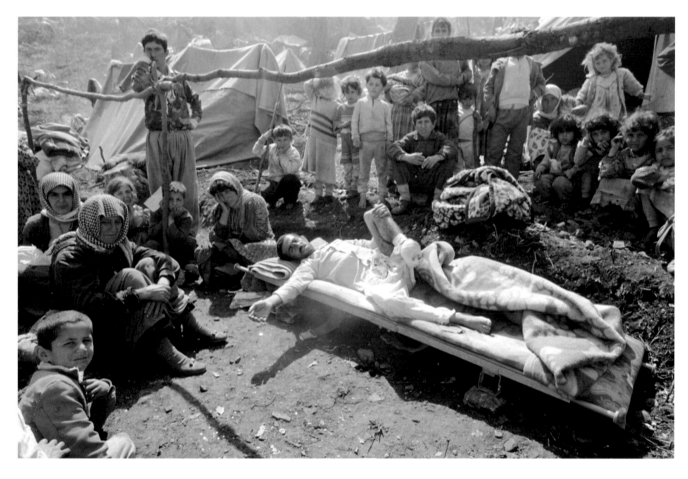

Humanitarian concerns in the West might serve as an appropriate tool! So, for once, Western media were welcome in Turkish Kurdistan. On April 5 Paul and I and a couple of Turkish journalists were loaded onto an army lorry that halted halfway up a blackish mountain slope, against a backdrop of snow-capped peaks that marked the border with Iraq. We went further on foot and crossed a long line of armed Turkish soldiers whose job it was to prevent the refugees from coming any further inside Turkey. There we split up and roamed among the utmost misery for an hour or so, taking pictures and listening to horrendous stories. There was no help available whatsoever. Some families had no

cover at all for the night and the rain, many had shelters made of blankets, only a few had reasonably good tents.

The tragedy brought a blessing to the Kurds which I happened to be a part of: journalists could actually go to the refugees, interview them, take pictures and tell the world. Since the beginning of the Anfal, four years earlier, the Kurds had hardly had any contact with the outside world. Now, all of a sudden, their images were splashed across front pages from the us to Australia, and from Japan to South Africa, and they were the sad stars on tv channels around the globe. But stars they were, the whole world seemed to sympa-

During the first few days, there was no medical care whatsoever, dozens of people died every day from exposure and exhaustion.

thize with them. For a few weeks they dominated the world's media and to a lesser degree they continued to do so for at least a year. During the Anfal (chapter 2), which was in fact a lot worse than the 1991 exodus, the world's media had kept utterly silent. One reason was the absence of certainty about the horrors of the Anfal, and more importantly: there were no images. This time around there were...

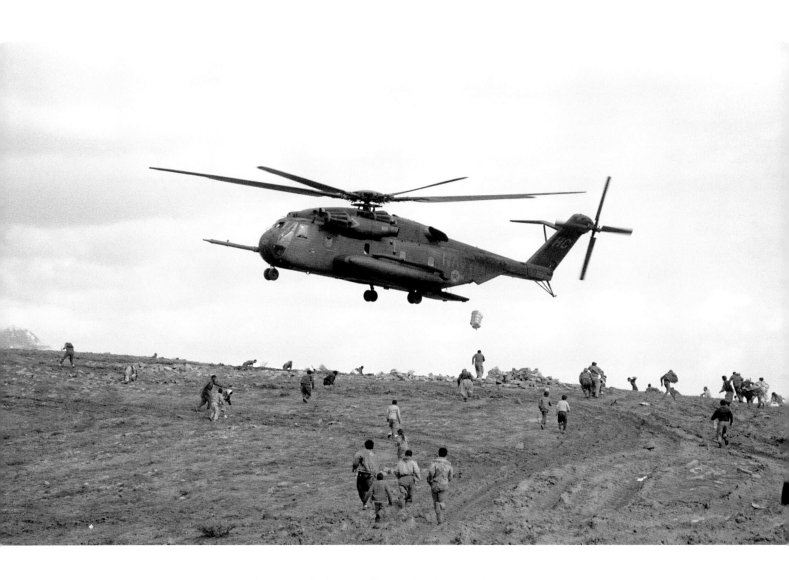

When some two million people fled to Turkey and Iran, chased by Saddam's forces, those in the rear seemed to be the unlucky ones because they had the greatest chance of being caught. But as it turned out, they had the great advantage of discovering that Saddam's troops had halted in some places, and were halted by the Kurdish defence forces in some other places. In other words: the refugees in the rear found out that they could safely stay inside Iraq. In the mountains north of Zakho, still inside Iraq, many families stopped running in the direction of Turkey when they noticed that Saddam's forces had done so too. These refugees could stay closer to home, they lived in far less contaminated places, at lower altitudes, and they received help just as well. Here a us helicopter drops blankets and food inside Iraq on April 14.

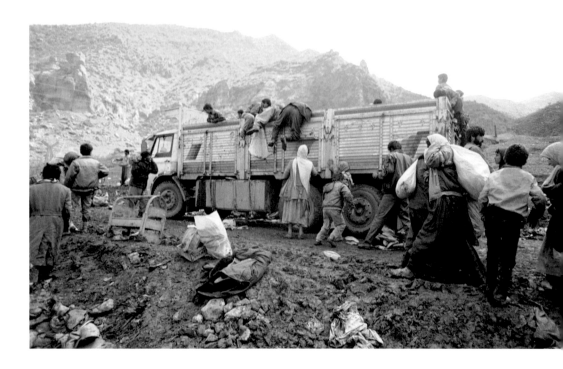

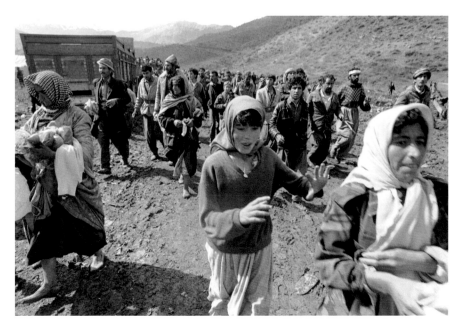

Around the same time came the first trucks loaded with bread and bottles of clean drinking water – not deep inside the camp, which measured about five square kilometers, but at the edge of all the misery. Before any truck could be properly unloaded it was plundered. The fittest returned to their tents with the most loaves of bread or bottles of water.

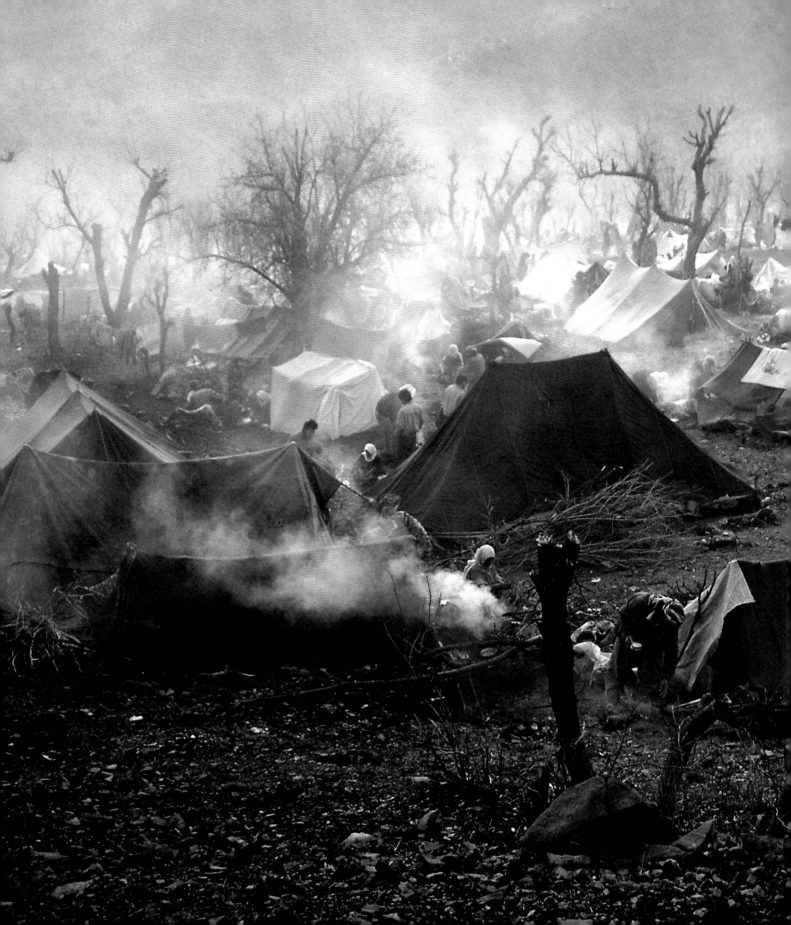

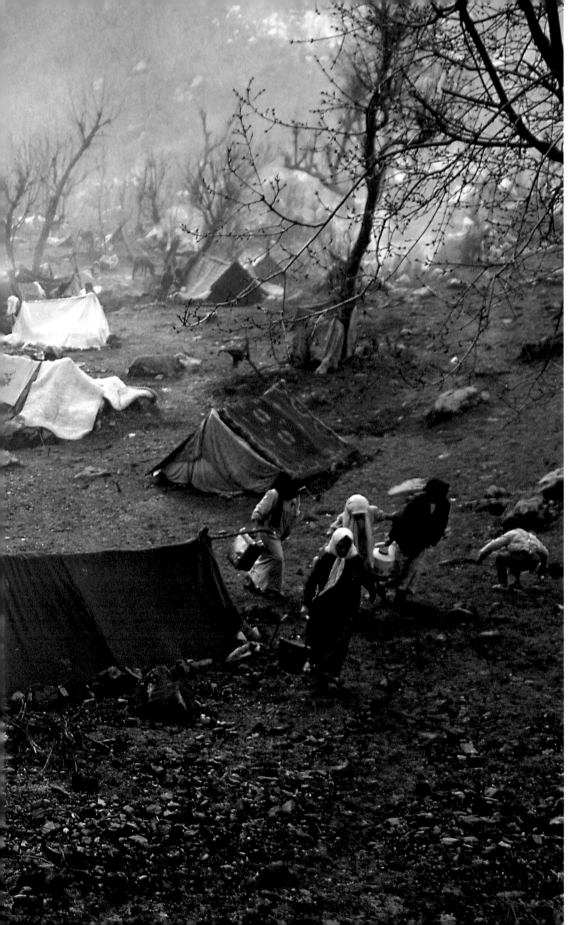

Every family wanted to have
a fire in front of their temporary
home, and there was no dry
wood, only branches cut from
the nearby trees. The result:
smoke all day and night all over
the place.

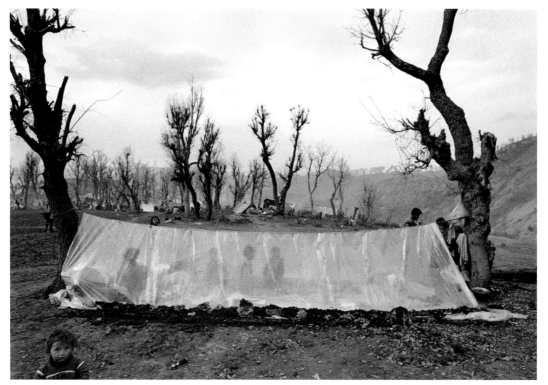

At first, many tents were just made of the blankets the people had carried with them. Water for over 100,000 people came from one small, filthy stream. The only food was the food they had brought. After a couple of days, foreign aid began to arrive, and pieces of plastic were handed out to provide some sort of shelter.

In their flight, the refugees had used buses, taxis, regular cars and even tractors as far as the vehicles would go, and then abandoned them. But some stayed near the vehicles and enjoyed proper roofs over their heads. This couple settled down in a bus. The baby was born inside it, just two days before this picture was taken.

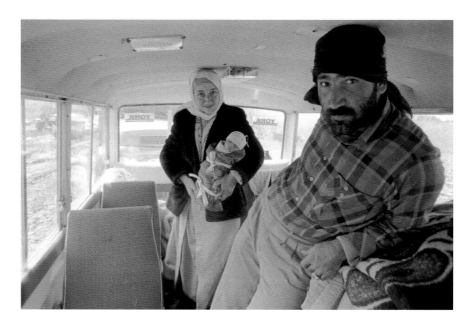

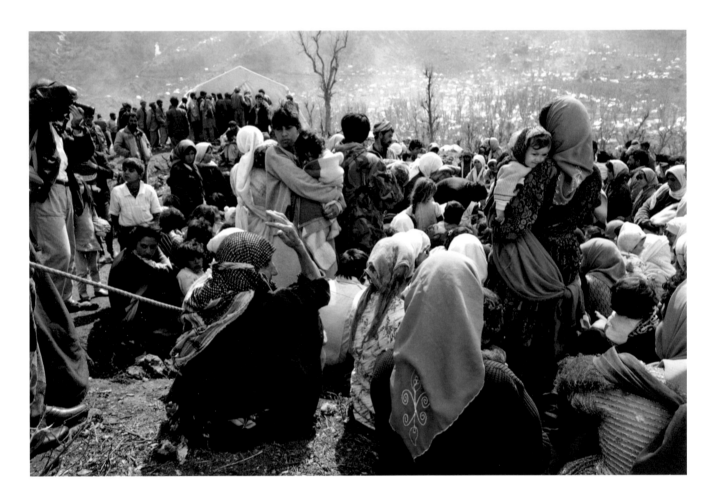

Medical aid by Doctors Without Borders for the refugees near Uludere, on April 15. The man on the left wearing a brown coat, his face behind the camera, is Kurt Schork. A year before, he had been serving as chief of staff for the New York Mass Transit Authority, the buses and the underground that is, and then decided to shed comfort and security and become a reporter instead. I first met him in the Kadooglu Hotel in Cizre, around March 25, 1991, when we and about a dozen other foreign journalists were waiting for the Iraqi border to be opened by the Turks, or trying to find ways to cross it illegally. So Kurt, Paul Castella, I and the others had days on end to talk. Kurt, an Oxford University graduate, told me that he had some contacts with Reuters, and maybe, hopefully, they would buy some of his stories. He was quite shy as a journalist, having no track record like the others, but in my mind he stood out as a very kind companion, the most friendly one of the lot. To cut a long story short, he became Reuters chief war correspondent a few years later. He was killed in Sierra Leone on May 24, 2000, aged 53. During the fifteen months after this picture was taken Kurt settled in Iraqi Kurdistan for Reuters, after which he spent many years in Sarajevo covering the war in Bosnia. For more information, check out the Kurt Schork Memorial on the internet.

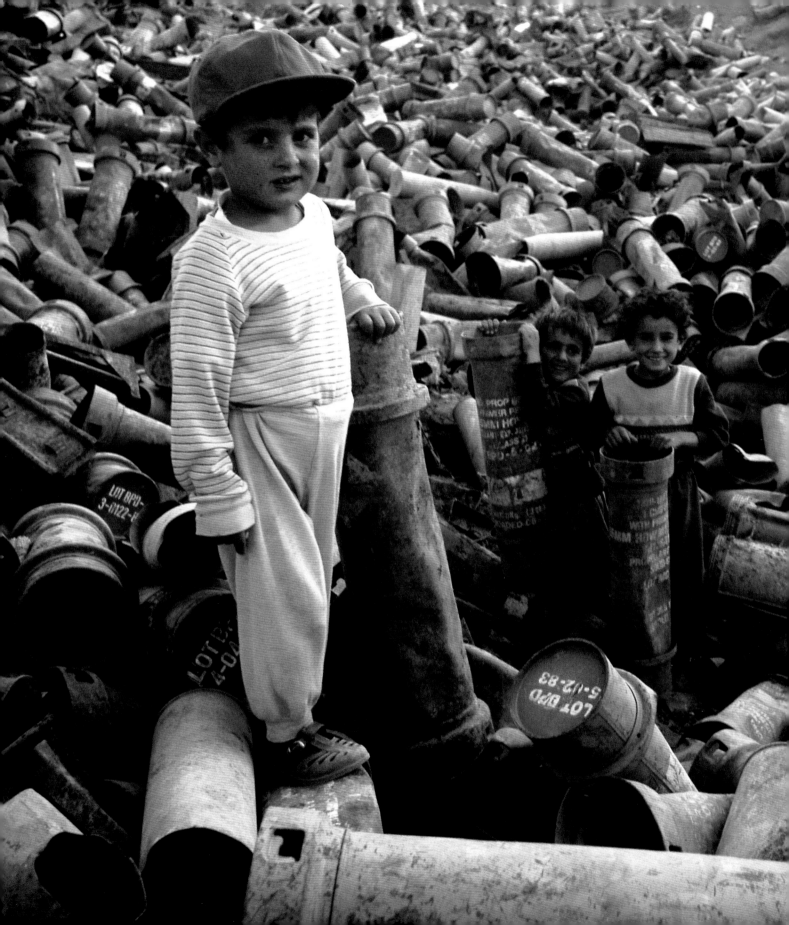

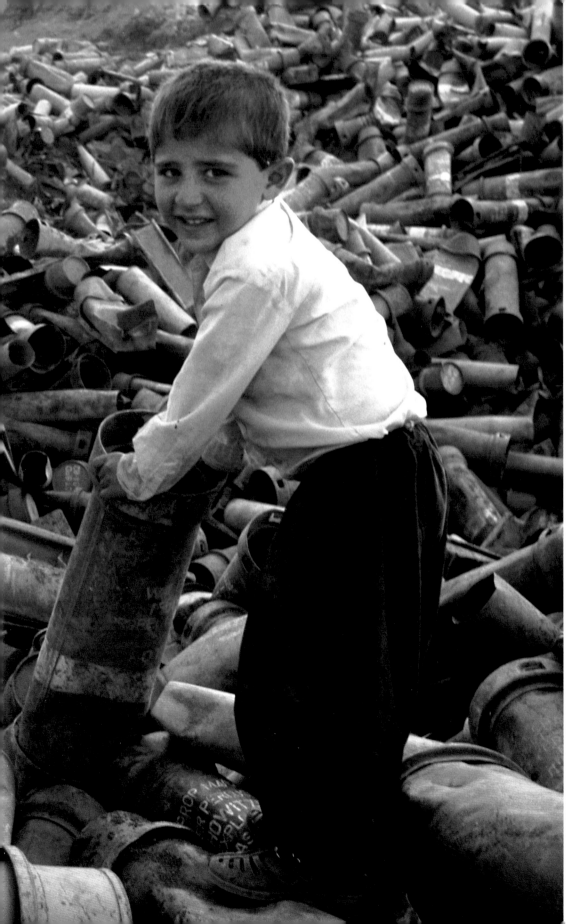

Survivors Spent shell casings from the 1980-1988 Iran-Iraq War nicely doubled as small stoves if some holes were added. It was important not to make stoves from broken casings, and these boys saw to that. They sold them for one dinar.

Survivors

After the Anfal, and after the uprising and the mass exodus, the worst was over. Since their flight to, and return from, Iran and Turkey, the Kurds were in the global limelight and were to remain so. By the end of 1991, they were enjoying de facto autonomy in an area of about 40,000 square kilometers and that is still the case today.

So how did the new freedom begin, after the uprising (March 5-28 1991) and Saddam's counter-attack (March 29-April 7)? The common version circulating in the West is that the Free Kurdistan, now known as the Iraqi Kurdistan Region, began with the Safe Haven, at the end of April 1991. Turkish president Turgut Özal, half Kurdish himself, keenly felt the need to send all the Iraqi Kurds on Turkish territory home as soon as possible. In September 1988, Turkey had accepted 63,000 of Iraqi Kurds who, due to a mistake by the Iraqi Army, had managed to escape from the Anfal. In 1991 they still hadn't left. That should not happen again, especially as there were hundreds of thousands of new refugees this time around. The best solution was to let them return quickly, before the situation on the mountain slopes became really untenable. On April 8 British Prime Minister John Major, at a EU meeting in Luxembourg, suggested the creation of a Safe Haven, a relatively small area in the northwest of Iraq, where decent refugee camps could be set up by the Americans and the others who had invaded the country after liberating Kuwait. Then other EU politicians came along and on 16 April, US president George Bush Sr. accepted the idea. Even Saddam cooperated by withdrawing his troops from

the Safe Haven. On April 20, US and British troops crossed the Habur bridge and moved into Zakho unopposed, marking the start of the Safe Haven. The Kurds were able to return.

Though John Major was a key factor in the creation of the Safe Haven and the ensuing protection of the Iraqi Kurds by the West (which, in fact, has lasted till the present day), the idea to support the Kurds really began with the wife of French President Mitterrand, Daniëlle Mitterrand. She laboured hard to convince her husband that the Kurds of Iraq needed attention and help, even before the uprising and the exodus. In 1982 she had co-founded the Institut Kurde in Paris. And so, president Mitterrand, encouraged by his wife to watch images on TV of Kurdish refugees in Turkey and Iran in the first days of April, sent his junior minister for Humanitarian Action, Bernard Kouchner, to Turkey on April 3. That mission was the actual begin-

ning of the momentous decision by the West to help the Kurds of Iraq.

But there is another story, about another area, which has rarely been told outside Kurdistan. While the media in the West were all reporting about Saddam's recapture of the liberated area in the last days of March and the beginning of April, the truth was that he only partially succeeded. Parts of the area where the uprising took place remained free. That was largely the result of a battle between Kurdish fighters and Saddam's troops at Sheraswara, near the village of Kore between Salahuddin and Shaqlawa, on April 7. There, Saddam's forces, mainly tanks, were defeated and halted. Shaqlawa remained as free as it had been since the uprising, and so did all the land between that town and the Iranian border. Many refugees heading for Iran stayed inside Iraq while Kurdish forces held Saddam's men at bay.

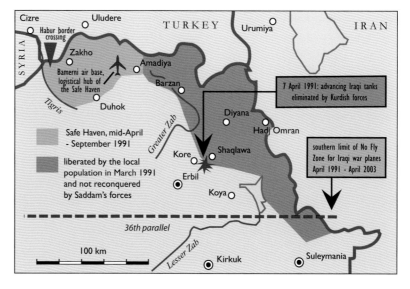

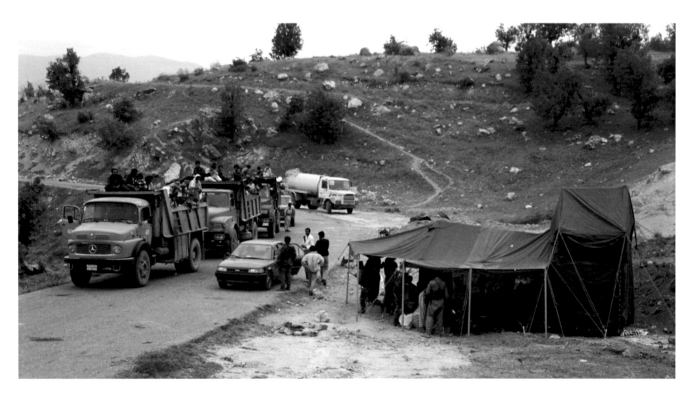

Success has many fathers. Not surprisingly, the PUK and the KDP disagree about who was the brain behind the Kore standoff and had led the pesh mergas in their finest hour. KDP sources had assured me that Masoud Barzani himself had collected all pesh mergas who were willing to fight and that he had led them to victory. But at the end of February 1992, in a derelict hotel in Shaqlawa where PUK leader Jalal Talabani had installed a temporary GHQ, I heard another version. While I was preparing for an interview with Talabani, Burham Saleh, Iraq's current vice-prime minister, brought a PUK commander to me and said with a smile: "May I introduce you to the man who led the defeat of the Iraqi army in April 1991 between Salahuddin and Shaqlawa!". Minutes away from a more important interview I declined to talk to the man at length, and I still regret it. At any rate, it seems that PUK and KDP pesh mergas fought alongside each other, knocking out the advancing tanks one by one. I visited the battle scene months later and saw Arabs milling around the burned-out tanks. They were the fathers of the defeat, looking for remains of their sons who had died in the inferno.

The free Kurdish area and the US-led Safe Haven bordered each other, roughly near the town of Amadiya. During the second week of May I stayed in the Safe Haven, mainly around Zakho and Batufa. Military from Britain, the US, France and my own country, Holland, were setting up tents for returnees whose houses stood in Saddam-controlled areas. Another job was to prepare villages in the Safe Haven, all of them rubble, for the people who had lived there before the Anfal. They had fled to Turkey and Iran from the resettlement camps (see page 35) and now, after three years, they really could go home again, even though home

Words can't describe what situations like this one meant to the Kurds of Iraq. About a month after having fled Saddam's army, refugees are being welcomed by Western and Kurdish military forces upon their return.

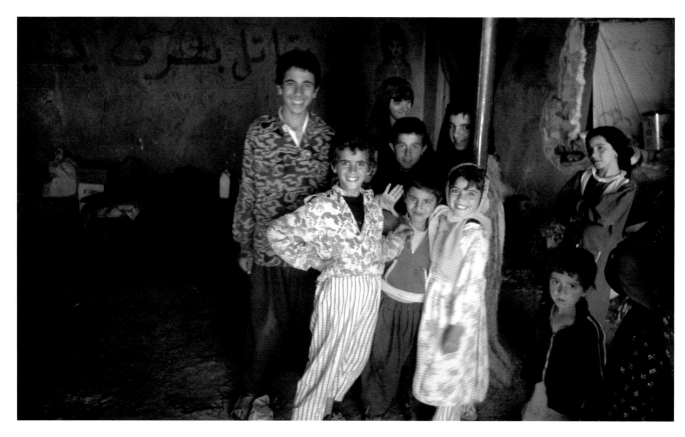

was a pile of stones. Installing drinking water was a priority, along with providing medical care, food, shelter etc.. In many cases, the men first descended from the Turkish mountains; and when they were satisfied with what they found they returned to Turkey to get the rest of the family.

Soon the Safe Haven was full of journalists as well. That was one good reason to leave, the second being that I had heard rumours about the Kurdish-administered free area in the northeast. On or around May 15, 1991, I, Greek journalist Elini Leontitsi, some pesh mergas that had the job of seeing to our safety, a driver and two or three other Kurds left the Safe Haven to see the Kurdish-led free zone for ourselves.

The last allied checkpoint, just a bit east of Amadiya, was manned by French soldiers.

Even they were ignorant about the Kurdish success in the northeastern corner of Iraq. "Don't go zère!! Don't go zère!!", they shouted through our car window as we stopped at their post. They meant well. But in fact the most dangerous aspect of the trip was that we were carrying all our petrol in and on top of our rusty minibus, as we had good reason to believe that fuel was hard to come by at our destination. The jerry cans had no proper lids, but a rubber band and a piece of plastic which failed to seal the nozzle, so we really were a mobile bomb.

But we made it safely – and in the free zone we found an infant state, the early beginnings of the current IKR. My first night there was spent in a bed in a hospital in Diyana because I couldn't find any other. The hospital was out of use and empty any-

way. Later on we found a vacant hotel overlooking Rawanduz – once quite luxurious, now without running water, linen, room service and indeed personnel. Someone with a key just opened it for us. How we got fed I can't remember exactly, I think the local Kurds brought us some food if and when we were there. Rod Nordland from *Newsweek* also checked in, a few other western journalists joined later.

It was a great time, inspiring and memorable. That had a lot to do with the Kurds who were all in the best of spirits, knowing their tide had irrevocably turned. They were fully aware that facilitating the work of foreign journalists was one of the best ways to safeguard their own future. So, despite the broken windows and lack of comfort generally, we had a great time there. Rod had an

< Many refugees returning from Iran and Turkey did so in phases: first back to Iraqi territory, to find a shelter of sorts where women and children could stay while the men explored the village left during the Anfal. These women and children had found refuge in an empty prison near Rawanduz on the road from Iran. The wall carries slogans from Saddam's rule.

> Despite all the cheer and optimism it was also a period of hard work and concern about practical matters like: where do we get cement? Since the Anfal, the stones of the demolished houses had been left where they had fallen, ready to be reused. There were enough hands to sort them out. But the cement really was a problem and many families just piled up the stones of their house – as here in Qala Diza in May 1991.

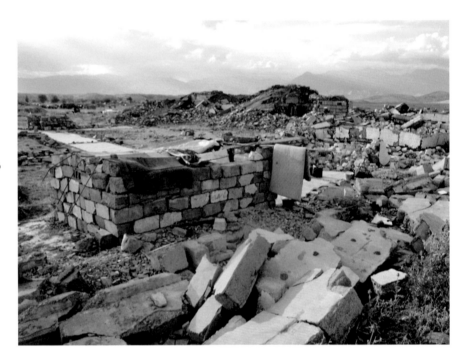

Inmarsat-A satellite phone, then a novelty, still weighing 100 kilos in those days. I had a seven-kilo satellite data transmitter (Inmarsat-C) which was even newer and which used the same Inmarsat satellites. So we could both send out reports from Rawanduz – in my case to the NRC Handelsblad daily in Rotterdam – and it was magical!

The pictures in this chapter were taken in May 1991 in the Safe Haven as well as the Kurdish-led area; in February 1992; and in July 1992. They are all related to the reconstruction of Iraqi Kurdistan from the ashes of the Anfal, and to the shaky beginnings of the de facto independent country, officially the Iraqi Kurdistan Region, that this book is about.

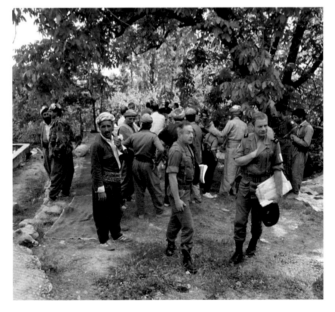

Kurdish officers and officers from the West, from France in this case, cooperated closely during the Safe Haven period. For decades the Kurds had been left on their own, at the mercy of various Iraqi regimes, their plight largely ignored by the world. And now they were suddenly rubbing shoulders with, and were respected by, Western officials.

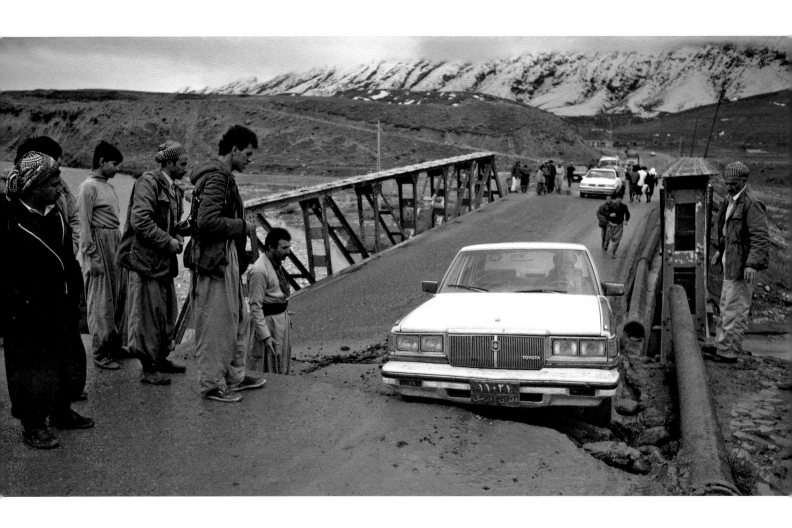

Right after the Kurds gained their de facto
independence, at the end of 1991, logistical
problems of all sorts were worsened by terrible
road conditions.

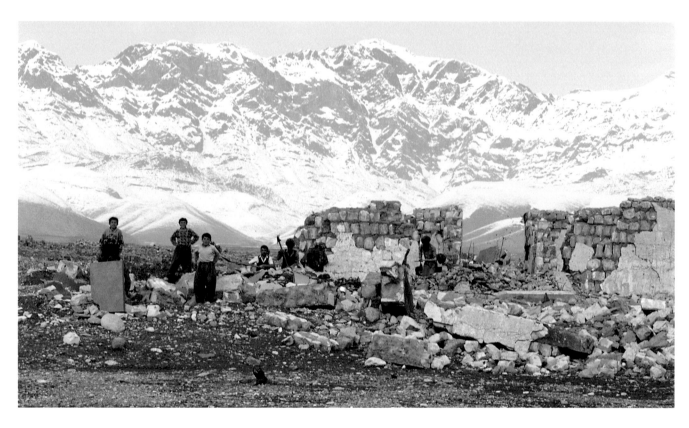

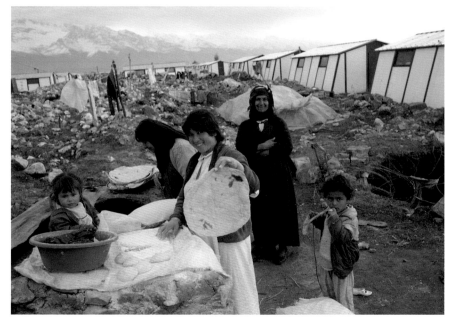

Rebuilding the ruins of the Anfal, winter 1992.

February 1992, near Suleymania. In 1991 the UNHCR brought in temporary homes like these, as well as windows, doors and frames to speed up reconstruction before the winter set in.

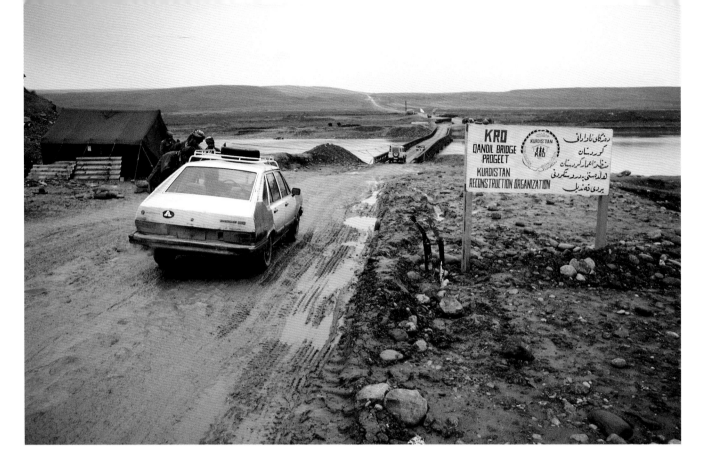

A fine example of how bad the roads were, in three stages. This is the Greater Zab, the widest river in the IKR. The retreating Iraqi army had left a number of pontoons which were used to make the bridge, seen above, largely financed by the Swedish Qandil Project. To underscore the importance of the bridge, Masoud Barzani and Jalal Talabani, the duo leaders of the Iraqi Kurdistan Front, were both present at the opening in January 1992. After some months, during rough weather, the current swept the bridge away, and all the pontoons drifted downstream to the Tigris and on to Baghdad. Then the ferry was installed at the same place, with two tractors pulling it across the Zab and vice versa. But while the bridge was free of charge, the ferry was not and some enterprising people made a nice profit from it. So the rumour quickly spread that the pontoon bridge had been cut loose during a night of bad weather...

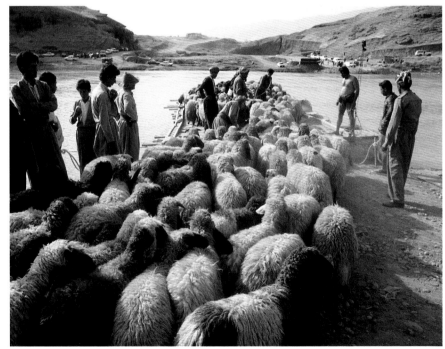

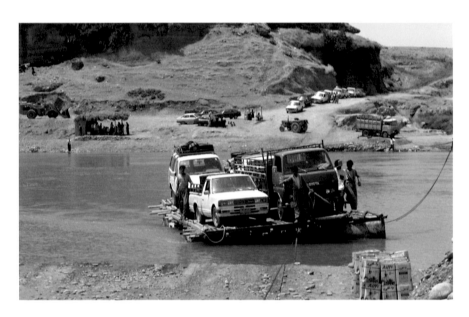

Anyway, a couple of years later a decent bridge was built a mile upstream with German aid, like so many bridges in the IKR during the critical early nineties.

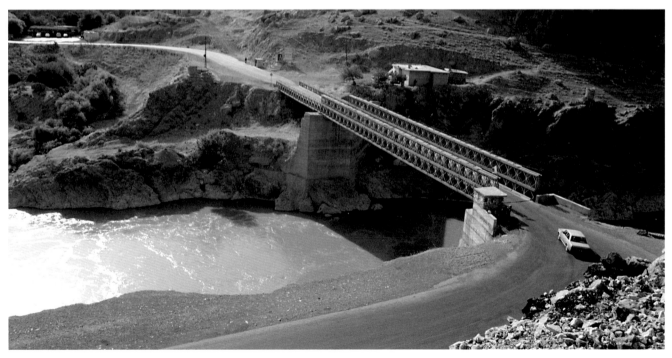

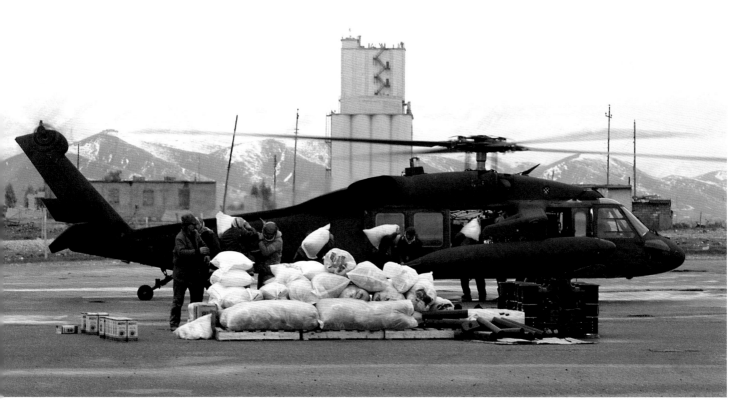

A US Black Hawk helicopter being loaded in Zakho, and dropping the supplies in a mountain village where people, although happy to be back on their own turf, were suffering from hunger. Snow of over a metre thick made it impossible to travel to markets – and the villagers probably didn't have money anyway. This was February 1992. All foreign troops had left the Safe Haven. Only Western NGOs remained and a mostly symbolic Allied Coordination Center in Zakho, led by US colonel Richard Naab. He organized these emergency flights himself and was sitting in the helicopter from which the second picture was taken.

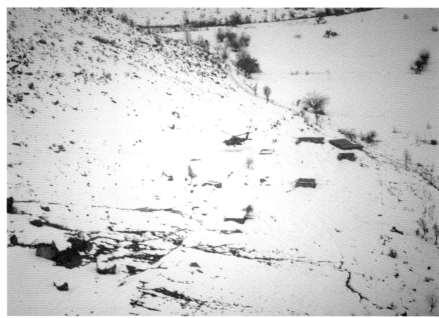

The Military Coordination Center in Zakho, the GHQ of Colonel Naab, in February 1992. This was all that was left of the Allied presence after the summer of 1991. The MCC was dismantled in 1994. However, the MCC had already become virtually powerless since Naab's departure, sometime in early 1992. When I called at the MCC in the summer of 1992 I was rather shocked to find a Turkish officer among a few others from Western Europe. The Turks, quite ridiculously, suspected that the MCC was aiding the Turkish-Kurdish PKK guerrillas and had demanded a presence.

Even the bags, used to deliver emergency food supplies, were gratefully accepted and reused, like this bag that had contained a GIFT OF EEC. Many people sold the flour, sugar or whatever was handed out to them. That was fine with the donors: the proceeds of the sales allowed people to buy things which, apparently, they needed even more.

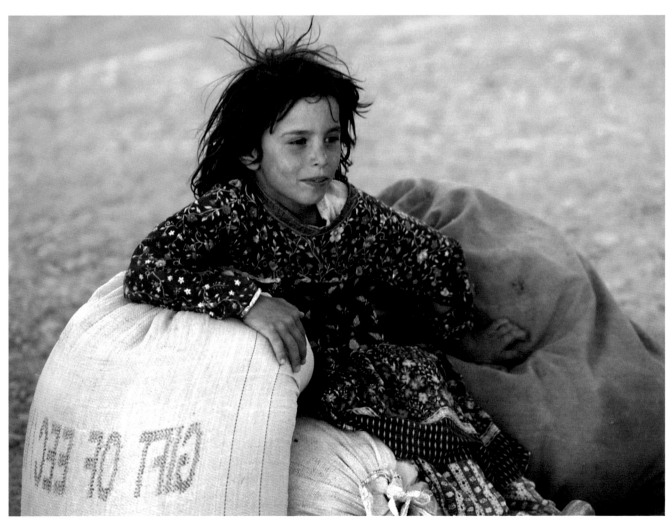

July 1992, near Derban I Khan.
The rubble from the Anfal is still
there, the villagers only have
tents to live in. Growing food
for the winter was a priority
as much as rebuilding was.

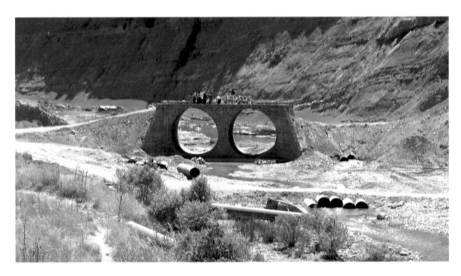

Not far from Suleymania, this bridge was built in the summer of 1992, financed by the Dutch NGO Memisa. The reason for building this bridge was unusual. The area to the right was close to the border between the Kurdish area and Saddam's Iraq. People from that area only wanted to go back and rebuild their villages if there was an escape route to the Kurdish area, in case of an attack by Saddam's forces. The bridge was flushed away the following winter.

Many just wanted to return to their villages, even if they didn't have a proper roof over their heads – as here in Hashizeni, Germian. This was July 1992, but rebuilding had yet to start.

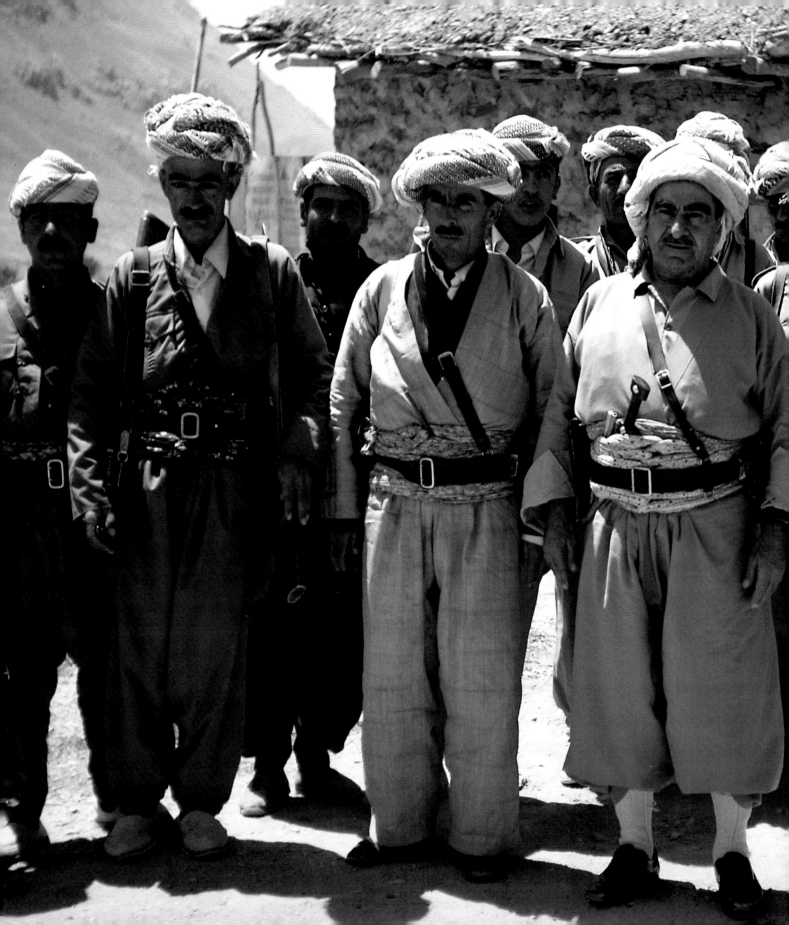

Authorities Mustafa Barzani, August 2, 1973 in Hadj Omran with his main lieutenants and body guards.

Authorities

First-time visitors to the IKR will be surprised by the ubiquitous portraits of a select group of political leaders: they hang on walls in airports, in hotel lobbies, and in and outside all sorts of public buildings. Almost invariably they show the benign smile of a political leader, dead or alive. Just occasionally, the leader looks stern and unforthcoming. The portraits are on sale in special shops, most civil servants have pictures of leaders on their desks, and of course they can also be found in many homes.

A westerner who had worked in the IKR for some months once told me: "There is no such thing here as a non-political act." The portraits have everything to do with that. They inform a visitor about the political leanings of the family, the organization, the public building, the restaurant or the car wash centre he or she is visiting.

I have had many conversations with Kurds who at first told me that they were fed up with party politics, that it was all rubbish, that they didn't want anything to do with it – and in most cases, after a little grilling by me, they would go on to say that, really, the PUK was a much better party. Or the KDP.

There is a second category of portraits, hard to discern from the first category. They transcend party politics and tell any passerby that Iraqi Kurdistan adheres to its own laws, status and identity within Iraq. Of course many pictures double as such. A picture of president Masoud Barzani could mean: please note that this is Kurdistan – not just Iraq, or Turkey for that matter. As Masoud Barzani is also the leader of the KDP, thinking and knowledgeable visitors may be a bit uncertain why his image would be on the wall or on the desk. On behalf of the KDP or the IKR? Or both?

A rule of thumb: if it's the IKR his picture represents, it will be just him, the president of all IKR citizens. If the owners of the premises wish to convey party allegiances as well, Masoud Barzani will be flanked by a representative of that party. If they are KDP enthusiasts, the picture of Masoud Barzani will probably be next to Masoud's nephew Necirwan Barzani, the IKR's Prime Minister and/or Masoud's legendary father Mustafa Barzani (1903-1979). In PUK circles, president Masoud Barzani's photo may be rubbing shoulders with a framed edition of PUK co-founder Jalal Talabani or a PUK leader like Kosrad Ali, the IKR's vice-president. Talabani, despite his fame, has the disadvantage of being Iraq's president. Why is his picture there, a visitor might wonder. Because you people love Iraq so much? Actually, few people in Southern Kurdistan love Iraq very much. As a side show during the January 30, 2005 parliamentary election, voters were asked to indicate whether they favoured cessation from Iraq. More than 98 percent said they did, even though it was just a poll without any consequences.

The importance of leadership in Kurdistan dawned upon me as soon as I got my initial bearings of the country. On my first trip to Iraqi Kurdistan, in 1973, I and the six others in the travel party were keen on meeting Mustafa Barzani long before we had left Holland. We were lucky. Soon after arriving in Barzani's liberated Kurdistan, which had enjoyed formal autonomy within Iraq since the March 11, 1970 agreement between Barzani and Saddam Hussain, we told our hosts that we were keen on conducting an interview with him. Several days later we got word that there was to be a meeting of the

KDP politburo in Hadj Omran that day. We could at least see Barzani from a distance, so did we want to come? We accepted, slightly disappointed, but seeing him was better than not meeting him at all. We went to Hadj Omran and sat on a back bench of the meeting hall, together with some twenty attending politburo members.

Mustafa Barzani came in some time after us. He was remarkably short and looked stockier than he probably was due to his elaborate waist belt, with some revolvers and daggers sticking in. Even more striking was his enormous présence, as the French would call it. During the meeting he didn't say much and, when he did, he spoke without raising his voice. His gestures were subdued and constrained. And yet he seemed to fill the entire hall, outshining the whole congregation.

After a while we were told to leave. As we did, Barzani followed us! Hadn't we asked for an interview? Let's do it now, his interpreter, Mahmut Othman told us, and we all went into an adjoining building. So there we sat, only half prepared, interviewing Kurdistan's most successful revolutionary and leader ever. We were not allowed to tape the interview, because on September 29, 1971 Saddam had sent a "diplomatic" mission to Hadj Omran to blow Barzani up – and the explosives had been hidden in a tape recorder. Actually the men sent by Saddam didn't know about the explosives, which were activated by the driver of their car by remote control. Both men were dead and so was the tea man who happened to be standing between the tape recorder and Barzani, who remained unscathed.

Our interview wasn't that revelatory. We asked why he was accepting help from the

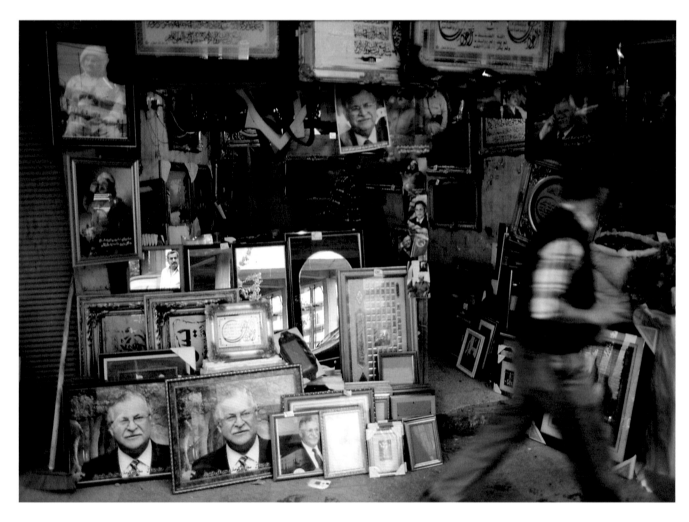

Shah of Iran, anti-aircraft artillery in particular, if the Shah had such a terrible human rights record. Barzani: "If the devil is the only one willing to help you, you may have to accept that help." After the rather brief interview, Barzani went out in the sunshine, lined up with his bodyguards and some key lieutenants, ready to be photographed. How devilish the Shah really was became clear nineteen months after our interview with Barzani. The March 11, 1970 Agreement had formally ended on March 11, 1974. During the four-year period, both parties were obliged to implement some promises,

and Saddam hadn't kept his. Most prominently, according to the 1970 Agreement, a census would determine the future of the oil-rich governorate of Kirkuk. But no census was held and instead the Baghdad government had stepped up its Arabisation programme in Kirkuk. So, fighting broke out in March 1974. Barzani's persh mergas had to withdraw but held out in the far north east, close to Iran.
Then the Shah showed his true colours: after striking a deal with Saddam, masterminded by US Foreign Secretary Henry Kissinger, about some contested islands

In a picture shop in Suleymania, a PUK stronghold, pictures of Jalal Talabani are in high demand, while in KDP-areas, framed Barzanis sell better.

in the Shatt al Arab waterway, the Shah withdrew his anti-aircraft artillery from Barzani's free state on March 6, 1975. Saddam's air force could bomb as and where it pleased, the free Kurdish area collapsed within a fortnight and the entire KDP leadership fled to Iran. Barzani never saw Iraqi soil again. He died of cancer on March 1, 1979 in a hospital in the USA.

When we met him he was still his magnifi–
cent self, radiating great power with a hint
of a smile. During the interview he looked
me in the eye for several seconds, an expe-
rience not lightly forgotten. It was the look
of an eagle, as powerful as any I have ever
seen, and yet friendly.

What we didn't know at the time was that
Barzani's own human rights record wasn't
that flawless. He once ordered a pesh merga
"to be arrested, tried, found guilty, sen-
tenced to death, and executed, all before
dawn," according to Jonathan C. Randal in
his essential Kurdistan – After Such Knowl-
edge, What Forgiveness? (1998).

My take on Barzani's human rights viola-
tions is that the good of Kurdistan was
always his top priority; that you can't make
an omelette without breaking eggs; that the
Free Kurdistan which he masterminded,
and which lasted from 1961-1975, was a
most daring venture which demanded stern
actions to survive because there were ene-
mies all around, keen to send out their
spies and their henchmen; and that, in the
final analysis, they were human rights viola-
tions after all, which admirers of Mustafa
Barzani mustn't forget about.

Let's flash forward. In November 2007, I was
driving along the Turkish border. Not far
from Amadiya, I noticed some pesh mergas
close to the road. We stopped and my inter-
preter asked if they had a camp nearby and
if so, could we visit and take pictures? We
were led to the commander, major Parazer
Besseri. The previous day, some foreign
journalists had filed a similar request, he
told me, but no photography was allowed
and no questions were being answered.
Then I told him a few things about my work
and my book project – and my meeting with
Mustafa Barzani 34 years earlier. I presented
him with a print of the portrait which is also
in this chapter. Instantly, the situation
changed completely: we had a meal together,

I was allowed to take pictures (though not
of everything in the camp) and all
my questions were answered. After I left,
Besseri and his staff lined up as a mark
of respect – not for me personally, but for
someone who had once met the man they
admired most and whom they had never
met themselves (picture on page 81).
This is not just one, rare example, even
though it stands out in my memory. This
is what happens all the time. The Barzani
pictures which I bring on each trip are my
passport to many photo ops and they have
opened many doors. Even among the PUK,
even among the PUK at times when they
were at odds with the KDP, offering a pic-
ture of Mustafa Barzani was guaranteed to
succeed. "The other Barzanis are no good,"
some PUK boss would grumble, looking at
the picture he had just received, "but Mulla
Mustafa… ahhh, he really was great."
The following selection of pictures is not
representative for Kurdish politics. They
mainly record my journeys as far as politi-
cal leaders go; but even from that point of
view the series is incomplete, which has
partly to do with my insistence on always
using available light. I interviewed Masoud
Barzani in 1992 in London and met him
again in 2007 in Brussels, but neither occa-
sion was suitable for taking pictures. I sat
for an hour in Shaqlawa with Jalal Talabani
in February 1992, in the vacated hotel that
temporarily served as his GHQ. But it was
well after sunset and there was only scant
electricity from a generator to power light
bulbs. Another memorable meeting, with
PUK politician Khosrad Ali, currently the
IKR's vice-president, in his Suleymania
GHQ in September 2003, also took place
well after nightfall. That is why some key
politicians are missing on these pages.

Mulla Mustafa Barzani (1903-1979) was a rebel
throughout his life. At the age of three, he spent
some time in an Ottoman Turkish prison,
together with his mother. He became a follower
of Sheikh Mahmoud and later on a sub-
commander of his elder brother Sheikh Achmed
Barzani. Mulla is a Kurdish boy's name, not
a religious title. In fact, Barzani never focused
on religion as an issue, although he had several
wives, as allowed under Islam.
Barzani took his place in history in January 1946.
He then became the military commander of the
armed forces of the only independent Kurdish
State in modern times, the republic of Mahabad
– which lasted for just one year, 1946 – in
Western Iran. On March 31, 1947, after the
collapse of Mahabad, president Qazi Mohammed
and some other leaders were hanged by the
Iranians. Mustafa Barzani and 517 pesh mergas
managed to escape to the Soviet Union. Both the
Turkish and the Persian armed forces did all they
could to apprehend them, but they failed utterly.
In Mahabad, Barzani and others had founded
the Partîya Demokrata Kurdistan, based on an
existing political party, the Komeley Jiyanewey
Kurd. The PDK was also a response to the PDK
Iran, as Barzani thought the Iraqi Kurds needed
a party of their own. The Iraqi PDK, usually
referred to in the West as the KDP (Kurdistan
Democratic Party), went largely underground
during Barzani's exile in the USSR. During those
years, the Iraqi KDP was led by Ibrahim Ahmed
(1914-2000), the father-in-law of Jalal Talabani.
In 1958, Barzani returned to Iraq, after a military
coup which he saw as a sign for the start of
much better times for the Kurds. But Barzani's
relationship with military dictator Quassem went
sour rather quickly. Fighting between Barzani's
men and the Baghdad regime broke out in 1961
and lasted for nine years, claiming 60,000
Kurdish lives. A rift between Barzani and Ibrahim
Ahmed occurred in 1964, and from 1966-1969
Ahmed and Talabani lived in Baghdad, to rejoin
the KDP ranks in 1969. In March 1970, peace
settled on the mountains of Northern Iraq once
again. This picture was taken three years later.

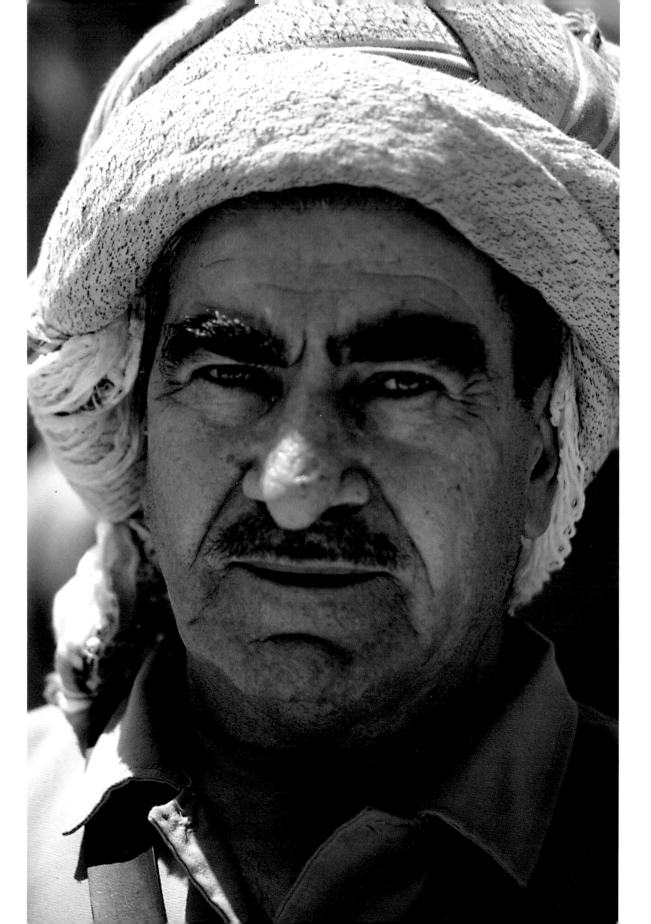

Barzani saying farewell to my sister Ineke, with Mahmoud Othman standing between them. Othman, born in 1938, studied medicine in Baghdad and became one of Barzani's most trusted men as well as his interpreter during the late sixties. At the time we met him, he was also working as a doctor in a local clinic. After the collapse of the free state in 1975, Othman founded the Kurdish Socialist Party (PASOK) in 1980. During the May 19, 1992 parliamentary elections, his party, like so many others, failed to reach the threshold of seven(!) percent of the votes, a draconian measure which the PUK and the KDP had agreed upon. This threshold effectively killed parliamentary pluralism in the IKR right at the beginning. During a meeting with Othman in February 1992, I gave him some of the 1973 pictures.

He was not too pleased with them. "So, these are historic pictures," he said slowly, with a lot of emphasis on historic.

Othman went into exile in London from 1992-1995 and then joined the in-fighting which had started in 1994. The Kurdish Socialist Party had its own pesh mergas and they had their share in the battles. Along with the KDP and the PUK, the KSP, too, was accused of torturing prisoners by Human Rights Watch and Amnesty International. In 2001, Othman helped to broker a peace deal between the KDP and the PUK. In 2004, he was elected as a member of the Iraqi National Assembly, and in 2006 he headed the list of all Kurdish parties in the Iraqi elections, the Kurdistan Alliance.

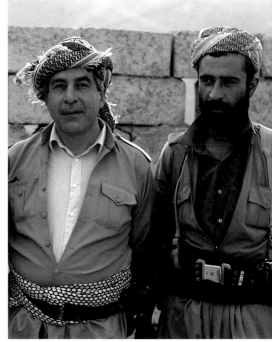

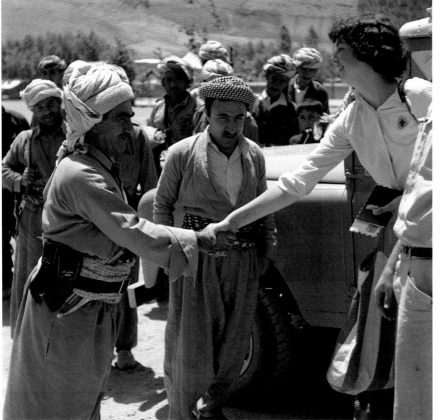

After the March 1991 uprising, Kurds from the worldwide Kurdish diaspora flocked back to the liberated area. At the left is Siamand Banaa, in May 1991 in Sardawa near Diyana, the temporary GHQ of the KDP. Banaa studied mining at Cardiff University. He became fluent in English and was interpreter for three generations of Barzanis: Mustafa, his sons Masoud and Idriss, and Idriss' son Necirwan. Banaa interpreted during my interviews with Necirwan and with Masoud. In 1975 he had arrived as a refugee in the Netherlands. In September 1991, Banaa became the first KDP representative in Ankara. After the formation of the Kurdistan Regional Government, following the May 1992 elections, Banaa became the KRG's first representative in London. And in December 2004 he became the Iraqi Ambassador to the Netherlands. Next to his desk in The Hague hangs a picture of him, taken in 1976 outside the embassy building, while he leads a demonstration against the very embassy he is now heading.

A memorial for Sheikh Mahmoud Barzanji (1878-1956), left, in Suleymania, who led the resistance against the colonial Baghdad government between 1919 and 1932, sometimes cooperating with the British, sometimes attacking them. In May 1919, just before he was to become the British appointed governor of Suleymania, Sheikh Mahmoud declared independence and had British officials rounded up by his militia. He made himself "ruler of all Kurdistan". In his book Mustafa Barzani and the Kurdish Liberation Movement (2003), Masoud Barzani writes: "While advocating the 1919 revolution of Sheikh Mahmud against British imperialism, Sheikh Achmed Barzani [Mustafa's elder brother, MH] sent letters to Kurdish tribal chiefs and sheiks in the Badinan region [the zone bordering on Turkey] urging them to

support Sheikh Mahmud. In addition, he sent his brother Mulla Mustafa, who was in command of a number of Barzani fighters, through the Piyaw Valley [east of Barzan], and another group of fighters through the Balek region [between Rawanduz and Hadj Omran] to join the revolution. Both forces were ambushed several times by British agents along the way, and several of the Kurdish troops were killed before reaching Suleymania. By the time the Barzanis arrived, the revolt had already been brought to an end. Sheikh Mahmoud was wounded in Darbandi Bazian and captured by the British."

In 1921, Sheikh Mahmoud was exiled to India, but his men continued to resist the central government. In 1922, back from India, he resumed hostilities to the extent that the British

could no longer deny his pivotal role. In September they appointed him King of the Kingdom of Kurdistan, which lasted till 1924. Creating new kingdoms was a trend among the British in those days: right after the end of World War I, they had crafted the kingdoms of Jordan and Iraq after drawing some new borders on the map.

Going along with the creation of the Kingdom was the British way of saying that they were unable or unwilling to defeat Sheikh Mahmud. Even so, at various stages before and after the Kingdom, the Royal Air Force committed large-scale atrocities in Iraqi Kurdistan – using machine guns from airplanes and, according to some historians, even by using chemical weapons from 1924 onwards, all British forces in Iraq fell under RAF command).

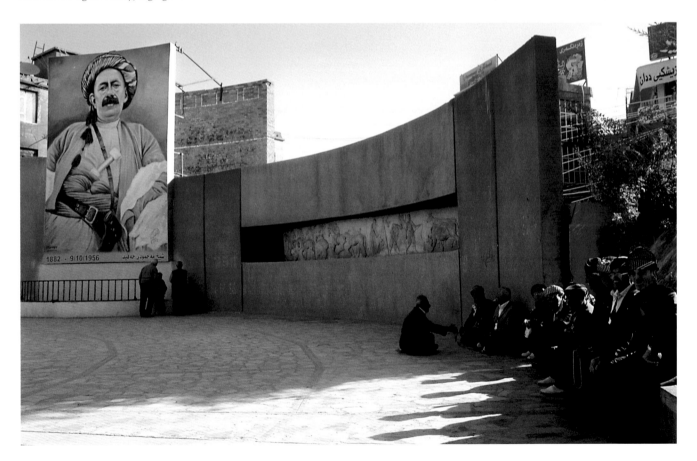

Changing the guards in front of the picture of Mustafa Barzani in the entrance hall of the parliamentary building in Erbil.

Despite appearances, this picture has a lot to do with authority in Kurdistan. After the Anfal (1987-1989) and the destruction of the Kurdish countryside, Iraq's president Saddam still enjoyed relaxing there. This was one of his palaces, in Iniski near Amadiya, surrounded by ruined villages. As the dictator liked to swim, he had a large pool made in the garden. The palace was demolished during and after the March 1991 uprising. In June 2002, when this picture was taken, the pesh mergas still considered the ruin important enough to guard and protect. Saddam was still in power, it was thought I might be on his payroll. They told me I had to leave at once, no picture-taking was allowed. But my brilliant interpreter Kheder Pishdery didn't stop talking to the men until he had convinced them that my presence in the region had the blessings of prime minister Necirwan Barzani. After two shots I was told to stop and asked to leave.

Hosyar Zebari in August 1990 in London, where he was the official representative of the Iraqi Kurdistan Front, the KDP-PUK-and-some-other-parties-coalition from 1986-1994. In 1980, three of Zebari's brothers were liquidated by Saddam in revenge for Hosyar's cooperation with Masoud Barzani. Since 2003 he has been serving as Iraq's Minister of Foreign Affairs.

Necirwan Barzani in 1998 in Geneva. He had been vice-prime minister of the KDP-led government in Erbil for two years and became prime minister in 1999. Following the discontinuation of the PUK-led Suleymania government and a rapprochement between PUK and KDP, Necirwan became prime minister of the entire KRG in March 2006. As such, he was elected by parliament, which in turn had been elected by 1,753,919 voters on January 30, 2005.

In May 1991 Masoud Barzani was in Baghdad to confer with Saddam – who had 8000 men of the Barzani tribe rounded up and executed in 1983 – about the future of the Kurdish region. In Masoud's temporary GHQ in Sardawa near Diyana, Necirwan, the son of Masoud's late brother Idriss, was in charge. After his uncle had left for Baghdad, one of Necirwan's tasks was to meet with journalists in the Kurdish-administered area, east of the Safe Haven. A BBC camera team was the first. The next day I met him for an hour and he told me that it was his first newspaper interview ever. This picture was taken after the interview.

Sheikh Bais Talabani, Minister of Finance in the PUK-led Suleymania government, in October 2003. He is a distant relative of Jalal Talabani, pictured behind him on the wall. The minister revealed that his main source of money was the Coalition Provisional Authority, led by the US, which had invaded Iraq in March. Every now and then a helicopter filled with banknotes arrived in order to pay civil servants. He admitted that the predominance of cash and the lack of electronic payment services seriously hampered the economic development of Southern Kurdistan, but that solutions were on the way (see page 171).

Nazanin Mohammad Waso, while Minister of Housing and Public Works in the KDP-led government in Erbil in 2003 under the watchful eye of Mustafa Barzani. She is currently serving as Minister of Municipalities in the unified government.

Abdulrahman Mustafa, a Kurd and governor of Kirkuk in 2003. He was appointed by the authorities in Baghdad, the Coalition Provisional Authority led by US proconsul Paul Bremer. Kirkuk was, and continues to be, outside the KRG's jurisdiction. Mustafa considered himself independent, said he maintained good relationships with all parties, and he dodged the question of whether Kirkuk ought to be part of the IKR: "That is up to the government in Baghdad." It still is, since decisions about the Kirkuk issue are endlessly being postponed by Baghdad, much to the annoyance of the KRG.

Nawzad Hadi Mawlood of the KDP, the first elected governor of the governorate of Erbil, making one of countless phone calls. Widely praised for being an effective, no-nonsense administrator, he was re-elected during the provincial elections in January 2009. On the right is a map depicting some highly ambitious urban planning, designed by the Lebanese company Dar Al-Handash, Shair & Partners. On the left: the unavoidable picture of Mustafa Barzani.

Policemen in Diyana. Asked whether I could take their picture, they agreed. They lined up and took the smiles off their faces. After three shots I thanked them. They broke out of line and started smiling again, resulting in this picture.

Policemen – at a trade fair in Erbil in 2007 – and one policewoman with head scarf properly genderizing the stand.

In Ranya, a new municipal building, costing 25 million USD, was opened on November 4, 2007. The building, which houses 320 civil servants, is seen here an hour after its informal inauguration. While the new building attests to the power and stability of the IKR as well as its affluence, the mountains in the background show the KRG's limits. In these Kandil Mountains, the PKK of the Turkish Kurds has had camps and training grounds for many years. The area is extremely inaccessible, with many deep caves serving as natural air-raid bunkers, and the PKK is very well entrenched here. The Turkish armed forces know nothing better to do than to drop bombs there every now and then, even though this is deep inside Iraq. The KRG's people don't bother to go there to flush the PKK out, as the KRG sometimes half-heartedly promises in order to soothe the Turks. Rather, municipal workmen in Raniya spend their energy flushing out the last remaining rubble from the former workplace with a fire hose.

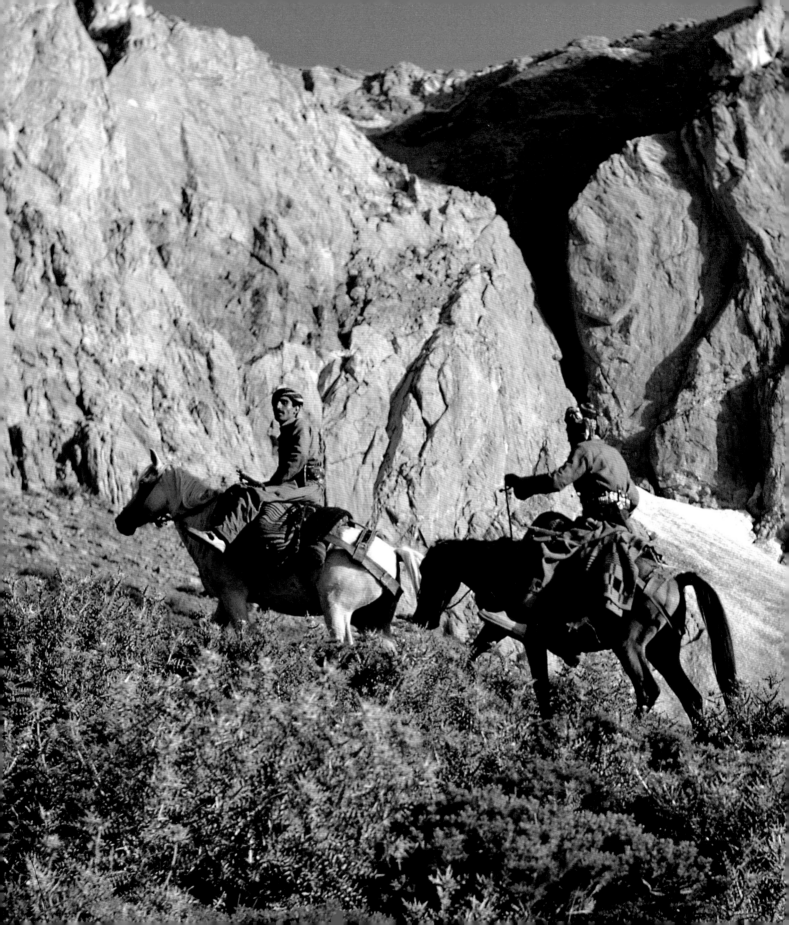

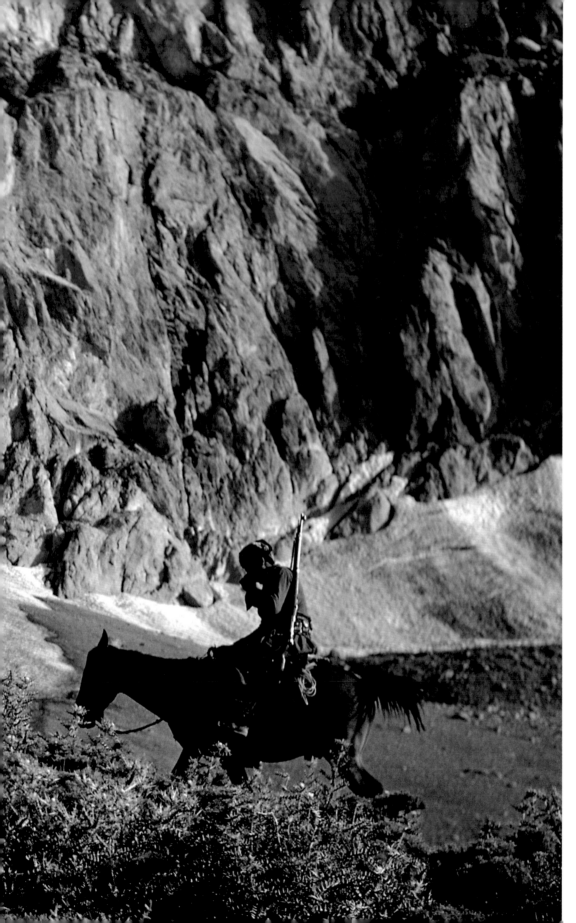

Soldiers In 1973 Kurdish
irregulars, the pesh mergas,
ruled the Kurdish mountains
as long as their enemies stayed
on the ground, just like the
pesh mergas themselves. Arab
infantry was all but useless
amidst the rugged mountains,
steep slopes and snowfields:
unaccustomed to the cold, and
on unfamiliar turf, they were
glad to return alive from any
mission. Arab cavalry, for want
of horses, just couldn't get
there. However, the balance
of military power in Iraq's
northeast was changed
profoundly with the advent
of the armoured helicopter,
which rendered the pesh
mergas quite powerless.

Soldiers

The history of the southern Kurds, in particular up till 1991, is one full of suppression and suffering. Less well known in the West is the Kurds' capacity to resist the many who have tried to rule them. If there had not been so much effective resistance by Kurdish soldiers, locally known as pesh mergas, the suppressors could have spent a lot of time sitting on their hands or suppressing people other than Kurds.

There has been fighting in Southern Kurdistan on and off for centuries. Turkic people, who migrated from Central Asia to Western Asia in the 11th century, have made endless efforts to subjugate the Kurds, and continue to have problems doing so in the Turkish part of Kurdistan. In southern Kurdistan it took the Turks about two centuries till, in the mid-19th century, they could more or less consider

the area with a Kurdish majority as theirs. The Turks knew the present-day Iraqi Kurdistan as the Vilayet (province) of Mosul, an integral part of the Ottoman Turkish Empire.

In 1916-1918 the Turks lost most of their empire – which encompassed the entire Middle East west of Iran – after intense fighting with allied forces, mostly British, who were aided by Arab guerrilla fighters led by T.E. Lawrence (1888-1935). Iraq, first conceived in 1916 by British and French diplomats, was created step by step from 1918 onwards by people like Lawrence, Gertrude Bell, Hubert Young and the British Minister of Colonies, Winston Churchill. In 1921 the brand new League of Nations gave the equally new kingdom of Iraq as a mandate to Britain. In 1932 Iraq became an independent kingdom.

In 1958 the monarchy was overthrown by a military coup and Iraq became a republic. After ten years and several more coups, the pan-Arab Baath party took over in 1968 and was dislodged from power in March 2003 when the US and its partners invaded Iraq.

The end of Turkish rule in 1918 didn't mean the end of fighting in the north of the newborn state. In the 1920s it was Shaikh Mahmud who organised resistance against the British, and from the 1930s onwards the big name was Shaikh Achmed Barzani (1896-1969). From 1945 till 1975 Achmed's younger brother, Mustafa Barzani stood at the helm of Kurdish autonomy (see also chapter 5).

Kurdish leaders like Shaikh Mahmoud and the Barzani brothers were first and fore-

Major Parazer Besseri (left), commander of a 500-strong pesh merga unit, close to the Turkish border, at the end of October 2007 when Turkey threatened to invade the IKR. We had a meal and tea, discussed the present situation and the future one. In the distance, some pesh mergas were washing up, others were cooking on log fires. Asked whether he had any artillery to knock out Turkish tanks, Besseri replied: "We have the largest cannon in the world: the willingness to sacrifice ourselves for the freedom of our country." He also stated: "We'll continue till our goal has been reached: the unification of all of Kurdistan." Including Turkish Kurdistan? "Yes!" Including Iranian Kurdistan? "Yes!"

most leaders of armed forces, the pesh
mergas, who formed the foundation of
their power. The effectiveness of their lead-
ership depended largely on their capacity
to unify quarrelling Kurdish tribes against
enemies, like the regimes in Baghdad. Each
tribe could contribute fighters, but without
confidence in the leaders, few tribal chief-
tains would send them their men. Most of
the time there were some tribes who pre-
ferred to back the regime in Baghdad, and
their fighters are known as jash, donkey
foals.
To achieve unity, there were two models:
dominance of one tribe over all the others,
or voluntary cooperation and common
goals. By and large, Achmed Barzani
achieved regional unity by making the Bar-
zanis the top tribe in the north east of Iraq
and, later, elsewhere in Iraqi Kurdistan as

well. His younger brother Mustafa Barzani
was mostly responsible for stage two, with
the Kurdistan Democratic Party (KDP) as
the platform for peaceful cooperation.
Rivalries among tribes continued to exist
of course. One of the traditional enemies
of the Barzanis were the Zebaris, living
south of Barzan, just across the Greater
Zab, and providers of Jash. One of Mustafa
Barzani's wives was a Zebari woman, an
alliance that facilitated military and other
alliances between the two tribes. A son
from that marriage, Masoud, is currently
president of the Iraqi Kurdistan Region.
And a much younger half-brother of
Masoud's mother, Hosyar Zebari, became
Iraq's first post-Saddam Minister of
Foreign Affairs, after serving as the Iraqi
Kurdistan Front's representative in
London and, later, Washington DC.

Some of the 500 men commanded by
Major Besseri.

Back to the pesh mergas, and more in par-
ticular their unity, which became the rock
bed of de facto Kurdish autonomy from
1961-1975 and from 1991 till now. How did
that unity come about? And were they
always unified? The platform for unity was
the Partîya Demokrata Kurdistan, founded
in 1945 by Barzani and others (see page 66).
The PDK, better known outside Kurdistan
as the Kurdistan Democratic Party (KDP)
achieved this goal of unity in the 1960s and
early 1970s. The only other party in those
years was the Kurdish branch of the pan-
Iraqi Communist Party.
In 1974-1975 the free Kurdistan which Bar-
zani had managed to create and to liberate
in 1961 – and which I saw during my first

trip in 1973 – collapsed. Saddam's forces moved in, Barzani fled to Iran and the KDP – meant to unify the Southern Kurds against enemies like Saddam – fell apart. In 1975 Talabani and others founded the Patriotic Union of Kurdistan (PUK), other parties followed, and each party – including the Communists – had their own pesh mergas.

In the years following 1975, the Kurds regrouped in the inaccessible mountains bordering Turkey and Iran, but unity had been lost. The PUK, led by Talabani, and the KDP, led by two of Mustafa's sons, Masoud and Idriss, logged some nasty battles against each other. This quarrelling didn't end when the Iraq-Iran war broke out in 1980. The PUK enlisted the support of Baghdad for some years and the KDP joined forces with Iran while each party had their own liberated area, whose borders were changing constantly.

A peace deal between the KDP and the PUK, in December 1986, was brokered by Iran, not without Iranian self-interest of course. If Iran had both Kurdish parties on its side, that would be helpful in the war with Iraq. In 1987 the KDP, the PUK, the Kurdistan Socialist Party (PASOK) and five other parties joined their scant forces in the Iraqi Kurdistan Front (IKF). During the closing stages of the war with Iraq, which ended in mid-1988, Iran occupied a strip of Iraqi Kurdistan of some 2,500 square kilometers.

The start of the Safe Haven in May 1991 gave the IKF, under the dual leadership of Masoud Barzani and Jalal Talabani, a chance to prove their worth. With onlookers from all over the world, including many reporters, NGO people and, in the Safe Haven proper, military from Western countries, the Kurds could absolutely not afford to split up again. And they didn't, as the IKF became a real success – for a while. Besides, many if not most ordinary Kurds were utterly fed up

with all the PUK-KDP struggles, military and otherwise.

In the course of 1991, the Safe Haven came to an end, as described in some detail in chapter 4. The IKF was ruling the new country, the Americans had reduced their presence to a mostly symbolic Military Coordination Center in Zakho. The MCC didn't have any military means, they simply had to report to Washington, London and Paris. If Saddam returned and hell broke loose again, the allies of the 1991 invasion might intervene, or they might not. There was protection against Saddam's forces from the air above the 36th parallel: US, British and French fighter jets, based at the NATO Incirlik Air Base in Turkey, were patrolling there on a daily basis. But south of the 36th parallel, above Suleymania for instance, there was no protection.

At any rate, Saddam's troops were close by, amassed around the borders of Free Kurdistan. The Kurds of Iraq were like children left home alone, with a big bad wolf patrolling the garden. They knew they could not afford any serious internal trouble. The pesh mergas from the various parties did all they could to be strong, plentiful, well-trained and above all – unified. For three years they succeeded.

But in 1994 the Kurds of Iraq entered one of their darkest periods ever. All parties engaged in dreadful fighting. Large-scale torturing of prisoners was reported by Amnesty and Human Rights Watch. Tens of thousands of people were driven out of their homes, some fleeing within the IKR (see page 108), some to Iran, some to the West.

This period doesn't get much attention in this book, as I didn't travel to the area between August 1992 and May 2002. After four trips in 1991-1992 averaging one month, I felt it was time for me as a journalist to move on, to other countries and

other themes. In addition to that, I lost most of my sympathy with the Kurds of Iraq because they were now fighting each other. Even so, there were times when I wanted to go and see for myself; but it was enormously difficult for journalists to get in. In 1991-1992 I had easily entered via Turkey, but Turkey closed its Iraqi border to journalists in 1994. Entering via Iran was almost impossible without having any connections there: I tried several times along official paths and was always halted at the Iranian Embassy in The Hague. Some journalists managed to get in via Syria, by crossing the Tigris just east of Qamishli, where the KDP-controlled area bordered the banks of the Tigris, with Syria on the other bank. Permission from Syria was needed at various levels, and was hard to get. I knew that some reporters made it to Qamishli, thinking that all their permits were in order, and found out that just one rubber stamp was missing. Once, in 1998 I think, Iraqi Kurdish representatives in Damascus had managed to arrange all my permits, and then forgot to inform me. To this day I doubt whether that was accidental, because the Iraqi Kurds had a lot to hide in those years.

In May 1998, when the fighting had officially ended and an official agreement between PUK and KDP was in the making (the US-engineered Washington Agreement of September 1998) the Prime Minister of the KDP area, Necirwan Barzani, was in Europe. Apart from a journalist of a London-based Arab newspaper, I was the only reporter he wanted to speak to. I saw him in a hotel lobby in Geneva. It was a memorable interview, largely about the human rights violations. As agreed with the Dutch daily NRC Handelsblad (for which I have been writing since 1984) I wrote a long, one-page article about the interview and its context. After completion, the article was axed by an editor. All these

KDP pesh mergas at the border of Free
Kurdistan in July 1973, just east of Rawanduz.
The minibus is the one in which I and six
others travelled from Holland to Iraq and back.

Kurdish human rights issues were not so interesting for Dutch readers, I was told, this was internal Kurdish stuff.

For me, that pulled the plug. Unable to get into Kurdistan, disenchanted with the Kurds, and let down at the home front – I can hardly describe how embarrassed I felt towards Necirwan Barzani and Siamand Banaa, who had arranged and translated the interview – I discontinued all my Kurdish activities. Hence the gap in this book.

In addition, there is a justification of a different nature: it is time to turn the dark pages and to forget. The Kurds really seem to have learned something. The road towards unification between the former enemies has been hard and long, and they still have some way to go. But the Kurds of Iraq just know that in the period between 1994 and 1998, they destroyed nearly everything they had gained since 1991, goodwill in particular, and that they nearly lost the Western friends on whom they depended for their survival. Everybody seems to realize now that it is crucial that they stay unified. Saddam has gone, but the IKR has

some enemies who would love to see renewed Kurdish infighting.

In 2002 my reasons to avoid Kurdistan were largely forgotten. Tensions were rising due to Saddam's refusal to show international inspectors his presumed weapons of mass destruction. A new war was looming and the time seemed right to return. In May 2002 I managed to get in again: by air with Medes Air from Dusseldorf to Urumiya in Western Iran and then over land to Hadj Omran and further.

Medes Air is worthy of attention, despite its track record of just a couple of flights before entirely vanishing in the haze. The trouble I had encountered to enter Iraqi Kurdistan was shared by many others: journalists, NGO staff, and many Kurds. For years, Turkey behaved just horrendously at the border, letting only a handful of people in and out every day and not allowing any journalists without Turkish accreditation. So the Kurds very badly wanted an air link, and Medes Air was the result, largely the creation of Necirwan Barzani, who had put

his Iranian network into good use. The four-hour ride by minibus from Urumiya, where the aircraft landed, to Iraqi Kurdistan, was part of the ticket, and so was the visa. But somehow, my visa, to be collected at the Iranian Embassy in The Hague, didn't materialize.

On May 25, the day before departure, I was called by someone from Medes Air in Germany. He told me enthusiastically that my visa for Iran was ready and waiting for me at Urumiya Airport. Unknown to me, the same airline official had called about a dozen passengers in France and Germany who also didn't have an Iranian visa and whom I met the next day at Dusseldorf Airport. We flew to Iran in a plane which Medes Air had chartered from the Iranian company Mahan Air. On board were some well-known friends of the Kurds, like Joyce Blau of the Institut Kurde in Paris and Sigi Matsch, a friend of the Barzanis and chief of the Matsch Corporation that was doing business in Iraqi Kurdistan as if it were Switzerland. Then there was a German-American photographer, Mark Simon, who, quite amazingly, had managed to get into the IKR via Baghdad in 2000. Another noteworthy passenger was a Kurd who had died, accompanied by two stern-faced relatives who were going to bury him under his native soil. In all, maybe twenty places were occupied.

That was fine, we passengers thought. But not so fine, as it turned out: upon arrival in Urumiya at 3 AM there were no visas.

Iran is the wrong place to be without a visa. Fortunately, Mahan Air felt responsible for us. To cut a long story short: we lost three days on the way to Iraq and had to go to

Teheran first. And we lost two weeks on the way back, also via Teheran. Still without a visa, we were locked up for a week or so in the hotel facilities for Mahan cabin crews in the Mahan Air building in Teheran. From there, Sigi Matsch made a call via his satellite phone to a personal friend, German foreign secretary Joschka Fischer. Fischer warned the Iranians that Germany would issue a negative travel advice for travelling with Mahan Air if Iran didn't release us within a few days. That worked. Soon after the call, I and the others had the exquisite pleasure of standing before an Iranian judge, who gave us a small fine. Two days later, a regular Mahan Air flight brought us from Teheran to Dusseldorf – in business class, to make up for our sufferings.

In 2002 the pesh mergas were in good shape. There was no war and Saddam was being kept at bay by the US. For five years, various groups of pesh mergas had been cooperating nicely. But in spite of the fine cooperation, they had their own areas, and they still do.

Let's flash forward, just to illustrate the current situation: in November 2007, after some days in the KDP area, I wanted to go to Suleymania and surroundings where PUK pesh mergas manned the checkpoints. I had all the clearances needed to operate in the KDP area and thought, optimistically, that they would be sufficient in PUK country as well. One reason to think so was the recent merger of the two governments – PUK-led in Suleymania and KDP-led in Erbil – that had existed from 1994-2006. With one government for the entire IKR, there should be one office for issuing permits to reporters, or so I thought. But Hana Jamal, my translator and fixer, got nervous and insisted I pull some strings at

Pesh mergas of the KDP in 2002, at a base near Duhok, once a stronghold of Saddam's forces.

high levels while still in the KDP zone. And so, the head of the external relations office of the government, Falah Mustafa, who has a KDP background, contacted a PUK commander in Suleymania, telling him that I was on my way and that they should let me through. Hana had been right: at various PUK checkpoints we had to make mobile phone calls to the important PUK official. Each time Hana had reached him, the phone was handed over to the commander of the checkpoint. Otherwise I would not have gotten very far.

The pesh mergas are not the only military in the IKR as the Turks are present as well, in particular in the Amadiya District (2620 square kilometers, 110,000 inhabitants) which borders Turkey. When I first saw them, in June 2002, I just couldn't believe my eyes: the entire Bamerni Air Base was full of tanks. Kurdish tanks? I knew the Kurds had captured some T-62 tanks from Saddam's forces but I was surprised to see so many. I took some pictures with a telephoto lens. Later I contacted KRG officials

who told me these tanks were Turkish – and would I please be so kind as to publish the pictures in the West?!

In early 2008 the Turks were located at four places at least, totalling some 1300 men and 42 tanks and armoured vehicles. In addition they were shelling border villages on a regular basis, I was told in 2007 by Mohamed Moshin, head of the KDP in Amadiya, the dominant party in the District. His headquarters are less than a kilometer from the Amadiya town centre, where the Turks occupy a prominent building on the central square, with two armoured vehicles in the parking lot. Moshin assured me the building "is also a headquarter of the Turkish secret service." He asserted that if the Turks were to come in force "we will burn the ground under their feet. We will follow them deep inside their own towns." Asked whether the Iraqi Kurds would cross into Turkey, Moshin said somewhat cryptically: "If the Turks invade, all Kurds will have one heart", an indirect indication that the Turkish Kurds would carry out at least some of the retaliations.

Chairman Rezgar of the KDP in Zakho was more explicit: "The fallout of a Turkish invasion will be huge", he predicted, also in the autumn of 2007 when Kurdish-Turkish tensions were running high. "All will be losers, the Turks included. We will burn the ground under their feet! Their economy means everything to the Turks, and we will hit their towns. We won't hit innocent civilians, just buildings." But who are "we" in this case? Iraqi Kurds operating in Turkey? "No, Turkish Kurds. When the Turks invade Iraqi Kurdistan, all of Kurdistan will have one heart."

In the 1990s and the early 2000s, the Turks had the habit of invading their former Vilayet of Mosul every spring, coming in via the Habur border crossing near Zakho. The official reason was to knock out the PKK camps in the border zone. Amazingly, the Turkish army always failed to achieve their goals, which is why they always had to come back the following spring...
In recent years, the Turks have threatened to invade on an irregular basis all year round, but they have ceased sending troops via the Zakho area. Nowadays it's more like limited incursions further to the east, North of the Barzan area and Sidakhan. Why the Turks invade and threaten to invade is evident to all Kurds: they want to make clear who is calling the shots in their lost Vilayet of Mosul. Many Turks still consider it theirs. Turkey has one symbolic lira on its annual budget for the Vilayet of Mosul and every now and then a nationalistic politician calls for a reconquest. The deeper reasons behind this attitude, and why Turkey never considers reconquering Syria or Jordan, which they also lost, are complex and go back to the 1918-1926 period. It has to do with the fact that the British occupied the Vilayet of Mosul after the 30 October 1918 armistice.
A very different sort of reason is that the Turkish army – reserve forces and paramilitary included about the 10th largest in the world – has lost almost all its enemies. The Cyprus question has settled down, new animosities with Greece might seriously hamper the Turkish EU candidacy, the Warsaw Pact no longer borders on the North Eastern fringe. The only serious enemy left – the only justification for an army of one million men with all its economic interests and all its jobs – is the PKK. So the Turkish army is careful not to destroy them, especially because military, political and diplomatic campaigns against the PKK conveniently double as a means to bully the IKR. "Why is this happening now?", IKR president Masoud Barzani wondered openly and rhetorically when the Turks suffered two bloody ambushes by the PKK on their troops in October 2007. Images of the dead soldiers and their weeping relatives were shown on Turkish TV almost round the clock, and mass demonstrations in Istanbul and elsewhere against the PKK ensued. In an interview in Newsweek in October 2007 the Iraqi Minister of Foreign Affairs, Hosyar Zebari, himself a Kurd, mentioned that the PKK had been infiltrated by the Turkish military, implicating that, maybe, they had a hand in the attacks on Turkish troops on October 8 and 21, 2007. Barzani's question referred to plans to sort out the Kirkuk issue during the following months, including a referendum in Kirkuk about its future: part of Iraq proper, part of the IKR, or a special status. The Turks did not, and do not, want Kirkuk to become part of the IKR, and therefore did not want a referendum. The troubles in October and November 2007, following two PKK attacks on Turkish troops, came at the right time for them, causing a further postponement of a solution for the Kirkuk issue. The PKK attacks provided Turkey with a pretext to invade the IKR. The invasion was thwarted, much to the annoyance of the Turkish armed forces, after hurried shuttle diplomacy by the Americans, Foreign Secretary Condoleezza Rice in particular, and some

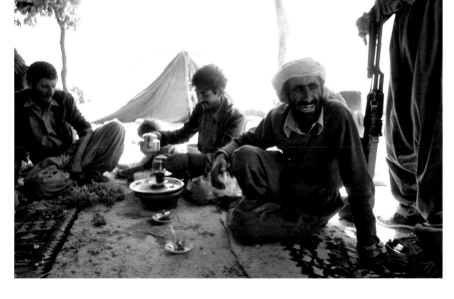

Pesh mergas of the PUK in Germian in July 1992 at tea time.

solemn promises by the Iraqi government to oust the PKK. As far as my personal observations go, the KRG no longer allowed PKK men and women to visit Kurdish settlements like Ranya – which lies close to a major PKK base in the Kandil mountains, see page 77 – to do their shopping.

In Zakho, on October 29, 2007, at the height of the tensions between the IKR and Turkey, Rezgar of the local KDP office ordered an assistant to join me on the mountain road which the Turks might use to invade. Checkpoints, more checkpoints. Kurdish artillery everywhere pointed in the direction from where the Turks might come. In the plain behind us, around Zakho, the drilling towers of Norwegian oil company DNO could be seen in the distance. We stopped to look and to ponder. The new-found oil in Iraqi Kurdistan is definitely linked to Turkish threats. Oil revenues will strengthen the position of the IKR. The stronger the Iraqi Kurds, the more reasons for the Turks to invade. Kurds with power – it's the nightmare of every nationalistic Turk. All Kurdish officials I spoke to, military and civilian, agree that the threat of the PKK is just a pretext for Turkey – the Turkish army in particular – to put pressure on Iraqi Kurdistan. Two thirds of the PKK forces are in Turkey anyway. No incursion into Northern Iraq, no matter how effective, will end Turkey's PKK problem.

After watching the oil drilling towers near Zakho, we moved on. Soon we passed the last pesh merga checkpoint. Two or three kilometers further on, we reached a village, Dashta Tag, where Iraq ends: Turkish army fortifications and watchtowers were clearly visible on the steep mountains all around, less than a kilometer away. No doubt the Turks inspected our antics as we were shaking hands with some of the villagers,

who showed us their church and their bright pink houses.
But architecture wasn't the purpose of our visit. About a hundred metres from the houses, a Turkish grenade had hit and exploded, just days ago. "Why?", asked Salem Michael Warda. "Are there any PKK fighters in our village?" On the road leading to the village, two craters in the asphalt told a similar story: the grenades which the Turks fire every now and then are just meant to frighten people.
Dashta Tag is one of the villages that has recently been hit by Turkish artillery. Another one is Isishki, halfway along the Turkish-Iraqi border, twenty kilometers inside Iraq. In Inishki, too, there are shell holes next to houses. About fifty grenades hit the fields around the village between 10:30 and 11:30 PM on October 13, 2007. Inishki is full of Christians who fled Baghdad, lest they be forced to convert to Islam or be killed. One of them is Yousif Toma, who counted the blasts during the Turkish assault on the village. He remembers: "People here prayed: where do we have to go now? We fled Baghdad because Muslims threatened us, now the Turks are trying to kill us!" Obviously, the twenty kilometers distance between the Turkish guns and Inishki make it impossible to get grenades to explode exactly a hundred metres away from the nearest house, as the Turks did in Dashta Tag. In Inishki, the Turkish intention was to kill innocent civilians, and they narrowly missed.

To end this chapter on a more optimistic note, and also because tensions between the IKR and Turkey have eased down since the troubles in 2007, I quote president Masoud Barzani from a November 8, 2008 Op-Ed page in *The Wall Street Journal*, writing about the IKR as a role model for all of Iraq:

"Regional stability cannot come from resolving internal disputes alone. That is why expanding and deepening our ties with Turkey is my top priority.
My meeting last month in Baghdad with the Turkish special envoy to Iraq was a historic and positive development. There should be further direct contacts between the KRG and Turkey, as well as multilateral contacts that involve the US. We are eager to work with Turkey to seek increased peace and prosperity in the region."

> Martyrs near Rawanduz. These pictures of PUK martyrs, here seen in the summer of 1992 when the PUK and KDP were still on friendly terms, were demolished during the KDP-PUK in-fighting in 1994-1996 – by the KDP of course.

>> Recruit training on a road near Shaways, nor far from Erbil, and near Suleymania during the harsh winter of 1992. With the Safe Haven dismantled, the Allied forces all but gone, the Kurds of Iraq were largely on their own. Saddam's forces were ousted from most of the Kurdish area, and the Allied Forces held the remnants of Saddam's army at bay by patrolling the Kurdish airspace North of the 36th parallel. The time seemed ripe to build up a Kurdish Army and that is what the Kurds did. Uniforms were scarce, but there was an abundance of motivation and volunteers.

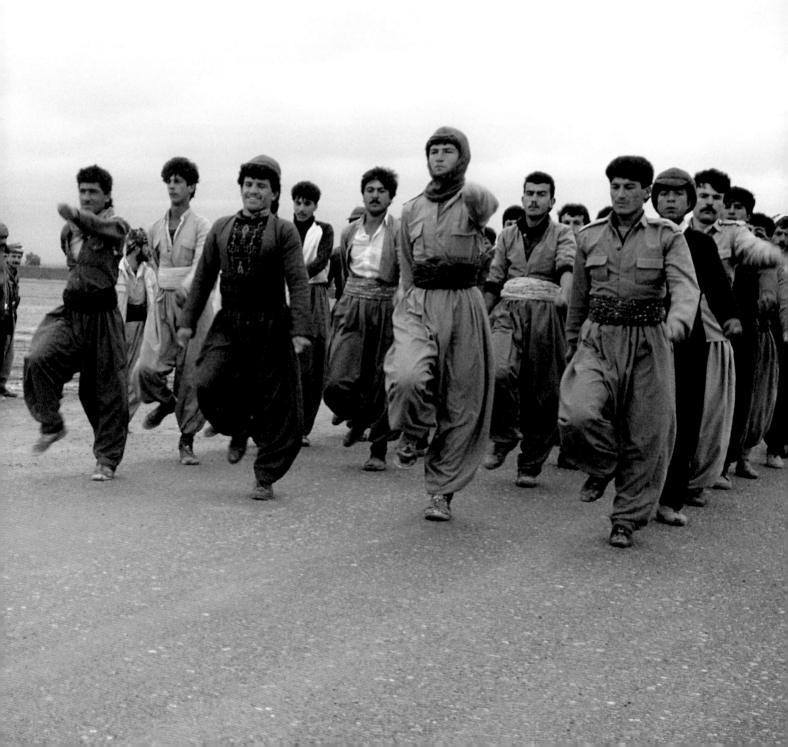

Pesh mergas from the KDP at a checkpoint
in February 1992, with the Greater Zab in
the background.

February 1992. Pesh mergas guarding the Kalak
Bridge between Erbil and Mosul. Saddam's
men were on the other side. The second man
from the left, a pesh merga from the
Communist Party, was killed in an exchange
of fire with Iraqi troops weeks after this picture
was taken, making him a martyr – just like the
man whose picture is pinned to his belt.

Kurdish and US soldiers cooperating.
Governor's palace, Kirkuk, autumn 2003.

US patrol in Iraqi Kurdistan, in the Barzan
village of Balinda. Autumn 2003.

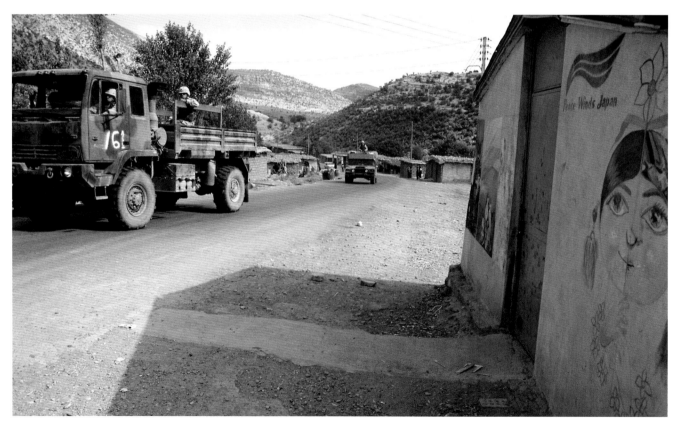

"Come on in," smiled Khassem Hadji Djasim, acting commander of the Kurdish troops in Sidakhan Valley, slipping his mobile into a pocket. The past three minutes had been spent calling his superior in a distant town, and reading aloud my letter of introduction. The far away commander consented: the three visitors – my driver, my interpreter and I – could spend the night in the military fort, built decades ago for Saddam's soldiers. The reason for my request went beyond the snow-capped mountains surrounding the valley.

Sidakhan occupies the furthest northeast corner of Iraq, bordering Turkey and Iran. Djasim commands three battalions, 1700 men, all from Sidakhan Valley itself, whose job it is to keep suicide bombers and terrorists out. That is no mean achievement, given the rugged wilderness all around. The porous borders of the Arab parts of Iraq allow a constant trickle of non-Iraqi insurgents, keen to join the fight against Western Crusaders and stability in Iraq. Then why is this strategic corner so peaceful? A mix of loyal locals, some 15,000 in all, and mobile

phones does the trick, as commander Djasim explains. "When villagers notice strangers or suspect vehicles, they immediately call us. And so do Kurds in Iran when people who might be terrorists are seen moving towards the border. Then we alert the closest of our sixteen out-posts." Simple and effective. Of course, a very closely-knit society, where people still know their neighbours and distant neighbours, is needed to make this strategy tick. If applied in the socially-atomized West, phones in military posts and barracks would be ringing all the time.

A KDP checkpoint at the entrance of the Sidakhan Valley. Behind the mountains in the distance lies Turkey and, to the right, Iran. On the left is the the KDP flag, flanked by the flag of Iraqi Kurdistan. As usual, an Iraqi flag is missing.

The military airfield of Bamerni, between Zakho and Amadiya, which was a logistical hub during the Safe Haven period, April - August 1991. From here, transport planes landed and took off, ferrying supplies and personnel from Europe to Kurdistan. In 1995 Bamerni was occupied by the Turks and they are still there to this day. This picture was taken in November 2007, but it could have been taken at any moment since 1995. The 20-odd tanks and 800 personnel don't do much there except sit in the heart of Iraqi Kurdistan and occupy its biggest military airfield. During a future Turkish invasion, Bamerni may serve as a bridgehead. C-130 transport planes could land a hundred heavily armed troops at a time here. Turkey has a dozen C-130s and one turnaround trip to a base like Diyarbakir might take about four hours. That means that the continued occupation of Bamerni allows Turkey to fly about 5000 men a day to the heart of the IKR. According to Turkish sources, these troops are here for liaison purposes and to monitor PKK activities. But Kurdish sources maintain they never have any contact with these "liaison" cavalry units. About a week after this picture was taken, some of the troops and tanks tried to leave Bamerni, probably to join a limited Turkish invasion against supposed PKK activities in the Barzan area. Pesh mergas effectively blocked their way.

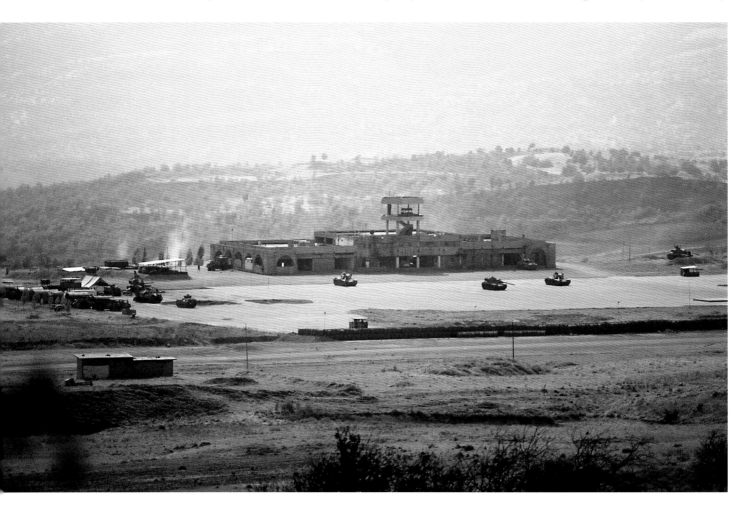

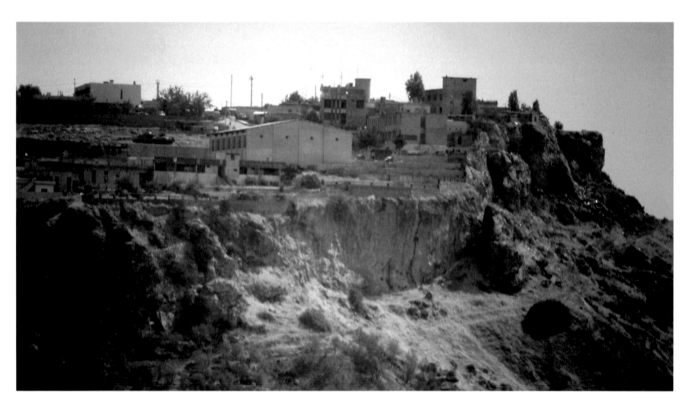

Turkish tanks in Amadiya, one of the six locations inside Iraq that is permanently occupied by Turkey.

Shell craters, the results of Turkish shells on villages inside Iraqi Kurdistan, near Dashta Tag (top), just hundreds of metres from the Turkish border. And near Inishki, twenty kilometers inland. In Inishki, fragmentation shells were used by the Turks, the fragments being brought to me by children who had collected them. Both pictures were taken in November 2007, but the indiscriminate, random shelling of villages inside Iraq by Turkey is a rather constant phenomenon. Iran operates in the same way a bit more to the east.

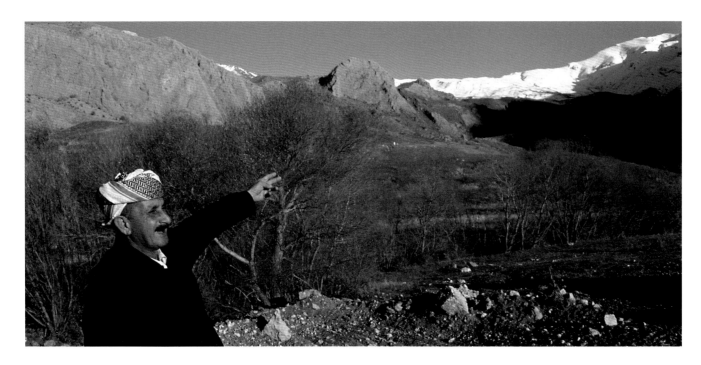

The village of Ena, in the vicinity of Choman, twenty kilometers from the Iranian border, which was shelled by the Iranians in the summer of 2007. Mina Rasul Hassan, imam in the nearby village of Bindaisan, indicates where the shells landed. Nobody was hit but some animals were. In 2008 Iran selected other targets to shell, notably in Penjwin, 150 kilometers further southeast. Imam Rasul Hassan told that Turkish planes had bombed the area around Ena and Bindaisan some five years ago, and that nowadays Turkish fighter jets are sometimes spotted while on their way to PKK strongholds in the Kandil Mountains (see page 77).

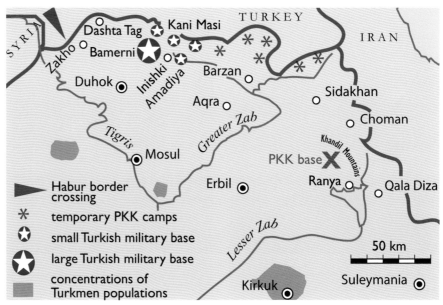

A PUK checkpoint near Dokan.

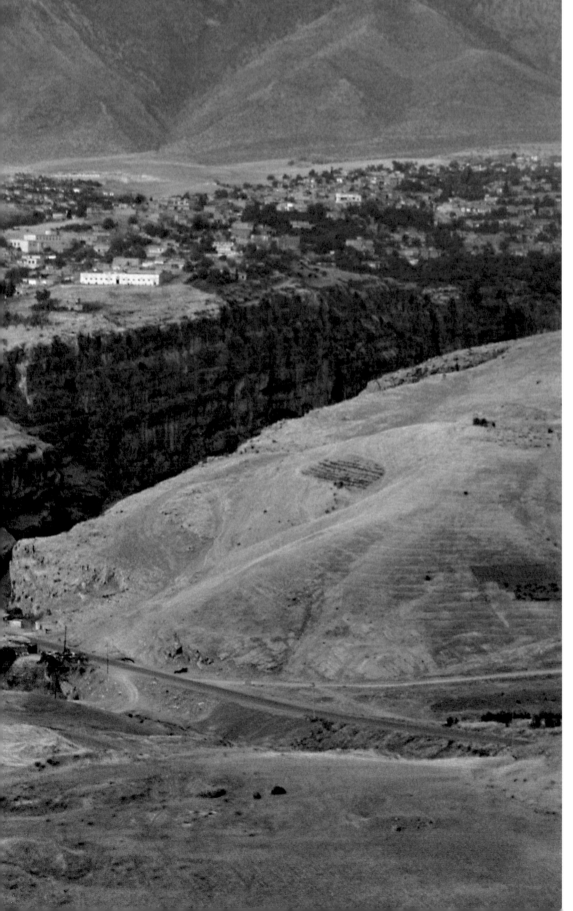

Dwellers Rawanduz lit by the
first rays of the sun on a day
in June. The Hamilton Road
(see page 134/135) needs long
bridges to negotiate the twin
gorges that have protected
Rawanduz in their embrace
through the centuries. In 1816
the old Kurdish Emirate of
Soran declared independence
from Ottoman Turkey. The
natural fortress of Rawanduz
was Soran's capital. In 1835 the
Ottoman Turks subjugated
the Emirate and conquered
Rawanduz.

Dwellers

Landscapes determine ways of living, farming and transport, which in their turn determine people's behaviour and character to a fair degree. The Kurds and the minorities in Kurdistan know all about it: there are blazing hot plains where temperatures can reach fifty degrees, and mountain villages so high up that people almost freeze to death in winter. And almost anything in between.

Although townscapes don't have as much influence on how people arrange their lives, neighbourhoods, streets and buildings certainly influence the moods and feelings of those who live there.

> A village near the Gali Ali Beg gorge.

Amadiya, situated on top of a natural fort. This is in 1991 Nowadays every house has a satellite dish!

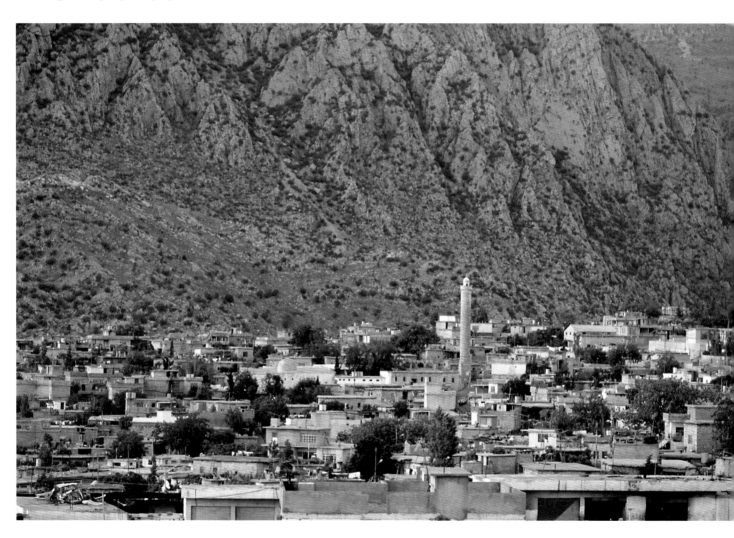

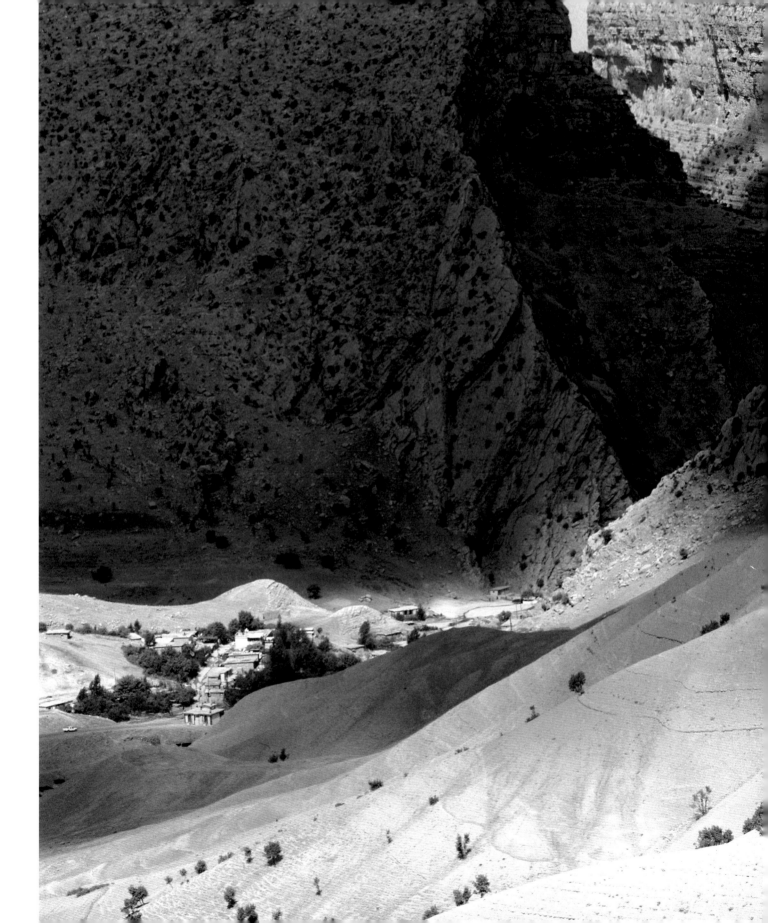

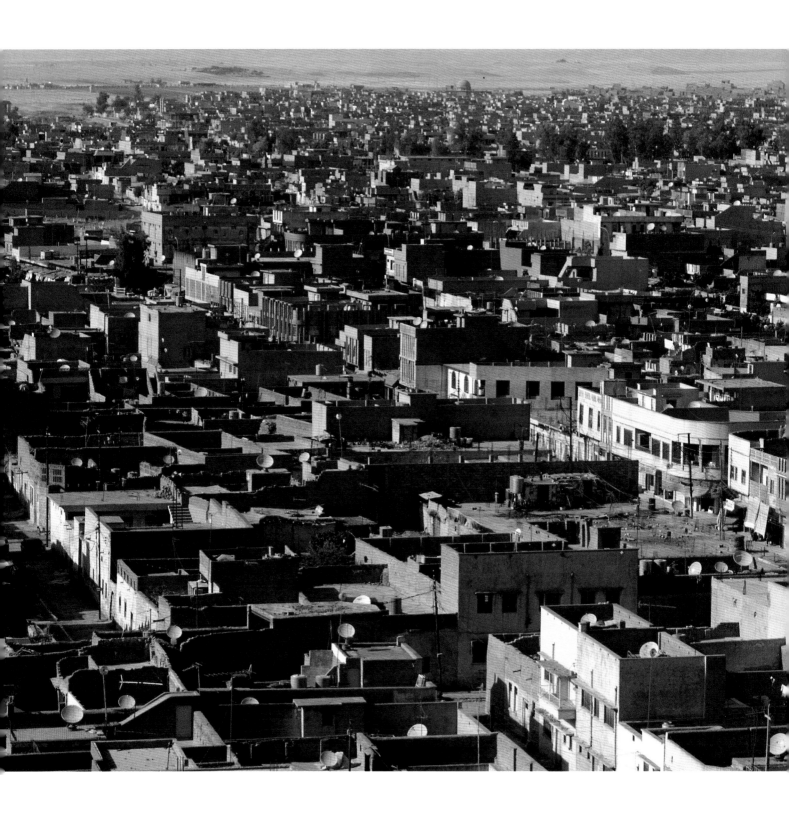

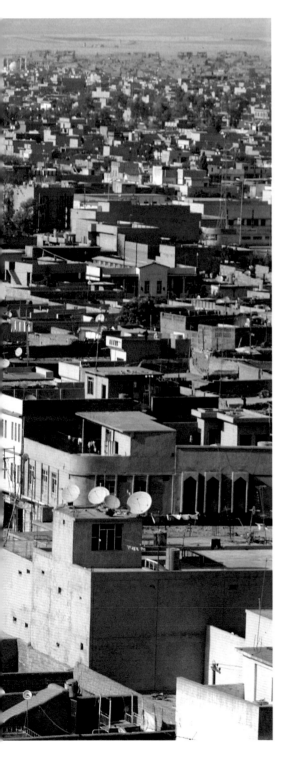

Erbil borders on a desert landscape, although it is green in spring. Note the myriad satellite dishes, no family can do without these days.

A boy in a village on the outskirts of Duhok at the entrance of an inner courtyard.

Suleymania.

The Kurdish Christian family of Shlemon Mamo (standing, centre) from Baghdad who – like tens of thousands of other Christians – were able to choose between converting to Islam, being killed or leaving their homes. They decided to flee to the village of Inishki in the IKR. The car and some belongings is all they could take with them, their house was confiscated. The new house was built for them, along with dozens of other houses for other Christian refugees, by Sarkis Aghajan Mamendo, KRG Minister of State for Christians as well as Minister of Finance. Mamo now earns a living washing cars in Duhok.

The man with the hat, Yousif Thoma, belongs to another family. He lived in Baghdad for fifty years and he first fled to Syria, staying there for three years before moving to Isishki in 2005. In all, 6,000 Christian families from Baghdad and Mosul fled to Inishki and other villages in the Amadiya district.

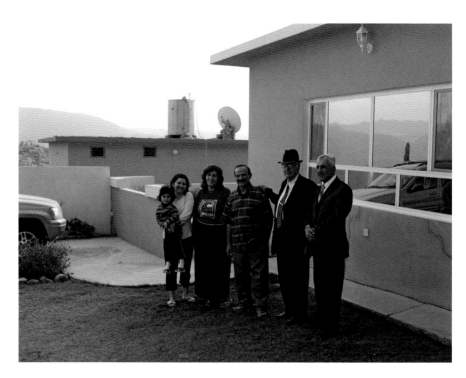

As a result of the in-fighting between the PUK and the KDP in 1994-1998, the IKR effectively fell apart in what some called Talabanistan and Barzanistan – an area around Suleymania ruled by the PUK and an area around Erbil and Duhok ruled by the KDP, respectively. In Erbil, scores of families with PUK allegiances were thrown out of their houses and sent off to Suleymania and the surrounding areas. Similarly, KDP families had to leave Suleymania and figure out for themselves what to do next. The men on the right are KDP pesh mergas who had fled from Suleymania, pictured here in a derelict building in Erbil in 2002.

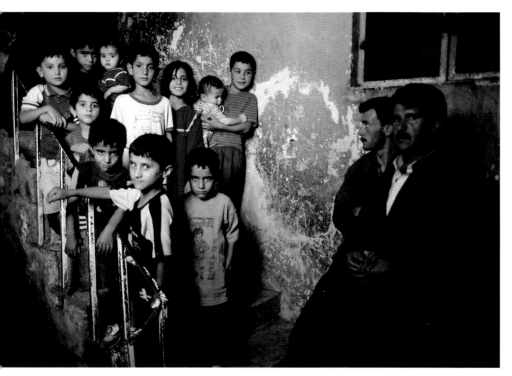

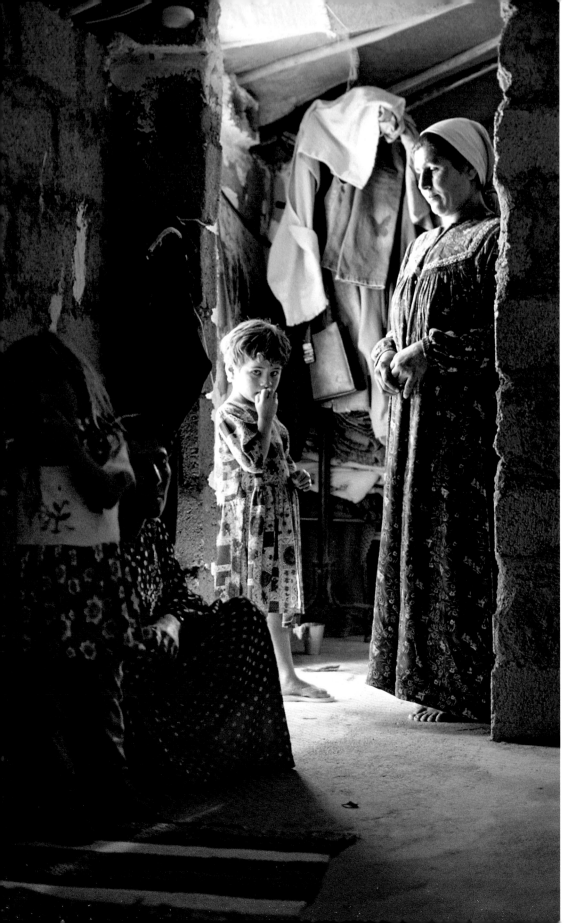

People from Kirkuk, living on the dusty outskirts of Erbil in makeshift housing. There is just one room measuring 3 x 6 metres, plus a bathroom of sorts outside. The building material for the house was partially financed by the KRG, the bathroom by the UN, but the family had to build their house themselves.

This was in 2002 when Saddam was still in power, and the process of Arabisation of Kirkuk was ongoing: Kurds were being chased out, Arabs from else-where in Iraq were being brought in. Kirkuk, which was almost entirely Kurdish a century ago, has the second largest oilfield in Iraq. Various regimes in Baghdad also used Arabisation as a means to lay claim to the oil. This family was forcibly removed from Kirkuk in 2001. Whether their house was still standing or occupied by Arabs they didn't know. One woman said: "Those of us who had money in the bank were not allowed to withdraw it before leaving." And was it possible to sell their house before they were ousted and move to the IKR? "No. We didn't have the ownership documents. Kurds in Kirkuk are not allowed to buy or sell houses. Even Kurdish names were not allowed, a new-born child had to be given an Arabic name."

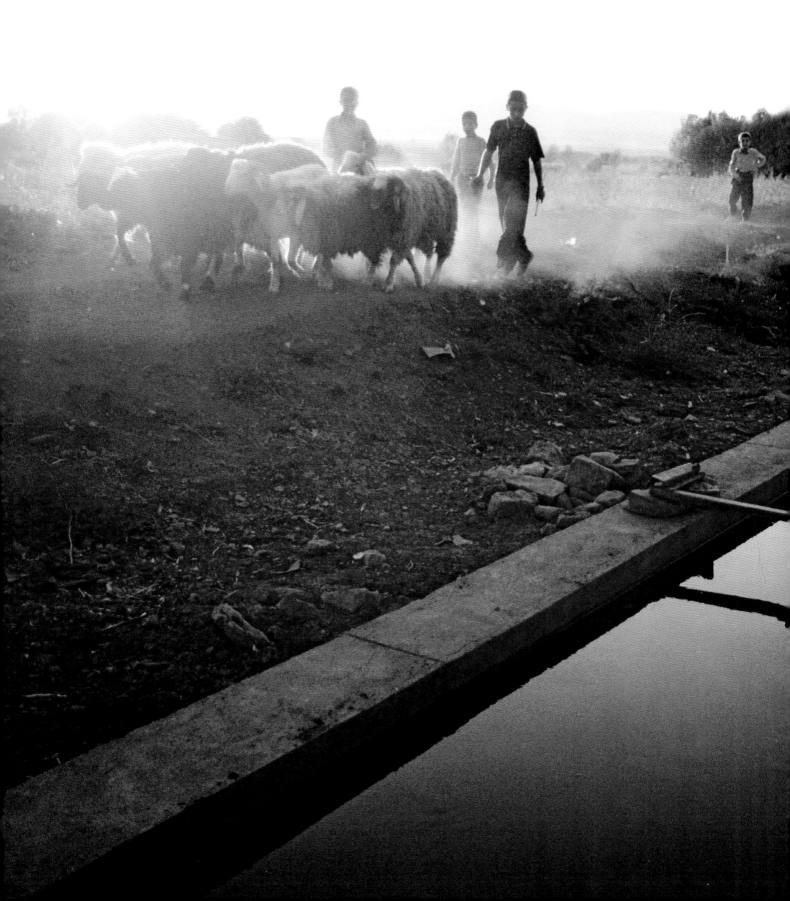

Farmers An irrigation channel in a village near the town of Halabja. The entire Halabja plain is littered with artesian wells. If the water can be distributed in the right quantities to the right places, the fertile plain becomes a farmer's paradise. That has been the case throughout history: an abundance of small tells (see page 12/13) in Halabja plain attests to its fertility.

Farmers

Iraqi Kurdistan was one of a number of places in Western Asia where sedentary agriculture took off, more or less simultaneously. There is evidence for farming in Abu Hureyra in Syria some 13,000 years ago, but it took several millennia before the rise of real farming communities like Çatal Hüyük in Anatolia, Jericho in present-day Israel and Jarmo in Iraqi Kurdistan became a reality. Jarmo, near Chamchamal, excavated by Robert Braidwood of the Oriental Institute of the University of Chicago in 1948-1955, long had the reputation of being the world's earliest known farming community, but that no longer holds true.

This is more than an archaeological footnote, as the area is eminently suited for farming: it is hardly accidental that agriculture started so early in Iraqi Kurdistan, nor that it has continued to flourish till today. In the 1950s, Iraqi Kurdistan was the bread basket of the whole of Iraq. Every village had its orchards and many had irrigated fields. In some places there were paddy rice fields. Shepherds and their flocks of goat and sheep crowded the hills, nut trees belonging to nobody in particular gave even the poorest people a chance to make some money by collecting nuts and selling them in the markets.

That situation has changed dramatically. To understand the current predicament of Kurdish farmers, you only have to go to Faish Khabur, the only border crossing between Turkey and the IKR fit for regular lorries (see page 176). Some 250 of them cross into the IKR every day, and most are filled with foodstuffs for the 3.5 million inhabitants of the free region. Today the IKR imports lots of food that was grown locally till a couple of years ago. Kurdish rice for instance is almost extinct – modern Kurds eat rice from Pakistan and Thailand, brought in via Turkey or Iran. Rice is just one example. Next to nothing is manufactured in Kurdistan, where a huge seventy percent of the working population is government-employed. Of the remainder, many are traders. Why? Iraq exports two million barrels of oil a day, and the Kurdish Government receives seventeen percent of the proceedings, equal to the IKR's share of Iraq's population. In 2006 that amounted to six billion USD. Three quarters of that amount is spent on civil servants, who have developed a taste for food from outside Kurdistan.

The victims are individual farmers, entire villages, and, in the final analysis, the entire IKR. In November 2007, when Turkey threatened to invade Northern Iraq to oust PKK fighters, the Turks considered closing Faish Khabur as a bloodless alternative. Indeed, by blocking the crossing, Turkey could have brought Iraqi Kurdistan to its knees within weeks.

"Very few people bother to live in villages anymore," laments Anwar Omer Qadir, head of planning of the Ministry of Agriculture, who fully acknowledges the import problem. "But you have to understand that our once very strong agricultural sector was systematically destroyed by Saddam, culminating in 1987-89, when all our villages were bulldozed and all villagers were killed or moved to resettlement camps (see page 35). In 1967, the year before Saddam came to power, 66 percent of the Kurds were farmers – in 1987 just 16 per-cent, and they were all government-employed. When we regained control in 1991, we had to start from scratch, farmers had to rebuild their houses, and they hardly had any equipment or animals, or even sowing seeds. Much knowledge had been lost. Nowadays the children of the old farmers want a modern life in the towns – not a hard life in a remote village with few amenities." Mechanized farming is rare, yields are low, and so are the profits. Few Kurdish rice growers bother to compete with the cheap imported rice that can be found in any food shop. Politics has little to gain by recreating the agricultural powerhouse Kurdistan once was: more than eighty percent of the voters live in towns and they are more interested in new flyovers to combat traffic jams than in distributing fertilizers in far-away villages. If townspeople think about agriculture at all, they think: "What's the problem if we can get tomatoes from Iran, rice from Pakistan and courgettes from Turkey at the bazaar?" Utter dependency, that's the new problem. Despite all its success, Iraqi Kurdistan depends on money from Baghdad to be spent on imports from Iran and, mostly, Turkey.

However, things are changing. Kurdish media have discovered the rapid decline of the farming sector and from 2007 onwards articles have appeared in newspapers calling for more attention to this huge problem. As a result, the awareness of the public has been raised. "Every day, people in the Kurdistan Region ask why there are no local agricultural products. Why are foreign products cheaper than local ones when Kurdistan is an ideal place for various forms of agriculture due to its fertile plains, plentiful water resources, and

Market in Harir, December 2008. Nearly everything is imported although this is related to the season as well. It was too late for Kurdish raisins but in Iran they were still being harvested – and exported to Northern Iraq.

favourable climate?", The Kurdish Globe wrote on December 6, 2007.

The quote rightly mentions water and climate as major assets: on average, Kurdistan is not as hot as the plains of Mesopotamia while the sedimentary rocks harbour enormous aquifers deep under the surface, and huge numbers of artesian wells on the surface. In quite a few places. Crystal-clear water erupts from the ground at rates of dozens of litres per second, day in day out, year in year out. There isn't much wrong with the soils either, and the roads are good enough to move crops from the farms to the markets. And yet there is a big problem...

Firstly: the depopulation of villages, especially by younger people and by men in particular. Lolan Sipan, director of the Kurdish Textile Museum, told me about the orchard of his elderly father in Choman, near Hadj Omran. "There are

beautiful trees, they yield splendid fruit every year, but my father is too old to pick the fruit and it isn't possible to get workers to do it for him."

The second problem is lack of incentives to invest. In nearby Turkey, potato yields per hectare are ten times as high as in Kurdistan. Therefore Turkish potatoes are cheaper, and the Turks know how to transport their potatoes cheaply and quickly to Kurdistan. And Kurdish housewives, keen on making their dinars go a long way, go for the cheap, nice-looking Turkish potatoes, thereby completing the circle in a negative way. Kurdish potato farmers are left struggling. In the border zones there is the additional problem of safety. Scores of small villages have been aggregated along major transport arteries since 1991, due to PKK activities, or shelling by the Turks or the Iranians (see page 97/98).

Anwar Omer Qadir of the Ministry of Agriculture asserts that politicians are awakening to the problem and the challenge. The key to all solutions is linking supply and demand. Bringing production close to the mass markets by building greenhouses near the towns is one possibility. Building canning factories near the existing production centres, as has been done in Harir with US assistance, is another.

In January 2009 an ambitious five-year plan with a 10.4 billion US dollar price tag was announced by prime minister Necirwan Barzani and the minister of Agriculture, Abdul-Azziz Tayyib. The goal: complete independence from agricultural imports by the end of 2013, with the main focus on water management. It takes a good amount of travelling to remote corners of Iraqi Kurdistan's agricultural production system to appreciate how ambitious the plan really is.

114 A technique that must be thousands of years old, practised all over the world. Here chickpeas are thrown into the air on a breezy day. The wind carries off the chaff, the heavier, edible bits fall where they started. It may be getting rarer – this picture was taken in 1992 – but it's far from extinct: and it's cheap and efficient.

Baking bread is the job of the girls and women in any Kurdish village. This is the bakery of the village of Alywa in Germian, home to twelve families. The black hole gives access to the oven, at the bottom of which burns a fire. The cheerfulness of these women belies the toughness of their lives. Saddam's troops razed and burned all of Alywa in April 1988 during the Anfal campaign. In May 1991, the villagers returned from their resettlement camps in Iran, retrieved the rubble and rebuilt their houses. At the time this picture was taken, in October 2003, the people from Alywa had not managed to sell any of their agricultural output, they just had enough to keep themselves fed. October is harvesting time. Figs, pomegranates, wheat and rice seemed abundant, the weather was at its best: sunny but not too hot. Note the river in the upper left corner.

In the summer, Germian – which means hot land – can feel like an oven. In harsh winters the hills are covered with snow, and wolves find their way to the villages. In fact, in the nearby village of Bachan (right), fourteen sheep had been killed by wolves just four days before this picture was taken.

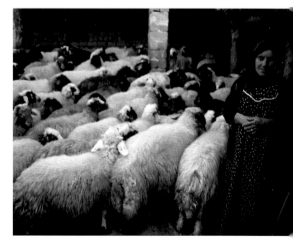

Main entrance of the Ministry of Agriculture in Erbil. One of the issues being pondered here is import protection. Would Kurdish farmers be better off if there were levies on all the foodstuffs coming in from Turkey and Iran? Anwar Omer Qadir, the Ministry's head of planning, explains: "That would be good for the villages, but we just can't afford it because production is too low. There just isn't enough

rice production to restrict rice imports, for instance. But we did impose restrictions on some foodstuffs of which production suffices to cater for our own demands: aubergines, tomatoes, onions, cucumbers, grapes, peaches and apples. And we have plans to actively support production of wheat and olives, two crops of strategic importance. In 2007, ten thousand tonnes of sowing seeds for wheat

were distributed with a 30 percent government subsidy. And forty thousand tonnes of fertilizer at 50 percent subsidy."

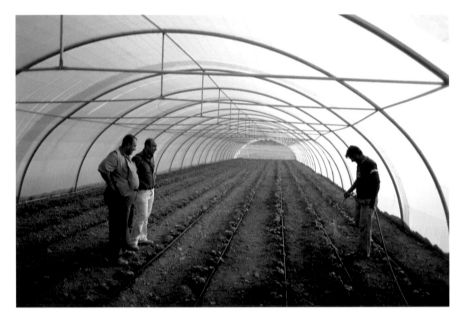

One way of dealing with the effects of urbanisation is to bring production to the markets. But then new problems arise: some of the biggest towns, the capital Erbil among them, lie in flat and hot plains where rainfall is rare. Hence these experimental greenhouses, run by the Ministry of Agriculture, on the outskirts of Erbil. Outside, an aggregate powers a water pump which brings water from a deep aquifer to the crops, in this case to aubergines. Irrigated greenhouses allow two harvests a year. One square metre yields nine times as many tomatoes or cucumbers as the sun-exposed fields. By 2010, the government hopes to have installed 5,000 greenhouses like this one, at 7,500 US dollars apiece. Most of the construction work has been outsourced to a Lebanese company.

A meeting of the farmers' cooperation in Sidakhan Valley in 2005. These men were frustrated, to put it mildly, and they had official support. "Sidakhan has always been famous for its tomatoes, but the farmers lack the means to get them to the markets," said Mustafa Aziz Rashid, third from right, representative in Sidakhan of the Ministry of Agriculture. The core problem is the recent population shift towards the towns. In the old days, the consumers were far more evenly spread out across the country – nowadays farmers have to rent pick-up trucks to move their products over long distances to potential buyers. In the absence of cooled storehouses and cooled trucks, transport-related worries stretch beyond the bill of renting a van.

A family from the Herki tribe harvesting goat fodder in a Valley near Merga Sur that is Dola Mari territory. Ten truckloads of tree branches should get all two hundred goats of this family, from Gala village, through the approaching winter. When the goats have eaten the foliage, the remaining branches will be used for baking bread. The tractor, the driver and the cart had to be rented of course. So, many hands are required, including those of the women, to get the job done before the bill gets too high.

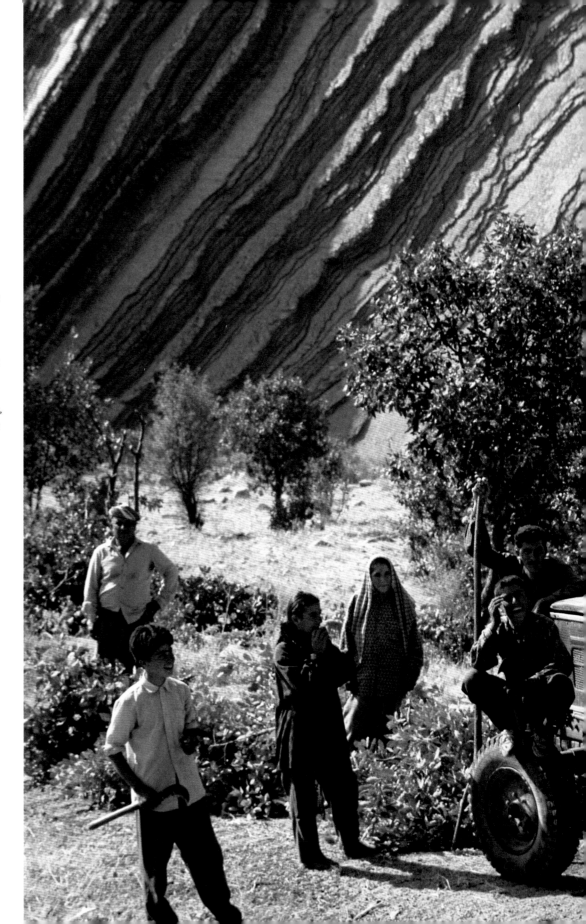

Mohammed Tahir in the village of Geluk near Harir, where practically all people are farmers. They till the fields without any irrigation and they sometimes rent tractors. There are just three products in Geluk: wheat, barley and chickpeas. A lot is used to feed the villagers, the rest is sold at the market in Acre – wheat at 250 Iraqi dinars (ID) per kilo, barley at 600 and chickpeas at 2,000 ID. One 1,000 ID was worth 0,65 USD at the time. Asked about his greatest concern, Tahir immediately mentioned land shortage.

Beekeepers can be found all over Kurdistan, and Sidakhan Valley is especially famous for honey. At ten to fourteen dollars a kilo it's good business. The family of Aziz Fakeh Amin, centre, produces about 200 kilos per year.

A fine example of an artesian well. This flow of crystal-clear water goes on and on, every day, year after year. Local farmers use it to irrigate paddy rice fields you'd expect to see in Indonesia – and to shower after a long hot day. The work done, dozens of sacks of rice, selling at a hundred dollars apiece, await transport.

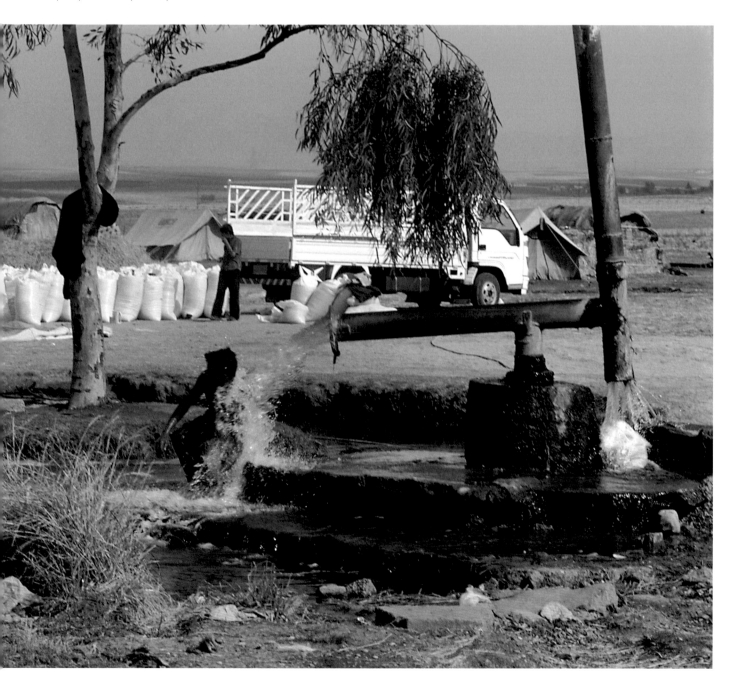

Sheep, not far from Suleymania. In case this looks like the end of the world, the reward after a long trek to a remote corner of the IKR – this picture was taken in April 2006 from the main road to Erbil. One and a half years later, I got to the same place, but this picture could not have been taken because the road was skirted by new buildings, blocking the view.

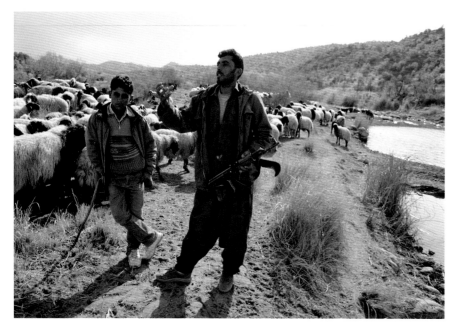

In the fields near Batufa, shepherd Kamel Sabri explains why he is carrying an automatic rifle: first and foremost to keep wolves at bay, just ten days earlier wolves had tried to get at his sheep, which sell at about a hundred US dollars apiece. Then there are wild pigs, which can be dangerous. Sabri mentioned a case of a farmer who was killed by pigs. And thirdly, the weapon helps to discourage cattle thieves. And bears? "They are rare, the last time I saw one was a year ago."

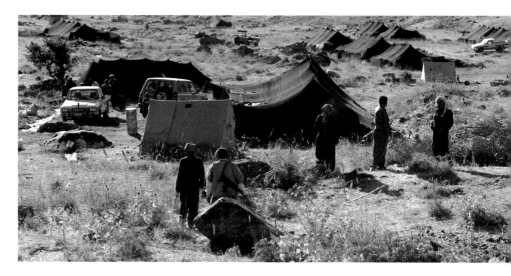

Nomads in Sidakhan Valley, 2005. Cars make a huge difference, and some have power generators. Nomadism today is done very much for the sake of it, for the freedom, the fun. Apart from meat, the production of cheese and the world's best yoghurt generate income, especially as the cars make rapid transport to markets possible.

Nomads of the Herki tribe in 1973, at about 2,000 metres altitude, near Hadj Omran. Real nomadism disappeared a long time ago, this is summer nomadism. In winter the nomads live in houses – in spring they pull out their tents from the attic.

Builders In Erbil the citadel, in the distance to the left, towers thirty metres above the bazaar, the myriad of shops and the bustling traffic, as it has done for many years. Started more than 7,000 years ago, it slowly rose to its present level as new houses were built on the rubble of their predecessors. Now the surroundings are really catching up, with many high-rise buildings being planned

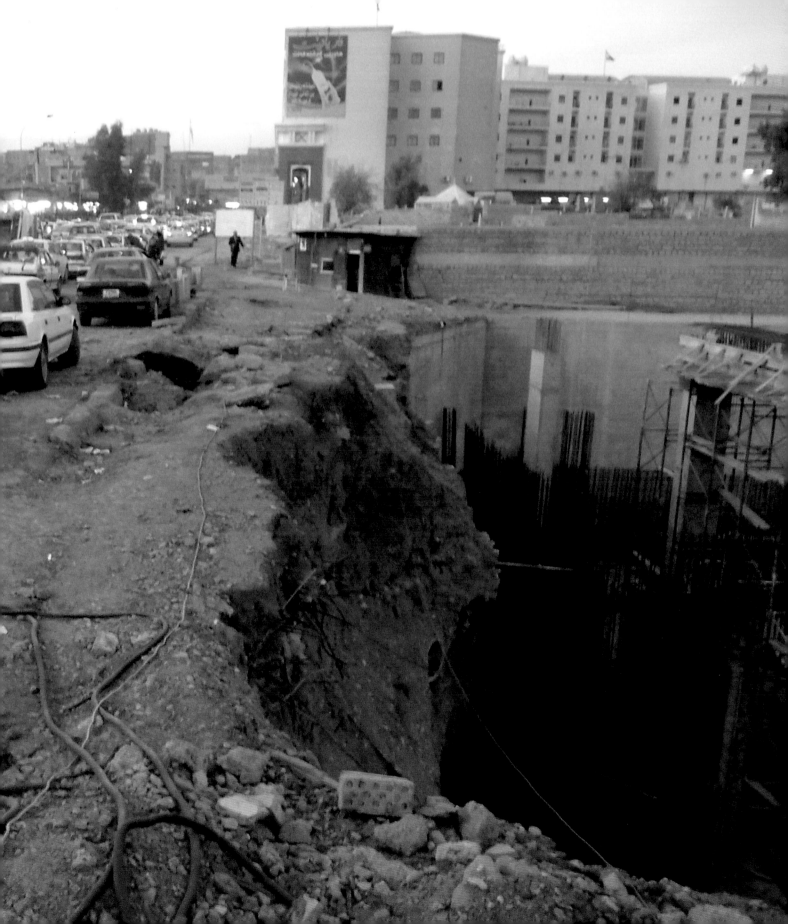

Builders

Since May 1991, the Kurds have turned the IKR from being an endless field of rubble, interspersed with a few big towns surrounded by huge resettlement camps into one of the fastest developing areas in the Middle East, covered with building sites. Huge yearly trade fairs in Erbil and Suleymania, dominated by construction companies and suppliers of construction materials, attest to the economic success of the Kurds.

In part, this is the result of the lack of safety elsewhere in Iraq. The dream of a new Iraq, which inspired the invasion in March 2003, was soon in shatters. Lifting the veil of Baath terror revealed more than grateful crowds, eager to embrace freedom and democracy. Dislodging Saddam from power also unleashed waves of vengeance, extortion, religious fundamentalism and kidnapping as the preferred way of getting rich quickly. No Westerner feels safe anymore in Iraq, few Iraqis do, and government officials avoid the roads, travelling by helicopter whenever they can, although the situation seemed to be improving in the course of 2008 and early 2009 when this book went to print.

Foreign investors who were keen to join the initial bonanza back in 2003 soon preferred to look elsewhere. To the north of the country for instance. The Kurdistan Regional Government has a 200,000-strong army and powerful intelligence services. The result is stability and safety, attracting lots of foreign investment. By 2008, dozens countries had consulates in the IKR. Turkey, Lebanon, Saudi Arabia, the United Arab Emirates, Iran and, unavoidably, China, are investing and building in the north. Just the fact that their staff can walk around without body-

guards accounts for a lot of the difference between Iraq and The Other Iraq, as the Kurds like to call their mountainous abode in ads when trying to attract investors. According to a 2005 count, 48 Turkish companies and 30 Iranian ones had set up shop in Suleymania alone, along with contractors from the far East and Western Europe. But it must be noted that Western companies are relatively scarce, frightened by the idea that this is, after all, Iraq and therefore Very Dangerous Territory.

The IKR is booming, to put it mildly. Towns are sprawling out across the surrounding countryside, real estate prices are sky-rocketing, and even in small villages, high up in the mountains, bricks, concrete and workers are in high demand. The price of cement more than tripled between 2003 and 2007. The town of Zakho, in the northwestern tip of Iraqi Kurdistan, is inexorably creeping towards the nearby Turkish border. Even before roads are properly paved, houses are being built alongside them, apparently without much interference from any planning authorities. The outskirts of Zakho look like the American West: dusty, rough, uncoordinated, energetic. "You do need permission to build a house here," asserts Hasheem Hamid, a doctor at the Zakho General Hospital, "but you can easily get it after the house is completed." In 2001 he bought a spacious villa for himself, his wife and their four children – two years later could have sold it for five times as much. Permission may be easy to get, mortgages are unknown and all houses are being paid in cash. Banks exist, but individuals avoid them. "I do not know a single person here

who has money in the bank," Hameed says. In the town of Shaqlawa, where twenty percent of the inhabitants are Christian, real estate trader Paulus Abdul Selman reported in 2005 that house prices had tripled in just one year. For those who had land suitable for building, it was the time to sell. "In fact, there was some slowing down of the real estate prices," Selman said in his downtown shop with large-scale maps of Shaqlawa covering the walls. "The fear was that the violence and the bombing might spread to here from the Arab parts of the country." But it didn't and prices picked up again.

To really see what Iraq without insurgents looks like, Erbil is the place to go. A four-lane motorway to Salahuddin, the GHQ of Masoud Barzani twenty kilometers east of Erbil, has just been completed and had reached Kore by early 2009. Flyovers and building sites skirt the capital. Large but otherwise ordinary houses are built with concrete blocks. No double walls, no insulation – that's the way to go fast. The most ambitious project is called Dream City, built on virgin desert land near the new airport and the old Christian suburb of Ainkawa. Typically, the staff are Turkish and Lebanese and the workforce comes from many countries but hardly ever from Iraqi Kurdistan. Some of the builders I met were Kurds, but Kurds from Turkey. When ready, there will be 1,200 houses ranging in price from 150,000 to 650,000 US dollars. The complex includes schools, supermarkets, and parks.
The project has a two-metre high wall all around it to protect the Dream against terrorists and other criminals. Similarly,

The brand new shopping mall "Nishtiman" with 1,200 shops, topped by two office towers of thirty storeys each, here seen during construction in 2005, a year before completion. Shops measuring twelve square metres sold at 32,000 US dollars in August 2004 and at 60,000 in 2005. The one billion USD needed to build Nishtiman was put up by Lebanon-based Middle East Construction.

Erbil's best hotels and the main government buildings are surrounded by massive concrete defence works, in particular against suicide car bombs. These are quite rare. When a suicide bomber drove a truck into the Interior Ministry and security headquarters in Erbil on May 9, 2008, The Kurdish Globe wrote: "The bombing in Erbil has sent waves of shock and disbelief among the city's residents. The city that was safe for almost two years has now started to worry about its security."

Whatever suicide bombers are causing elsewhere in Iraq – it is not disbelief. The IKR can rightfully call itself The Other Iraq, where safety and stability form the foundations of all the current building frenzy. In August 2008, Dubai-based Damac Properties announced a 55 billion dollar mixed-use development project, including houses for 50,000 people, a thousand offices, golf courses etc. on sixteen square kilometers near Erbil, which the developer got for nothing from the KRG. It is the largest investment in the IKR so far, and the sec-

ond largest for Damac Properties. "We found that Kurdistan was one of the easiest places in the region to work with," according to Hussain Sajwani, chairman of Damac. "We found a big co-operation with the government when it came to regulation, location, investment." The IKR's safety

was quoted as one good reason for choosing this location. But even so, according to a press release, "the development will also offer major security coverage, including fences, checkpoints, high-technology screening at the entrance gates and round-the-clock security patrols."

Even in the countryside, foreigners enjoy the opportunities the Kurdish economy has to offer. Against a backdrop of rugged mountains, a few dozen Pakistanis are setting up iron towers that will lead electricity lines to the remote Sidakan Valley near the Iranian and Turkish border.

< Roller skating near the most luxurious hotel in downtown Erbil, the Erbil International Hotel, formerly known as the Erbil Sheraton Hotel. The Sheraton chain parted company with this establishment around 1995, when PUK pesh mergas invaded the city and temporarily occupied the parliament buildings. Part of their mission was firing shells at buildings, including the Sheraton, resulting in huge holes in the walls. In 2003 the Iraqi Nasri Group acquired the ruin and admirably restored its former splendour, making it the favoured Erbil base of operations for CNN, the BBC and scores of business expeditions. Tight security is part of the hotel's appeal, hence the concrete blast walls. The text of the central panel is a song for New-roz, the Kurdish New Year (21 March), singing the praises of the role of women in the liber-ation of Kurdistan. The text on the black panel is about the power of cooperation between husband and wife, in this case resulting in a successful escape from prison.

Housing projects for the rich are becoming numerous. Dream City near Erbil was the first, one square kilometer of luxury homes. Ten kilometers east of Erbil, with a view onto the premises of president Masoud Barzani in Salahuddin, the somewhat smaller but even more exclusive American Village – Welcome to Luxury is nearing completion: hundreds of villas at 600,000 US dollars apiece. These are just two examples. Pictured here is a stand at a fair designed to attract buyers for the new and not-so-Kurdish convenience and comfort.

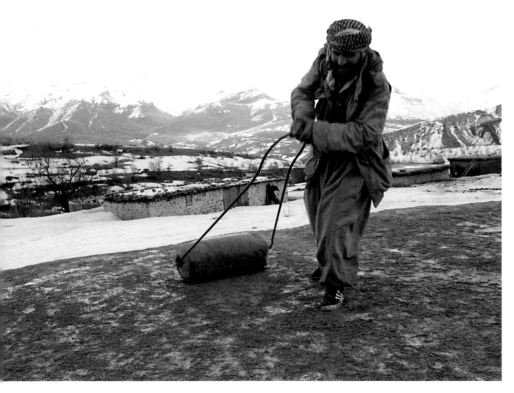

Roof maintenance Kurdish style. Kurdish houses almost invariably have flat roofs. Traditionally, poplar poles provide the support, woven reed lies on top of the poplars, and a layer of loam over the reed should keep the rainwater out. It is essential to keep the top layer as compact as possible, hence the rolling. The first picture shows a vanishing art, as more and more traditional houses contain big sheets of waterproof plastic, plus many stones to keep the plastic in place.

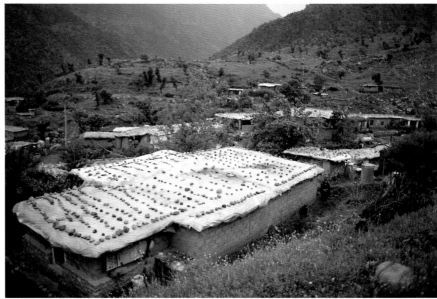

The new public library
in Suleymania, reflecting
one of the town's many
building sites.

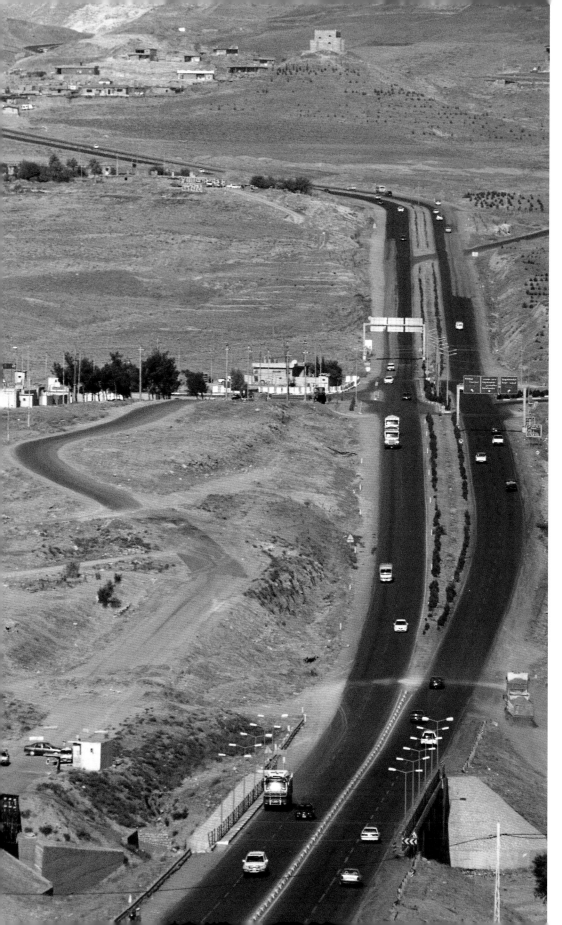

A new four-lane motorway leading from Erbil to Salahuddin was completed in 2005. For a couple of years the IKR's government struggled to realize this project but progress was slow and hindrance for the traffic was considerable. Then a Turkish road building company was hired in 2003 and the road was completed within a year. In the background is another reminder of Turkish involvement in Southern Kurdistan: a small military fortress of the Ottoman Empire which was recently restored by the Ministry of Culture, partly because it is so visible from the motorway. Many foreign dignitaries travel along this road: from Erbil where the airport, the parliament and all the ministries are, to Salahuddin, the GHQ of the Barzani family. Salahuddin is where Masoud Barzani, the IKR's president, and his nephew Necirwan Barzani, the prime minister, are residing in a large and very heavily guarded complex just outside the upper right-hand corner of this picture. The plan is to extend the motorway much further towards the Iranian border, following the trace of a famous road whose remains can be seen in the bottom left-hand part of the picture, plus a small stretch near the upper right-hand part. This road, from Erbil to the Iranian border at Hadj Omran, was built in 1928-1932 by A.M. Hamilton (1898-1972), an engineer from New Zealand who wrote a famous book about his project: *Road Through Kurdistan* (1937). Even now, many Kurds call Hamilton's great achievement the Hamilton Road.

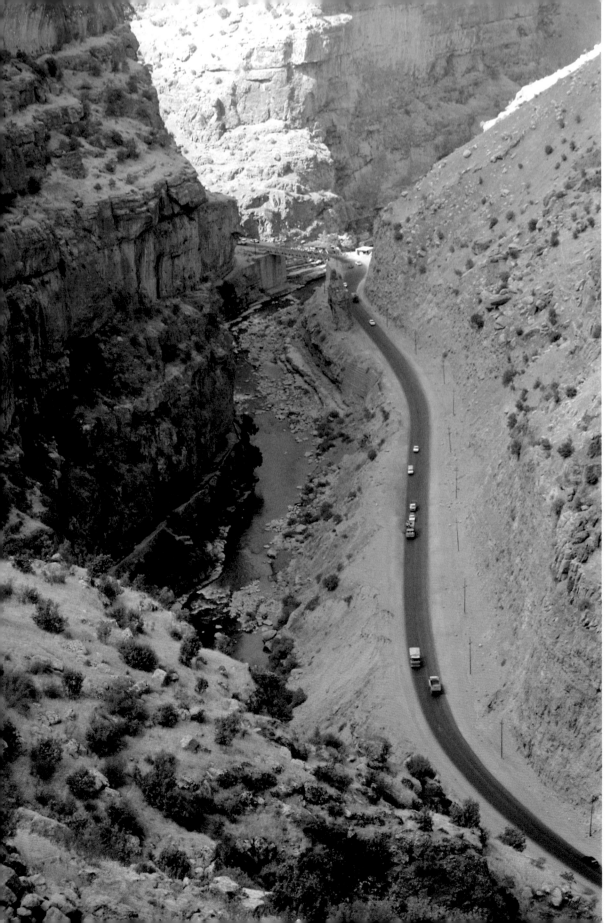

Some of the skills of Hamilton and his Kurdish workforce can be seen at the Gali Ali Beg, a gorge between Kalifan and Rawanduz. The Hamilton Road is on the left. In the bend, the road goes through an unusual tunnel, with one of the sides open. On the opposite bank of the river is the fast road which Saddam had made to move his troops from A to B.

136

Women A bus at the Zakho bus station. The adult women wear headscarves. The younger girls don't, just like the model on the faded ad for Turkish shampoo (right) and like Lebanese singer Baskal Mashalani, a Middle Eastern women's lib icon.

Women

Why is there a special chapter devoted to women and not one about men?

For one reason, men are far more visible in Kurdish society than women. The number of women in the higher strata of society is quite limited, lagging far behind the percentages of Western societies. So, a journalist doing his or her work, making the rounds at ministries, universities, municipalities, markets etc., won't meet many women. Some extra effort is needed to get them into view. Leaving the big towns is helpful: in villages the women seem to be on a par with the men in many respects. Meeting them is easy, they are often keen to explain their daily work and their situation. That is why village life may be somewhat over-represented in the following pictures.

The basic tenets of Kurdish society are not so bad for women, and their legal position seems good in many respects. A law states that at least 30 percent of all 111 members of parliament must be women. There are sizable women's rights organizations, most of them with either a PUK or a KDP background. The Christians – mostly Assyrians or Chaldeans – have their own institutions for women's rights. The Kurdistan Communist Party-Iraq has its Kurdish Women's League, whose chairwoman Nahla Hussein al-Shaly was decapitated by men who had stormed her house in Kirkuk in December 2008. Generally speaking, Christian women enjoy more freedom. For one thing, they don't have to wear headscarves. Female circumcision is unknown among Christians while it is still quite common among the Kurds. In 2005, the German NGO WADI interviewed 1,554 women in Germian province aged ten or older, and found that more than sixty percent of them had been circumcised. Later

on, similar research in other areas revealed similar percentages.

The response to these findings was better news. A public debate soon followed, and all who spoke out in public condemned it for being out of tune with the modern Kurdistan they were working on. It became a hot issue in the media. In 2007, 14,000 people signed a petition against female genital mutilation. Legislation imposing a ten-year jail sentence for carrying out the practice was proposed. But then the passing of the law was kept on hold. According to The Washington Post of December 29, 2008 "the legislation has been stalled in parliament for nearly a year, because of what women's advocates believe is reluctance by senior Kurdish leaders to draw international public attention to the little-noticed tradition. The Kurdish region's Minister of Human Rights, Yousif Moham-mad Aziz, said he didn't think the issue required action by parliament. 'Not every small problem in the community has to have a law dealing with it,' he said."

Something similar applies to honour killings, women being murdered or forced to commit suicide because they were seen with a man other than their husband, while no member of her family was present. Yousif Aziz said in 2007: "I think it takes place daily, some are killed, some burn themselves, so there are many cases." Of course, many of these killings fail to get noted by the police, and many cases that do get attention are labelled as "an incident". On April 7, 2007 Doa Khalil, a Kurdish Yezidi girl, was stoned and kicked to death in a street, outside the IKR. Mobile phone images of the honour killing spread over the whole world, CNN showed them too.

There was a public outcry in the IKR, the government condemned it once more – and in the meantime the death of Doa Khalil triggered a wave of new honour killing in the IKR. "Since the seventh of April, so many women have been killed. So many women, it has just been packed, packed with killing women," said Erbil women's rights activist Chilura Hardi. "Because it just made it okay. When those images were seen by people who have this idea about killing a woman for whatever the reason – whether she did not listen to you, did not obey your orders, did not want to get married to so and so – thought: if that happens, then I can do the same thing."

Utterly strict moral rules like these, so strict they become evil, are in striking contrast with the lack of morality when it comes to prostitution. In July 2008, Soran Mama, a 23-year-old reporter working for the IKR's best selling weekly, Lvin Magazine, was assassinated in his home in Kirkuk. That is outside the IKR – but Kirkuk is ruled to a great extent by the Kurdish political parties, notably the PUK and the KDP. Here is an extract from the article (Lvin Magazine, 15 June 2008) about prostitution in Kirkuk that cost Soran Mama his life (see also page 206):

"Although prostitution is an illegal affair and it must be prevented by the police and authorities, as far as Um Latif's network is concerned, the matter is quite contrary. Some policemen and officers are part of the market of her prostitution rings. She says: 'Sometimes high-ranking police officers phone me and threaten me because I have not taken girls to them for free.' She gave the example of one of the police stations. 'They

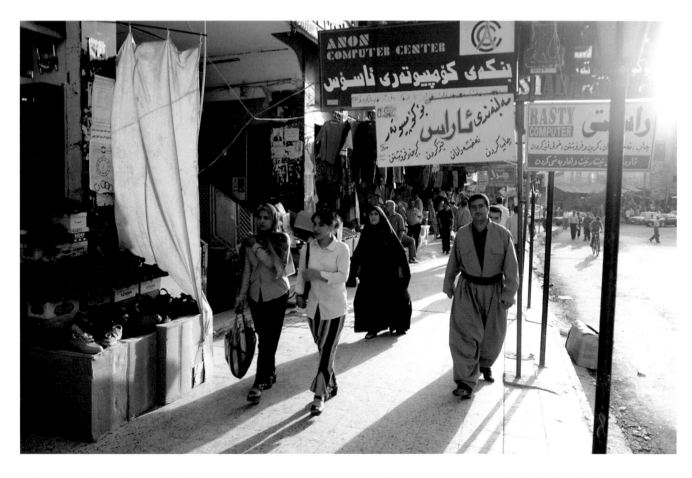

took away a girl named Nura allegedly because she was under arrest. After some time Nura came back. She said they had raped her in the police station.' In following up this report, I managed to obtain the names of three police lieutenant colonels and colonels and other high ranking officers who are the prostitutes' customers. But for journalistic morality we have not published these names although the names are kept at Lvin magazine.

Latif's mother even said that she has sponsors at police stations who bring girls to her for prostitution. She asserts: 'They have brought me many girls.' But although the police are supporting her in her business, she says 'they also harass us a lot.

I change my place every month.' In spite of this, she talks proudly about the strong support she has. She talks on behalf of a political party. She says: 'I belong to one of the political parties. I work for them. I have handed over three terrorists to them so far.' She indicated that they have also customers who are terrorists. She says: 'The terrorists have come here several times and taken away girls for sex.' Prostitutes' tales travel beyond Kirkuk and become the focal point of the talk of the youth and the officials in Sulaymaniyah and Erbil. About the sex trips by people of Sulaymaniyah and Erbil to Kirkuk, Latif's mother says: 'A number of officials have come here from Sulaymaniyah and Erbil.

One girl with a headscarf and one without, followed by a woman in black, and shops filled to the brim for all. That is pretty much the predicament of the average Kurdish woman. This is Erbil, with the IKR's largest bazaar beginning to the left and the citadel, outside the frame, on the right.

They have taken away girls for one week, ten days or two weeks for 700 to 800 dollars. We have the names of those military officials of Sulaymaniyah and Erbil who have taken away girls for sex. Most of the customers are military officers, police and security men.' Um Latif feels sad because 'the girls are often beaten and harmed especially by security men. PUK's security men are the worst.'"

From 1994-2005, there were two governments in the IKR with some marked differences regarding the position of women. Characteristically, the PUK area had homes for battered women seeking refuge from violent husbands. The first refuge for women in Suleymania, the Aram Shelter in 1998 (aram meaning "quiet"), was initially funded by PUK leader Mr Talabani himself. Afterwards, UNICEF, the UK governmental aid organization DfID, and the PUK took over. Mr Talabani was also behind the introduction of Law 51 in 2000 in the PUK-governed area, at a time when the IKR had two governments, which established a 25-year prison sentence for honour killings.

Some of the wives of the leaders of the PUK were, and still are, highly visible, and not just when their husbands are cutting ribbons. Hero Talabani – the wife of PUK leader Jalal Talabani, who became president of Iraq in 2004 – has always been a prime example. For many years she has been making appearances at political rallies and advocating women's rights. But within the KDP it is customary for the wives of leaders to remain in the background. Very few Kurds are familiar with the face of either the wife of Masoud Barzani, the president, or the wife of Necirwan Barzani, the prime minister.

In 2004 a piece of national Iraqi law with strong Shiite overtones caused uproar in Iraqi Kurdistan, among the PUK and the KDP alike. It had to do with the rights of women to inherit from deceased husbands, something Muslim clerics considered to be out of tune with the Koran. The stance of most Kurds, many women in particular, was that widows should be entitled to inherit from husbands. But not all agreed, some thought that Islamic law ought to be the basis for the laws of the IKR. "The rights of women are determined in Islam, and any changes will be at odds with the jurisprudence of Islam," said Shamsa Saeed, a female member of parliament for the Kurdistan Islamic Union (which has 6 seats in parliament) in June 2008.

As was reported by the women's rights group Isis International, in April 2008 a committee advising the IKR government had told Kurdish women's advocacy groups "that it would recommend that Islam be the sole source of legislation for the personal status law. This created an outcry from women's organisations who say such a move will hinder women's rights." In conjunction with this inheritance debate, Islamic parties defended the continuation of the legal status of polygamy in the IKR. There are not many men who have several wives, and their numbers are dwindling, but the practice is hard to eradicate.

For the latest news on this continuing story, check out the excellent website of Kurdish Women's Rights Watch.

More important than any law is what is actually going on. Can a woman go shopping unescorted? Hardly. Can she go for a swim? Only in the company of other women and – an amazing sight to behold – with all their clothes on. Can a woman go out with a man, other than a relative or a very good family friend, without being married? Definitely not. Can a Kurdish woman present a radio programme about boy-girl relationships? Yes, provided the issues raised stay within accepted bounds. Can she agree when a foreign photographer crosses her path and asks her to pose for a few pictures? No problem, almost all Kurds love cameras. Can she go to university? Certainly.

So it's quite a mixed bag, as these pictures show.

The position of Kurdish women may seem constrained from a Western point of view – compared to surrounding countries they are surprisingly free and uninhibited. These two women near the village of Choman were quite pleased when I approached them and asked to take their picture. In all I shot a whole film and they just continued smiling.

At the end of a long day in June 2002, I passed through a tiny mountain village near the Turkish border. There was less than an hour of sunlight left before shadows would engulf the valley we were in. So interpreter Kheder and I left our vehicle and approached a couple of young men. Would they be kind enough to show us their village? Of course, they appreciated our request. This was a standard tactic. Wandering through the village as a complete stranger was not a good idea, and my cameras wouldn't help. But surrounded by half a dozen locals, keen to tell anyone on our way that I was utterly reliable, I would feel free to shoot. When this girl suddenly turned a corner I was as pleased by the light and the whole sight as she was taken aback. "Tell her to stand still." I whispered. The girl got her orders from my escorting village boys, and obeyed. Some months later this picture appeared in a Dutch weekly and in The Irish Independent. In 2003 I visited the village again and showed the magazine to some men along the road. The recognition was as immediate as the village was small. One of the men stepped into our car and gave directions. We drove up a steep hill – and soon I was enjoying the pleasure of presenting a copy to the girl herself in the courtyard of her parent's home. As with our previous meeting, she didn't quite know how to react. Then she showed the magazine to some of her sisters and they all started giggling.

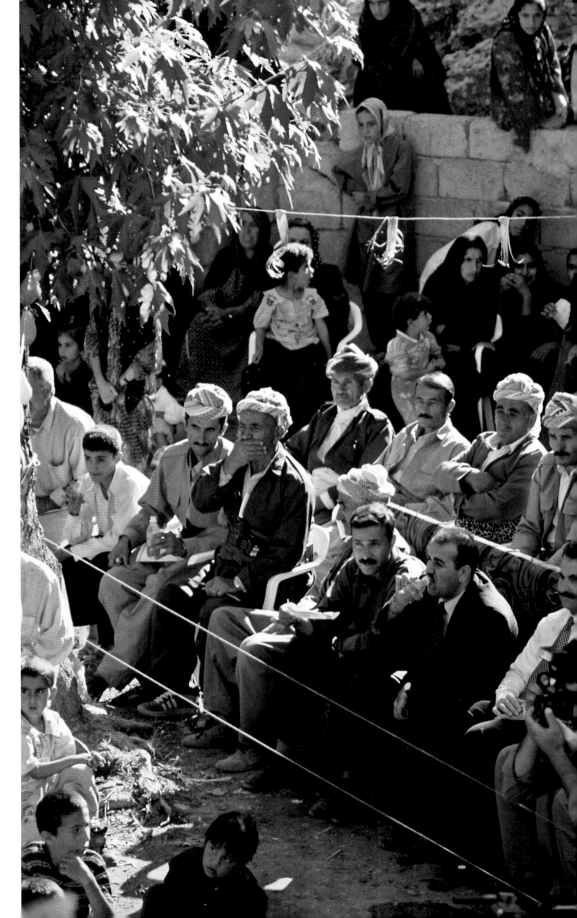

Villagers in Barzan are
watching children perform
a show of sorts. Note the
stratification of Kurdish society
in one of the more traditional
areas: men and women are
separated, and the men
prominently occupy the
front rows.

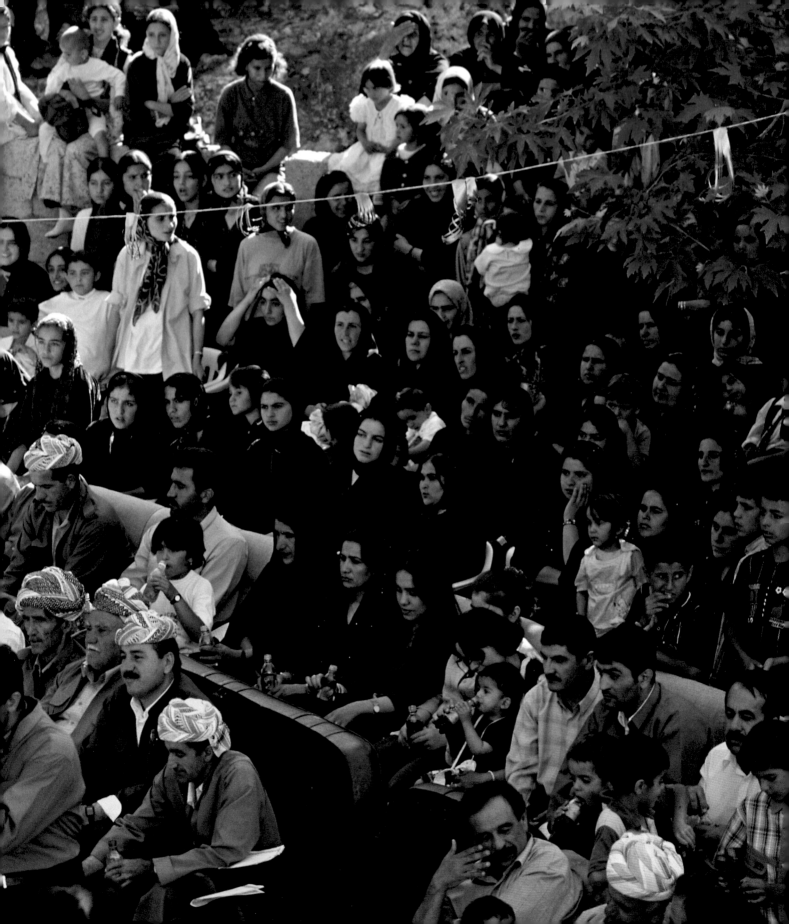

Before long, these two girls from Germian will be wearing headscarves.

Headscarves are on the increase all over Southern Kurdistan. Of course, social pressure has as much to do with that trend as personal preferences. Islam is gaining ground and the girls show it, as here, on the campus of Salahuddin University in Erbil, which added a College of Shari'a and Islamic Study in 2003.

Kafia Suleyman, centre, in 2003 chief of
the PUK Women's Union, which is affiliated
to the Patriotic Union of Kurdistan. She
is seen here at the Union's Suleymania
headquarters, flanked by Sewan Jaf, right,
and Munir Mohammed. The KWU had
a busy agenda, Suleyman said. "A family
that lacks the means to send all children
to school will typically send the boys. [...]
Polygamy is very hard to tackle because
the Koran allows it – that is one reason
why we are in favour of separating church
and state. [...] Women are not free to go
out unless escorted by family members.
[...] Pre-arranged marriage is still
common in villages. We are fighting
to have it outlawed, although going to
villages and talking to the people there
might be more effective than legal means.
[...] Boy-girl relationships are notoriously
complicated here and we shouldn't stick
to the old ways."

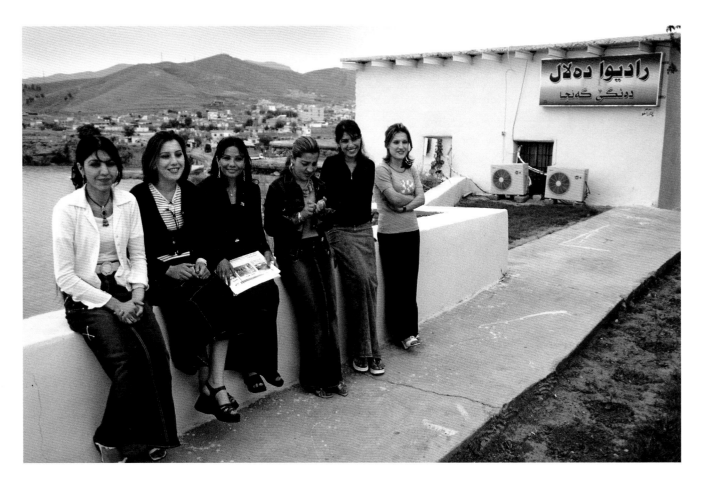

The voices of Radio Genj in Zakho, "genj" meaning young, as are most of its listeners. The station was founded a couple of years ago when it became clear that the youth of Zakho hardly tuned in to the well-established station of the Kurdistan Democratic Party. As the girls explain, the programmes feature western music as well as traditional music, and talk shows about, for instance, girl-boy relationships. How far can boys and girls go? Can they sit down and talk in a public space? Questions like that. The uniformed schoolgirls in Erbil (right) might well be interested in the answer. And also in the answer to the question: what to do when you suddenly see a stranger with a camera?

Worshippers The Jalil Khayad Mindalakanian mosque in Erbil, built between 1996-2007, is the largest mosque in Iraqi Kurdistan.

The mosque was entirely financed by the late business-man Jalil Khayat, who bought the land for the mosque back in 1974, and his son Dara Jalil Al-Khayat (see page 174). Note the satellite dishes. Arguably, watching TV has taken up such a prominent place in Kurdish households that its almost become a way of believing. A more concrete link between religion and TV is the constant flow of signals from foreign TV stations, many of them with strong Islamic overtones, pouring into Kurdish homes.

Worshippers

According to a Turkish proverb "only compared to the unbeliever is a Kurd a Muslim". Kurdish Muslims, most of them Sunnis, have had a long-standing reputation for practising Islam in a moderate way. Travellers rarely get the feeling of being in a province of Islamistan. Up until recently, political parties hardly had any religious flavours. Politics in Kurdistan used to be the KDP and the Communists. Then, in 1975, the PUK was founded. A Kurdish Socialist Party was founded in 1980, and other small parties followed. Almost all of them, starting from the KDP, were based on secular principles.

Since 1991, religion and politics are no longer as separate as they used to be. Iran did its best to pull as many Islamic strings in Kurdistan as it could. During the 1994-2005 rift between the KDP and the PUK, and due to the existence of a separate PUK-led government in Suleymania, Iran gained lots of influence there. A glance at the map shows why: Iran was the only friendly neighbour of the Suleymania government. But it was a love-hate relationship and PUK pesh mergas fought fierce battles with Iranian-backed groups at various stages of the cooperation. In the 1990s, Saudi Arabia generously provided the funds for the construction of small mosques in many villages.

Satellite TV, Islamic stations in particular, also helped to articulate and consolidate the position of Islam. Now there are Islamic political parties like the Kurdistan Islamic Union, founded in 1994 and currently occupying six seats in the 111-seat parliament. The Islamic Movement of Kurdistan had been formed as early as in 1980. But during the first parliamentary elections in the IKR,

in May 1992, they failed to reach the threshold of 7 percent and so didn't get into parliament. However, they consolidated a fairly large pocket of support, around Halabja, and effectively controlled that area during 1998-2000 until they were ousted by PUK pesh mergas. In 2001, the Kurdish Ansar al-Islam managed to get hold of another area, around Biyara, till they were kicked out by pesh mergas and US Special Forces, with US air support, during the American-led invasion of Iraq in 2003.

All of this just goes to say that Islam is spreading in Kurdistan, geographically and otherwise. It is getting more difficult for women to evade wearing a headscarf. After 2003, Iraq changed from a rather stable, secular dictatorship under Saddam and his Baath party (which was founded by a Christian) into an unstable hotchpotch of groups and parties who are all more or less Islamic, despite their differences and mutual hatred. Of course, the rising Islamic tide in Arab Iraq is spilling over into Kurdistan.

When the IKR was drafting its own constitution in 2007, Islamic parties managed to have an article included that recognizes "the principles of Islamic Sharia as one of the sources of legislation". Scores of Kurds felt very uneasy about this, and the Christians must have felt extremely uneasy. The two main parties, KDP and PUK, were against, and 54 percent of the population wanted a secular Kurdistan, according to a poll in March 2007. But the Islamists were too influential to repeal this article 7. In 2007 a petition against article 7 was written by a committee led by a woman, Houzan Mahmoud. She said: "We are here and represent masses of people and we

would like to inform you that people don't want Islamic Sharia Law and that they have already organised their lives according to secular values." A quote from the petition: "There is no question that making Islamic Sharia Law a base for lawmaking in Kurdistan will inevitably produce attacks on freedom of thought and expression and restrictions on civil rights. Gender apartheid will be practised. We have seen the consequences of Sharia law in countries like Iran, Saudi Arabia, and Afghanistan. We need only to look to the south of Iraq where the Islamic Shiite parties are in power and are forcing through Islamisation with an inevitable rise of bloody sectarianism, attacks on modernity and civilisation itself as consequences."

An aspect of Sharia law which rarely gets the attention it deserves is the prohibition to abandon Islam and to take up another faith – be it Christianity, atheism, agnosticism, Buddhism or whatever. To change one's religion, or to abandon all religion, is a fundamental human right, enshrined in article 18 of the Universal Declaration of Human Rights, which says: "Everyone has the right to freedom of thought, conscience and religion; this right includes freedom to change his religion or belief." In early 2002 I heard or read somewhere that Islam prohibits Muslims from changing faith, and that Mohammed himself had imposed the death penalty for leaving the creed he founded. I wondered: what is the reality on the ground in Kurdistan? Is the Kurdish situation in accordance with Islam or with basic human rights? So, during my last six trips, in 2002-2008, I conducted some research.

I asked a number of Kurdish friends whether they were free to leave Islam and speak openly about why they left. Most often the reply was: No, I can never get out, if I do I may be killed. Some of those with whom I discussed this matter came close to tears. When they were born, they were made Muslim for life and they just were not allowed to leave, they told me. No one had ever asked them whether they wanted to be a Muslim or not.

Of course, these replies were given by doubters. Kurds who really embraced Islam dodged the question or simply said there was no problem whatsoever. One Kurd with a university background, told me: "The question you ask has never occurred to any Muslim. Islam is the best religion, and therefore nobody ever wants to step out." Baloney, of course. Nowadays, courtesy of the internet, there are thousands of testimonies in the public domain from

About one percent of the inhabitants of Iraqi Kurdistan are Christians, Assyrians or Chaldeans, totalling 50,000. This is their stronghold, the town of Ainkawa near Erbil. Strangely, Kurds will usually refer to Chaldeans as Christian Kurds, whereas the Chaldeans themselves will assert that 'Chaldean' is also their ethnic identity and that they are not Kurds. Many Christians in Ainkawa don't know any Kurdish. They have their own language, Neo-Aramaic, and use Arabic or sign language on the odd visit to central Erbil.

people worldwide who want to leave Islam but are afraid to do so and from those who have already done so in secrecy. They can tell their stories anonymously on sites like faithfreedom.org.

In the IKR there is no law that states that Muslims have to stay Muslims till they die, and that arrest by the police and capital punishment will await them when they abandon Islam. Iran, Sudan, Yemen, Saudi Arabia, and Mauritania are among the countries that do have such laws. In Kurdistan the situation is like the one in Egypt, Pakistan, Kuwait and the rest of Iraq: as far as the written law goes, citizens are free to leave Islam. But anyone who does had better keep very quiet about it. In Pakistan, Egypt and even in Turkey, people who leave Islam risk being killed, just like Mohammed had ordered.

For sure, most Kurds are convinced that they cannot leave Islam. But is that a real limitation of their religious freedom, or just a perceived one? What is the actual fate of those abandoning Islam in Southern Kurdistan? It appears to depend on geographical differences and on the family. In some places, maybe in many places, an apostate can expect Muslims to carry out the punishment that Mohammed imposed for leaving Islam: death. And the chances are that the police won't bother.

But at the same time, the situation is locally better than in the Islamic world as a whole. For one thing, the IKR government silently allows individual religious freedom. There are even converts who can congregate. In 2000, the Church of Christ was founded in Erbil, with a constituency of Kurdish-speaking converts, and it now has branches in Suleymania, Duhok and Kirkuk. They are protected while among their own, but how safe are they in an Islamic environment? What if they speak out in public? Social scientist Diana Colby wrote in 2007: "Kurds from a Muslim back-

ground are turning to Christ in numbers greater than in recent decades and perhaps even since their ancestors turned to Islam centuries ago. They are joining or starting evangelical fellowships with others from similar backgrounds. These fellowships resemble the New Testament church to a greater degree than they resemble the historically Christian churches in Kurdistan. Most of them face persecution from their families [...], especially when their faith first comes to light, but this has not stopped them from meeting together and growing and encouraging each other in their faith."

One Iraqi Kurd who left Islam and became a Christian, Daniel Ali, wrote a book about his experiences, Out of Islam – Free at Last (2007). From the introduction: "If one declares a faith other than his native Islam, he faces death at the hands of any Muslim who discovers him. At the very least, he or she becomes totally outcast from society." Significantly, Daniel Ali has been living in the USA since 1993.

What I have heard, not occasionally but almost invariably, about the dangers of leaving Islam warrants close monitoring of this sensitive subject. However, Kurdish Human Rights organisations carefully avoid mentioning the freedom to change religion. As far as my knowledge goes, the government in Erbil has never made a clear statement about this right.

So there is work to be done. Every human being, including every Kurd, should be totally free to relate or not relate to God and/or metaphysics in the way he or she chooses, without any coercion from anybody else, including relatives. This includes the freedom to change beliefs and to speak openly about those changes.

This problem also exists in the West, especially since the advent of Islam. The Guardian newspaper reported on 16 September 2007: "A poll of more than 1,000 British Muslims, conducted by the Policy Exchange

> One of a small group of Muslim Kurds from Quamishli, in North-Eastern Syria, who had fled to the IKR and found work as painters in St Joseph's Church in Ainkawa.

think-tank this year, found that 36 percent of Muslims aged between 16 and 24 believe those who convert to another faith should be punished by death." In my own country, the Netherlands, the situation is not that shocking, but even so: six percent of all Muslims think that violence against Islam leavers is justified (survey, published on 10 September 2007).

It is a global problem, which exists everywhere where Islam exists – and it should be attacked head-on and worldwide. Let the Kurds show the way to the rest of Islam. Of course, everybody who wants to be a Muslim has the fullest right to do so. But everyone who wants to quit should feel free to follow his or her own path.

Mosque, men and microphones waiting for the imam to begin his sermon. This is the Jalil Khayad mosque one of more than 300 mosques in Erbil.

The minaret of a Kurdish Shiite mosque in Suleymania overlooking a shopping street. Most Kurdish Muslims are Sunnis, only a small percentage are Shiites.

> Although only three percent of Iraq's population at the time of Saddam's downfall were Christians, they constitute forty percent of those who fled Iraq after Saddam, according to UN counts. The wide-scale prosecution of Christians in Iraq has also led to an influx of Christians to the Kurdish region.

This Arabic couple from Baghdad, seen here with two of their children, had the same choices as many Christians in Baghdad: convert to Islam, be killed, or leave immediately. They went the same day and soon their house was taken over by Muslims. They set up this shop in Ainkawa.

A Christian Kurd in Mella Arab, near Batufa.
From the 5th century onwards Southern
Kurdistan was predominantly Christian.
In the mid-7th century, Arab armies coming
from the South imposed Islam.

> One of the dozens of mosques in Southern
Kurdistan financed by Saudi Arabia in the
1990s, when all help was welcome. These
mosques include a first-line medical post.
This one is in Deralok, East of Amadiya. It was
in November, so villagers were busy collecting
wood for the winter.

Consumers Bazaars are losing ground to a supply-driven wave of supermarkets – not a supply of goods, but a supply of supermarkets. This one in Duhok opened its sliding doors in 2002 and was said to be the first in the IKR. Prices in supermarkets are fixed, there is lots of room to move around, there is often marble on the floor, there is plenty of light, and a shiny checkout is waiting at the exit. How appealing is that to people accustomed to bargaining in crowded, cosy bazaars?

Consumers

As far as appearances go, the shopping habits of the Kurds aren't so special. The need to buy, to sell, to earn money, to spend money – all of these cross-cultural elements are at work in Kurdistan as much as in any modern society. Yet a few special trends need to be mentioned.

When wandering through the bazaar of Erbil or Suleymania, the very presence of all that's for sale won't raise many questions. But trace the provenance of any number of articles and you'll find lots of adventure stories. Southern Kurdistan is surrounded by enemies who all share one weakness: the wish to earn money. Turkey is bombing Kurdish villages regularly, has troops at six locations in the IKR and threatens to invade every now and then – yet the Turks allow some 250 trucks full of goods, mostly Turkish goods, into the IKR every day. The same applies to Iran to a lesser degree: fewer trucks, fewer threats to the IKR's integrity.

Notable too is the trend towards spic & span shopping malls, a departure from the traditional bazaars, large and small, and street vendors. But these new shopping paradises were not preceded by a lot of research into the wishes of the customers. Or at least, that can be deduced from the limited numbers of people who go there. Many ordinary Kurds think, and actually some told me: someone has to pay for these new buildings, for the chromium, and all the marble – and that someone is probably me, if I go there. So the new malls mostly cater for the rich upper class, which is growing fast. The number of one-million-dollar-millionaires has grown from five in 2002 to well over a thousand now. Nonetheless, many small entrepreneurs went out of business within a couple of months of opening up shop.

The family of Houssain Ismael in Erbil, not very rich, not very poor, seen with some basic necessities of Kurdish life: a house, a carpet on the floor, a kerosene heater, tea, a fridge and, very important in almost every Kurdish household, a TV set. Most Kurdish families switch the TV on first thing in the morning and it won't be switched off till the last person goes to sleep.

< Kurdish women are fond of glittery dresses. The cloth is factory-made and comes from abroad. The whole feel of any bazaar shop like this one is different from the modern shopping venues being built all over Iraqi Kurdish towns nowadays.

> Kurds have almost ceased making carpets themselves (see page 188/189). But a first necessity of life in every household is to have something nice on the floor – or rather, on each and every floor in the house except the kitchen and the bathroom. It is still quite common to have meals while sitting on the ground, and bare tiles just don't meet the requirements. That custom alone guarantees a flourishing market for carpets. Here is a shop in Suleymania. These carpets are all factory-made and they probably all come from nearby Iran.

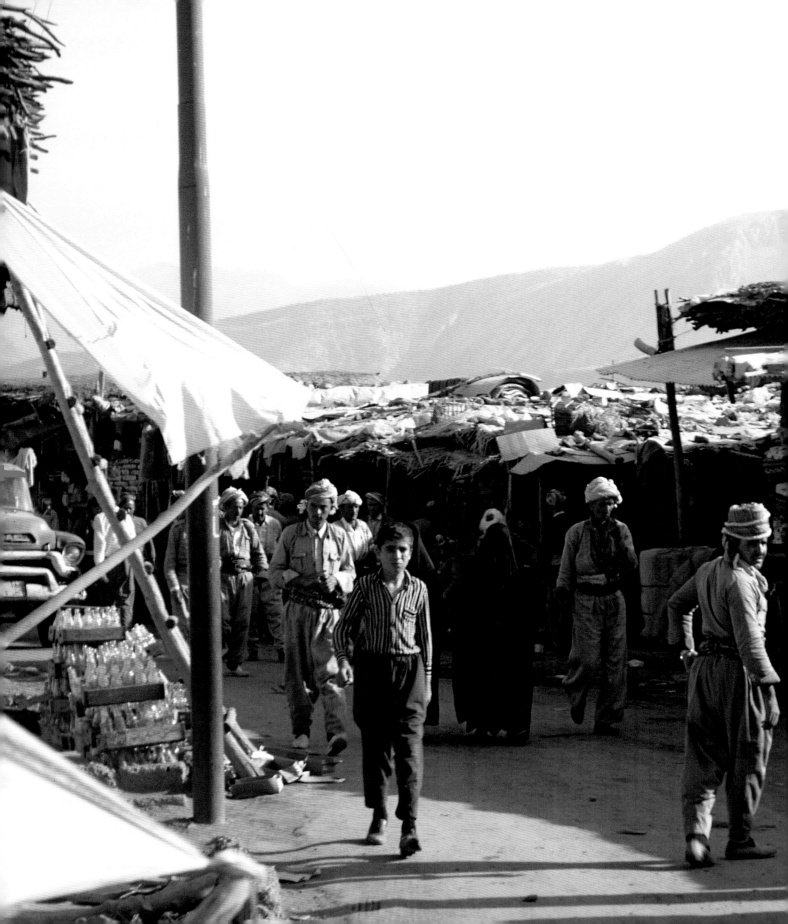

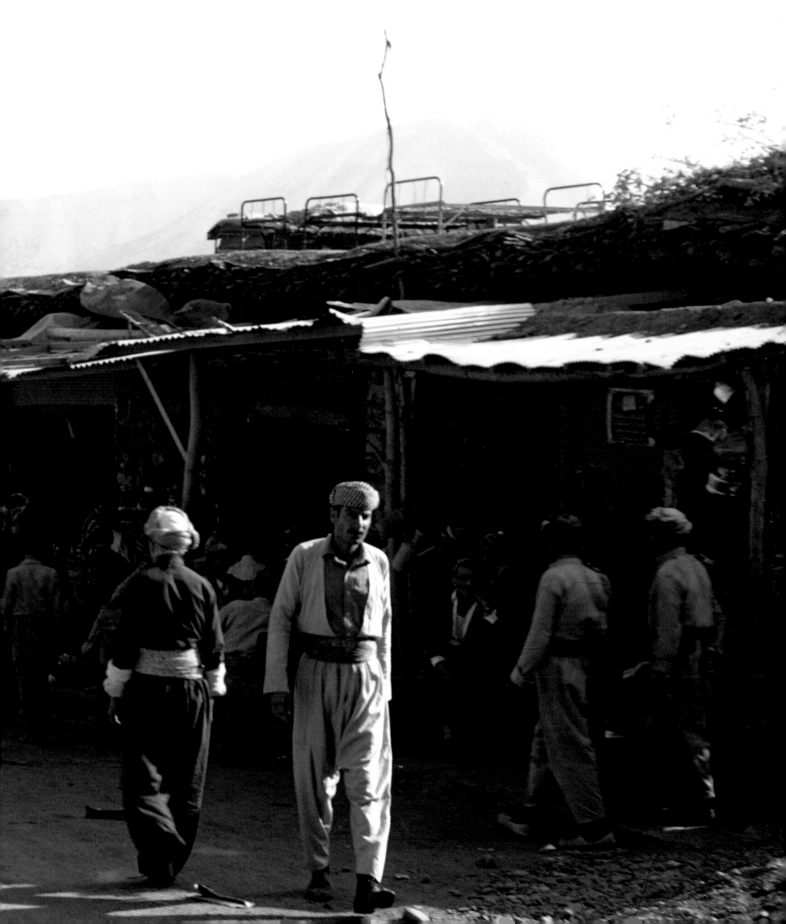

Selling bananas between Diyana and Rawanduz.

Buying petrol, in Erbil (right) and in Choman. Regular, western-looking petrol stations are on the rise, but these images are typical for the time being. In the 1970s, petrol was so cheap that you could drive from Iraq to Western Europe with just a few dollars' worth of fuel, provided your tank was big enough. Nowadays everybody complains about prices of about 0,40 US dollar per litre on the black market, as in this picture. This is petrol from Iran or Turkey. Iraqi petrol is a lot cheaper but sales are rationed and queues are long.

< How shopping used to be. Galala, 1973.

The Erbil bazaar, the IKR's largest shopping venue, stretches out behind these shops, on both sides. The picture was taken from the citadel.

< Buying a car at the Erbil car centre, where prospective buyers find plenty of car dealers next to each other.

> An old-style shop in the bazaar of Rawanduz, demolished, along with most of the bazaar, in 2007 when the road was broadened. Mickey Mouse may seem a bit lost here, but he and the Duck family are part and parcel of the traditional Kurdish street scene. Their images, although not always instantly recognizable, are livening up countless shops.

Just a stone's throw from the bread shop (previous page), there used to be the splendid Old Teahouse, run by Said Jabar Said Aziz since 1954. He took over from his father. As far as he knows, the place is at least a century old, which makes it a rarity in modern Kurdistan. On eight of my eleven Kurdish trips I drank tea here. In 1973, it was in this teahouse that our travel party really got the feeling of being in Kurdistan, just before crossing into Barzani's rebel free state (see page 83). From the rear window, the customer stares into a deep gorge, which can be seen on the left of the picture of Rawanduz on page 100/101.

When calling on the teahouse in 2006, I found Said Aziz in a gloomy mood. The roof was leaking, he said, pointing at about a dozen pots and pans on the floor. So, back in Holland I contacted my 1973 –fellow-travellers. We collected 500 us dollars and sent it to Said Aziz, who had his roof repaired. A year later, the entire Rawanduz bazaar, including the fixed roof, was demolished and sacrificed in accordance with the wish of the Kurdish government to broaden the road through old Rawanduz. The demolition of the Old Teahouse is just an example. In Erbil, parts of the old bazaar will have to make room for parks in the next few years.

The Old Teahouse on 10 December 2008: gone, all that remains is an empty space and a broader road through the old town centre.

< Said Jabar Said Aziz in his makeshift teahouse in an old garage, 100 yards from the former Teahouse, following the demolition of the Old Teahouse in 2007/2008. He received a plot of land in Rawanduz, but not the money needed to build a new teahouse.

<< The Old Teahouse and Said Jabar Said Aziz in 2005 (above) and the Old Teahouse in Rawanduz on 29 July 1973.

Restaurant old-style in 1992 when Kurdish consumerism was at a low point. No one had money and shops were empty. In this restaurant near Zakho's old bridge (outside the window), toilet paper had replaced napkins. In order to save energy, heating was really up close and personal, while a timeless lady on the wall provided some consolation. The growing influence of Islam has rendered cheerful paintings like this one suspect – if, indeed, any can be found at all these days.

One of the most amazing phenomena of the Kurdish economy is barely visible because virtually everybody hides it: cash – piles of banknotes hidden in drawers, mattresses and fridges, under carpets and behind walls, even in boxes in the ground.

Why not go to the bank? Most Kurds will argue that you would then lose sight of your money, maybe for ever. Cupboards are safer. Indeed, in the early nineties some Kurds lost money they had deposited in Iraqi banks, and many still remember that. "But those banks were state banks", explains Ibtisam Najem Aboud, general manager of the Kurdistan International Bank (KIB), founded in 2005. "We are a private bank. The major shareholders are five Iraqi banks. If you deposit ten million dollars here you can withdraw it anytime you want, from any of our branches."

Aboud, an Arab with a resumé spanning forty years in the international banking sector, is amazed that the KIB has only 2500 private account holders among the more than one million inhabitants of Erbil. "We tried to change the minds of the people, with TV commercials and ads in papers." The obvious reasons for banking aside, even a regular account will yield an amazingly high interest rate. Aboud: "In 2006 we paid 37 percent interest and in 2007 we paid 26,5 percent over deposits which can be withdrawn at any moment." Interesting? Aboud insists that all Iraqis and non-Iraqis are welcome to open an account, in dinars, euros or US dollars.

Customers will have to make do with fewer services, though. No mortgages for instance. Kurds will hardly mind, because few know what a mortgage is anyway; if you want to buy real estate you will have to pay cash, your own cash that is. Internet banking isn't available yet, and at the time of the interview, December 2008, credit cards could not yet be issued, nor could credit card holders withdraw cash from the KIB's cash points.

Some of this will change soon. In the course of 2009, there will be over a hundred shops, hotels, supermarkets, petrol stations etc. where customers can pay with their KIB card, a novelty in Iraqi Kurdistan. Aboud is also confident that the KIB will be licensed to issue Master Cards, Visa Cards and American Express Cards – beginning with Master Card by mid-2009. But the KIB will not provide mortgages in the near future. Aboud: "We won't get the money back till many years later and we are talking about fairly large amounts. A bank needs at least ten billion dollars, which is more than we have, to provide mortgages on a regular basis." On the other hand, the KIB is involved in cheap housing projects in Erbil, Duhok and Suleymania. The land was provided free by the KRG while the bank builds 15,000 units at 30,000 dollars apiece, and sells them at 35,000 dollar.

In the meantime, the bank is linked to some large banks in the West and elsewhere in the Middle East, and transfers using the SWIFT system are common practice. Aboud finds it almost unbelievable that so many truckloads of imported commodities are being paid for in cash. "Why not transfer the money to a bank in Turkey or wherever?"

Downstairs, in the hall of the bank's office, people are queueing at a counter marked Western Union, where they can transfer money to, or receive money from, friends and relatives abroad. The maximum amount is 7,500 dollars – cash of course.

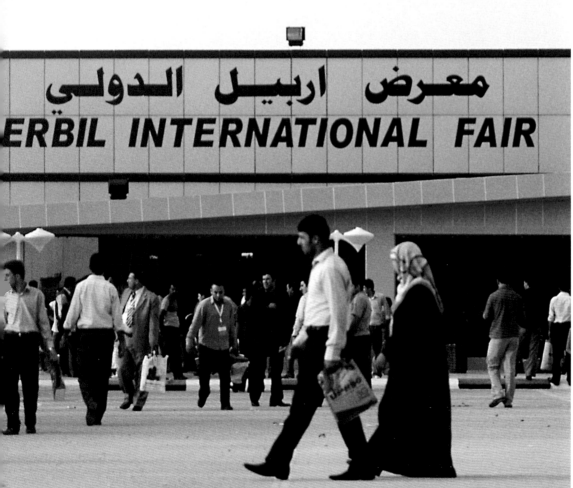

معرض اربيـل الـدولى
ERBIL INTERNATIONAL FAIR

Traders Both Erbil and Suleymania have their own annual international trade fairs, mostly aimed at the construction companies and the security branch. At this fair in 2007, oil and gas companies were also present in big numbers. From Iran there was a factory for canned fruit trying to find new outlets in the IKR, from Egypt a company making underground telecom cables, from Baghdad a blanket factory. But there were very few Iraqi Kurdish companies – the Kurds came here to buy.

Traders

To witness the flipside of the IKR's economic boom, go to the western outskirts of Zakho: a constant flow of lorries, some 250 a day, can be seen crossing the border between Turkey and the IKR. Bazaars and shops are crammed with foreign goods and the IKR is now importing lots of food that was grown locally till a few years ago. Kurdish rice is almost extinct – modern Kurds eat rice from Pakistan and Thailand, brought in via Turkey or Iran, and that's just one example. Next to nothing is being manufactured in Kurdistan, where a massive seventy percent of the working population is government-employed. Of the remainder, many are traders. Why? Iraq exports two million barrels of oil a day, and the Kurdish Government receives a share, much of which is spent on civil servants. The bottom line of the Kurdish economy: people have money to spend and they spend it largely on imports.

In 2005 the IKR received 3.5 billion US dollars from the central government in Baghdad, increasing to 6 billion in 2007, 17 percent of Iraq's budget since 17 percent of the population resides in the IKR. In addition to that, the IKR has received a lot of money from the Food for Oil Program. In 1995 the UN allowed Saddam to resume the sale of oil, which had been blocked since the invasion of Kuwait in 1990, in order to buy food and medicines for the population. As Saddam's government didn't give the breakaway Kurds their share of the revenues, the IKR has received considerable delayed payments after Saddam was dislodged from power.

Low-ranking civil servants earn five hundred to a thousand dollars a month. This is a lot more than in Saddam's days, when a hundred dollars a month was a good deal. Tens of thousands of immigrants arriving from the rest of Iraq into the much safer KRG Region brought a huge influx of capital with them, which also helped to boost consumption. And then there is the booming construction sector, attracting hundreds of millions of dollars a year, largely from foreign investors. So there you are: money is pouring in, the state is a big spender, a lot of people are getting rich quick by investing in real estate, and there's plenty to spend in the bazaars and shops. Such demand triggers huge imports, and at the same time the production sector is neglected. Many of the hundreds of lorries that enter the IKR every day contain building materials. On a wall in the office of the governor of Erbil, Nawzad Hadi Mawlood, a large map shows what Erbil will look like in 2020, according to ambitious plans for redesigning the layout of the capital. The map, and the story behind it, also show how much construction material will be needed to make it all happen. Kurds produce their own cement and concrete, and they have a good supply of marble. Where will all the rest come from? Mawlood: "The buildings of the parliament and the Council of Ministers will be rebuilt. So will the entire Salahuddin University, they already have the land for that along the road to Kirkuk. We will also create twenty thousand hectares of irrigated farmland near the city, the Shamamak project, and a lot of money will be needed for pumping, etc." And so the governor goes on. Even the industrial zones on the map will need a lot of imports for their implementation. But after that, they might of course help to lessen the IKR's dependency on those imports.

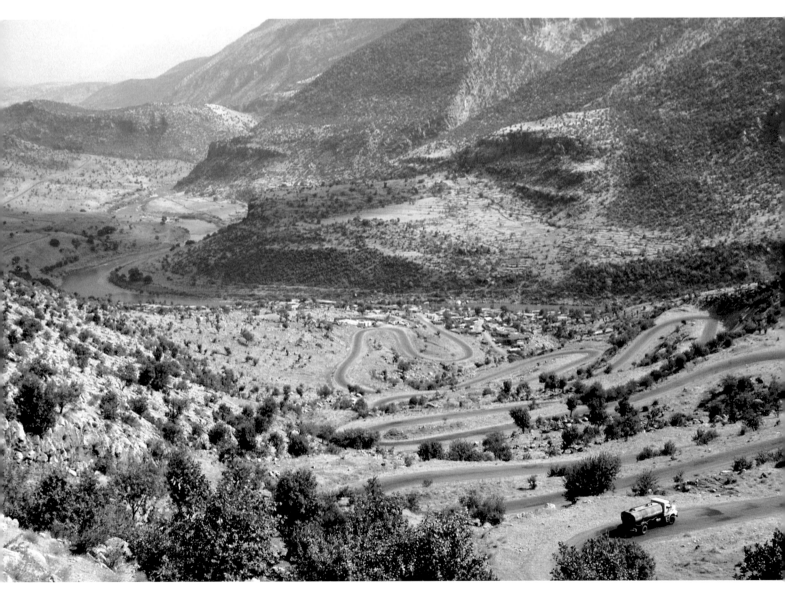

< Dara Jalil Al-Khayat, one of the most affluent men in Iraqi Kurdistan and president of the Kurdistan Chamber of Commerce and Industry. He is also vice-president of the Iraq Chamber of Commerce.

Yet another Turkish lorry making its way through the IKR. This is the entrance to the Barzan Valley when arriving there from Amadiya.

> Here is where all the Turkish lorries hit the IKR, on the western flanks of Zakho, a few kilometers after Faish Habur.

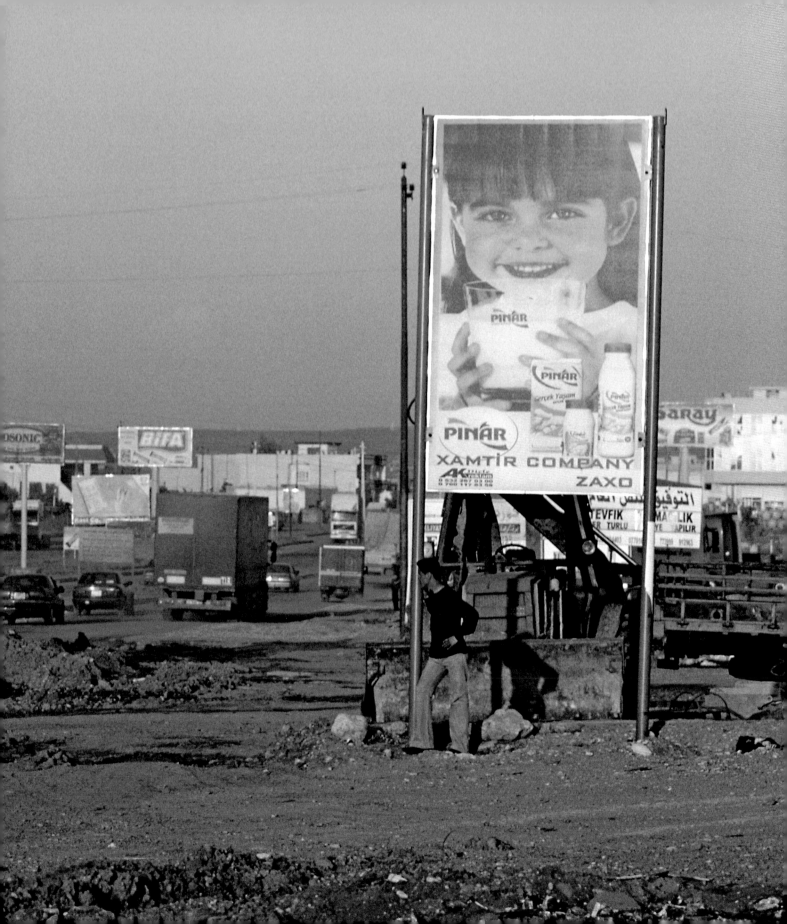

A lot of petrol, diesel and kerosene (for cooking and heating) is coming in from Turkey – unbelievable for a country like Iraq, which produces more than two percent of the world's oil. But there is a serious shortage of refineries, hence the imports. Here is a storage facility on the outskirts of Koya and some Turkish fuel trucks.

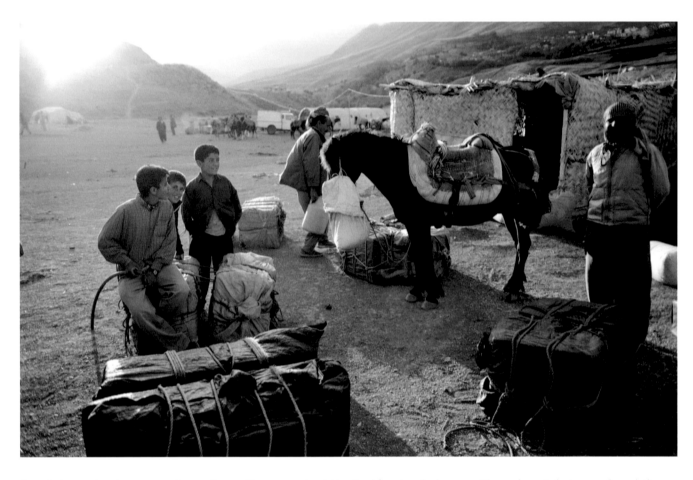

Part of what reaches the IKR gets taken out by smugglers. This is one of their logistical hubs, between the village of Hadj Omran and the Iranian border. Every day at sunset, dozens of horses leave here for Iran. If the smugglers run into Iranian border patrols, they just abandon their horses, who reportedly often find their own way back to the villages. In 1997 these men and these horses saw to it that Iran got a fair supply of videos of the movie Titanic – which many wanted to see but which was axed by the censors – for just one hundred dollars apiece. They also transport landmines – installed during the Iran-Iraq war, dug up by Kurdish boys who know (more or less) how to deactivate them – and sell them to the military in Iran.

The man on the right, a Kurd from Iran, had a raw singing voice like no other. For a while, the three boys had been encouraging him to sing something and at last he sang, with a voice so loud that it must have reached all border patrols: "Don't bury me here, because of the snow and the rain. Bury me in Sawlaq where the girls are beautiful." This picture was taken just as he had finished.

> The sun has set, the journey through the night has begun. Each horse is carrying two TV sets. These smugglers became famous in 2000 when Iranian actor Bahman Ghobadi made a film about them, his directorial debut which won a Best Film Award at the 2000 Cannes Film Festival. The title, A Time for Drunken Horses, refers to the habit of mixing the water for the horses with some rum, which is supposed to enhance their performance.

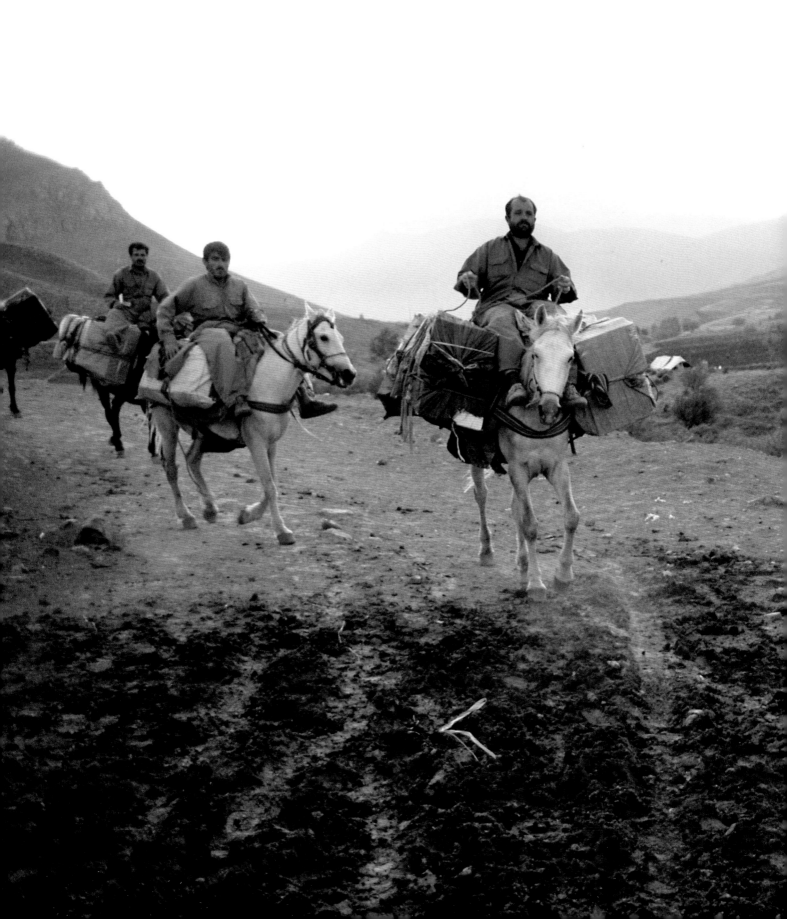

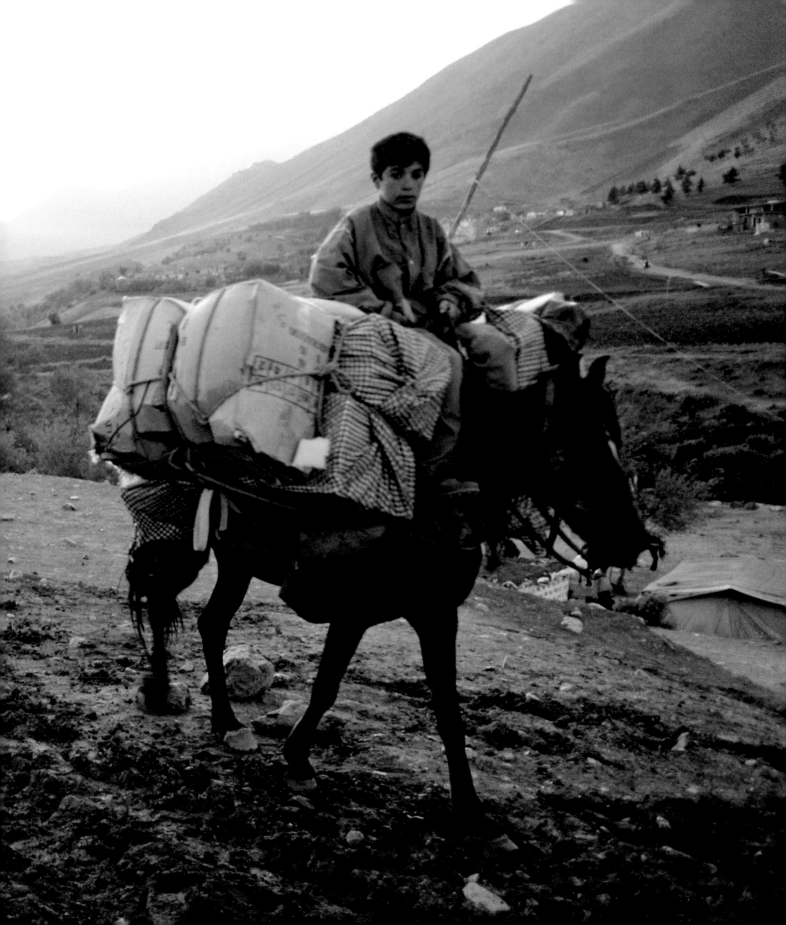

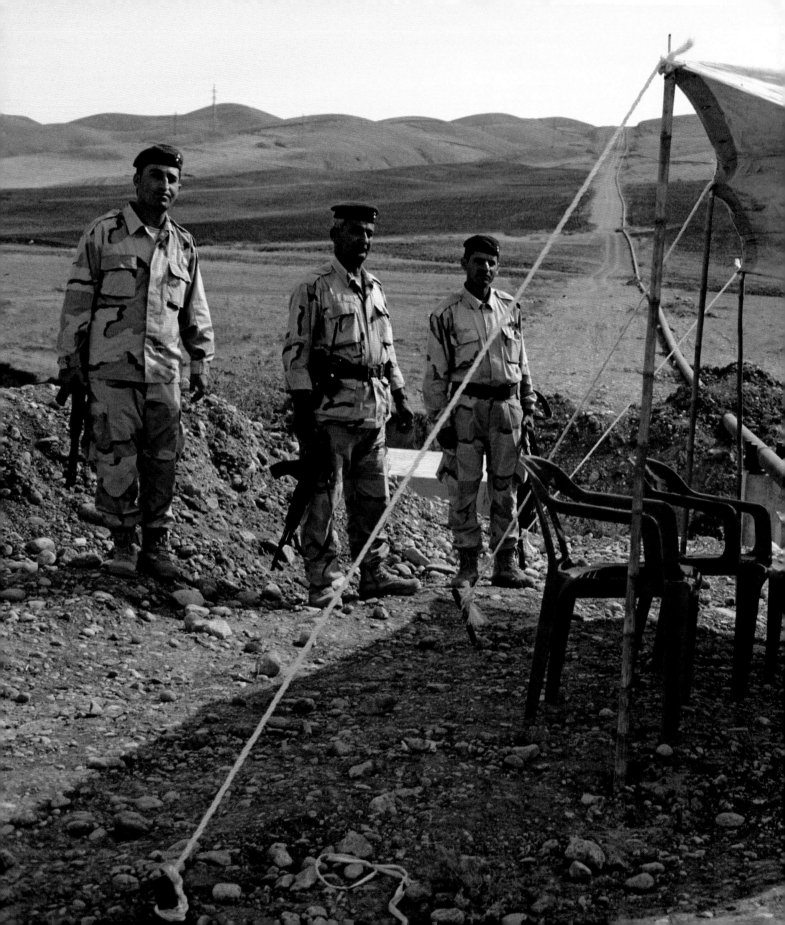

Producers The first oil company to start surveying and drilling in the IKR was Det Norske Oljeselskap, a well-established Norwegian oil company. Near the town of Zakho, in the far north-west of Iraqi Kurdistan, DNO found reserves of 100 million barrels – and more than that, they actually have a pipeline. At just 35 centimetres wide and just forty kilometers long it seems modest, but this is the first real Kurdish pipeline ever, although it was still empty when this book went to print. It runs from Zakho field to the trunk pipe from the old and large oilfields in Kirkuk to refineries and harbour facilities in Turkish Ceyhan, which transports 400,000 barrels a day. Visiting the DNO site seems impossible – many journalists have tried, no one ever got permission from the Norwegians. But the pipeline is under the control of units of the Kurdish army, the pesh mergas. After talking to their political chiefs in Zakho, I got permission to visit the pipeline and its guardians. The pesh mergas who must keep assailants at bay told me where to shoot and especially where not to.

Producers

Insufficient production may well be the IKR's greatest weakness. The current dependency on imports, and on money from Iraq's oil sales to pay for the imported goods, is in marked contrast to the wish to be independent, as a federal part of Iraq or even as a separate country. Furthermore, all those imports are hardly conducive to real self-confidence. Wouldn't it be marvellous if Kurds could ride bicycles or wear jeans marked with *Made in Kurdistan*?

In Ranya, Bakhtiar Salh, head of the municipality, told me that unemployment was one of the biggest problems in his town. But new jobs could be created if Ranya got some help to build a fish canning factory, he said. Fish is plentiful in nearby Lake Dokan. But what to do with the fish, apart from selling it locally, if you can't cool it right after fishermen bring it on shore and without facilities for refrigerated transport and packaging? A canning factory would encourage fishing, and it might serve the entire IKR.

The same applies to the fruit and vegetable canning factories which Kurdistan needs badly – although there is one in Harir – to encourage agricultural production, to create jobs, to stimulate villages and to make Kurdistan less dependent on imports. Right now, Iran's largest canning factory, Sahar Food, is bringing in truckloads of canned tomatoes, pears, etc. from many hundreds of kilometers away, not to mention similar factories in Turkey.

Better news is that the IKR is now producing a lot of bottled mineral water to satisfy its own demand. Cement too, is being made locally, if only because the raw material is easy to find, because it's so bulky and because demand is huge. The same applies to marble, which is also heavy, in high demand and found locally.

And then of course there is oil and gas, sectors which are about to boom, although there's a danger that the IKR will only export crude oil and leave the processing to the buyers.

Seated behind her broad desk, surrounded by pictures of Kurdish politicians, Kurdo Omer, mayor of Koya, unfolds a detailed map of the rugged surroundings of her town. To the south-west a rectangular area, 15 X 20 kilometers in size, has been marked: this is the oil concession of the Taq Taq Operating Company, TTOPCO, which has by now dug about half a dozen wells, each of which could produce 3,000 barrels of oil a day. Could – right now they don't, in the absence of a pipeline to get the oil from the Taq Taq field to a refinery or a harbour.

The Habur border crossing. In the right hand corner is the IKR's first oil pipeline.

Here, not far from Duhok, Jin mineral water is bottled at a rate of 10,000 half-litre bottles per hour. The water comes from the same source as the water used for rice farming, seen on the picture on page 120/121. The first bottle was produced on September 3, 2006. The bottles themselves are made in the factory, the raw material comes either from Turkey or Iran, as do the labels. Problems at the border can halt the entire factory. The director, left, used to be a guard of Mustafa Barzani. One of his eyes is missing, the result of a bullet that also traversed his nose. In his room in the factory he keeps two machine guns ready, in case the enemy gets too close – the Turks for instance, he said candidly.

Having oil in abundance and no means of moving it other than by lorry just shows how fast the Kurdish oil sector is developing. Work on a pipeline running from the Taq Taq field to the old 400,000 barrels-a-day pipeline between the Kirkuk oilfield (outside the KRG) and the port of Ceyhan in Turkey began around the time this book went to print. Mayor Omer is all optimism and expects a bright future for Koya and lots of investment in the slipstream of the oil flow. "The number of wells may rise to two hundred," she predicts – and she ought to know, as the TTOPCO people visit her office twice a week. "Lots of companies will invest in this area. And maybe there will be a refinery in Koya – that's still being discussed."

Mayors are paid for being optimistic, but in the case of Koya the cheer seems justified. There are gas fields as well, currently being explored by a British company. The rapidly expanding University of Koya is the only one in Iraqi Kurdistan where you can study oil engineering. Courses started in 2004. There are thirty new students each year and from 2008 onwards, about as many graduates. They will be needed because oil is abundant in many places in the IKR. Estimates range from 12 to 45 billion barrels and the KRG hopes openly for a production level of 100 million barrels per year, about 0.3 percent of the world's 2008 oil consumption. "There could be oil right under this building!", says professor Nazim Salih, dean of the College of Information Technology, which includes the geotechnology and oil department. All buildings are new here – the whole university was founded in 2002 by Kurdish politician Jalal Talabani, now the president of Iraq.

At the TTOPCO site, there wasn't even time to build: the employees are working and living in prefab houses and containers. Before we get there, our car bumps over twenty kilometers of dust road through unattractive, hilly moonscapes where just a handful of locals try to carve out a meagre living by breeding sheep. The TTOPCO site can't be missed: surrounded by high fences, watchtowers and lots of barbed wire, it resembles a prison. Men are wearing sunglasses and carrying weapons. Piles of segments of pipes litter the area. Microwave towers are trained on distant horizons. Light masts everywhere. Oil storage facilities. Dust is all over the place and blowing between the shambolic settlement of containers, each filled with small offices and men working around the clock seven days a week surrounded by large maps on the walls. No photography – of course not.

Safety is paramount – here, and in the IKR at large. Hundreds of checkpoints across the federal state are part and parcel of one of its key assets: the absence of terrorism. In the IKR, unlike most of the rest of Iraq, companies can survey potential oilfields,

A carpet factory in Merga Sur, 2002. It takes these machines a day or two to make one of these large carpets like the blue ones. The machines had been bought second-hand in Iran. In the foreground, a skull and some similar imagery including a stop sign feature on doormats to remind visitors of the house of the danger of mines.

drill wells, construct pipelines and move around without serious risk of terrorist attacks. Even so, some forty percent of all expenses of oil companies are for safety, I was told in 2005 by Micael Gulbenkian, who was then chief of Heritage Oil, the first oil company in Iraq, built almost a century ago. Currently, Heritage is drilling wells at the Miran field in the IKR. A mix of safety and lots of natural resources has attracted twenty foreign oil and gas companies and consortiums. They all signed deals with the Iraqi Kurdish government, got one or more concession areas, and are now in various stages of prospecting and drilling. TTOPCO – 55 percent Turkish (Genel Enerji) and 45 percent Canadian (Addax Petroleum) – is just one of the parties keen to join the bonanza. What sets TTOPCO and the Norwegian company DNO, active near Zakho, apart from other oil companies is that they signed contracts with the KRG before a serious and ongoing conflict erupted between the KRG and the government in Baghdad in 2007. To what extent is the KRG licensed, if at all, to clinch lucrative deals with foreign oil companies without the nod from the central government? Amidst an abundance of untapped oil and strong rhetoric from both sides, a solution was not in view at the beginning of 2009 when this book went to print, despite a special committee including KRG president Masoud Barzani and Iraq's prime minister Nuri Al Maliki. But in November 2008, TTOPCO and DNO, both with wells ready to go, got permission from Baghdad to tie their pipelines into the main artery from Kirkuk to Ceyhan. DNO had already had their pipe in place for a couple of years, TTOPCO could start building theirs.

Gas is even more abundant. "And it's very sweet," guarantees Mazar Zorab, senior secretary at the office of Dana Gas in Suleyma-

nia, Iraqi Kurdistan's second town. "Sweet" means with hardly any sulphur, and therefore almost ready to heat houses, kitchen gears and power plants. Zorab: "Most natural gas is polluted and needs costly cleaning processes. Here in Kurdistan the gas fields have never been exploited and the gas is of superior quality." The reason is simple: Baghdad governments never wanted the ever rebellious Kurds to have their own gas resources, and now the Kurds are benefiting from that policy. The same applies to oil. The abundant fields in the IKR are in a virgin state. In many cases, no pumping is required as natural pressure brings the oil to the surface as soon as a field is tapped.

Arab Emirates-based Dana Gas, the Middle East's largest regional private-sector natural gas company, and Crescent Petroleum signed a deal with the KRG in 2007. Their total investment will be around 400 million US dollars, including a 180-kilometer gas pipeline. The consortium began delivering Kurdish gas in 2008, with an estimated output of eight million cubic metres by 2009. While most of the IKR's oil is destined for export – with some tricky details concerning revenue sharing between Baghdad and Erbil still to be hammered out – most of the gas will be used in Kurdistan. "Ha! My mom and I are still cooking on liquid petroleum gas brought in from elsewhere," says Zorab. "So bottling our own liquid petroleum gas for cooking and heating is a priority." Then there are the big power plants in Suleymania and Erbil, currently both running on imported oil. Furthermore, Dana Gas is planning Gas City, a conglomerate of activities that will require lots of energy: certain industries, a power plant, five-star hotels and luxurious housing projects.

Lolan Sipan, director and founder (in 2004) of the superb Kurdish Textile Museum, located on top of the citadel of Erbil, in the former house of a rich merchant. In 2007 the museum attracted 48,000 visitors. However, at the time this book went to print, ominous plans had been drawn up to relocate the museum as part of the restructuring project of the entire citadel. Arguably, the citadel is the best possible place for the Kurdish Textile Museum because the citadel attracts tourists, and because both citadel and museum deal with the past.

Weaving carpets, kelims and felts used to be an essential part of Kurdish culture, not just in Iraqi Kurdistan. The colours of the carpets, with lots of deep, dark red, were typically Kurdish, as were the geometrical patterns and symbols. While the women did the weaving, the men herded the sheep that provided the wool and helped collect the herbs to make the dyes – and everyone needed the carpets to sit on, be it in nomadic tents or in village dwellings. In times of need, carpets provided a source of cash.

Cheap factory-made carpets have been largely responsible for the demise of the art of carpet weaving. That applies across the whole of Kurdistan. Additionally, in Iraqi Kurdistan the Anfal in 1987-'89 led to the destruction of all the villages there. "Nowadays no traditional hand-made carpets are being produced in Iraqi Kurdistan," says Sipan. "The art is all but lost." The Ministry of Culture has some projects, in Erbil, Koya and Rawanduz, designed to get younger women to learn how to make carpets again. But the material comes mostly from Iran and the carpets show non-traditional themes like lady's faces or the Erbil citadel. Lolan Sipan is committed to reviving the art of weaving traditional Kurdish carpets. He thought up an ambitious project: find women who still remember how to weave carpets, bring them over to the Kurdish Textile Museum, provide them with looms (old or newly-made), give them locally produced, naturally dyed wool and let them teach young girls. Sipan: "So in 2007 I sent out proposals to some international NGOs

and to the UN. One of the recipients, the American Regional Reconstruction Team, linked to the US Embassy in Iraq, was interested in financing the project."

In the autumn of 2008, production started and all parties involved were winners. Sipan: "The younger girls loved it and the sixteen elderly women involved, some in their seventies, enjoyed teaching and to be weaving again. They had never done this in front of people other than their family – and now here were visitors of the museum watching them." Sipan also found some elderly men willing to join the project. They made new looms, traditional furniture and felts, which has always been men's work. The carpets, felts and furniture are now being sold in the museum shop.

In 2009 and after, the museum will host several more 'weave and teach' sessions, each lasting some weeks. The sale of carpets and other products should make the project self-sustaining. Sipan hopes that more stability in the region will encourage tourism. And tourists, willing to buy real Kurdish hand-made carpets, may become instrumental in really bringing back the art of weaving to the villages. Sipan: "Financial incentives will help to revive the art. But in addition to financial reasons, I think it is very important for Kurdistan to preserve its own culture and identity, instead of endlessly copying from the West."

For more information, see: www.kurdishtextilemuseum.com

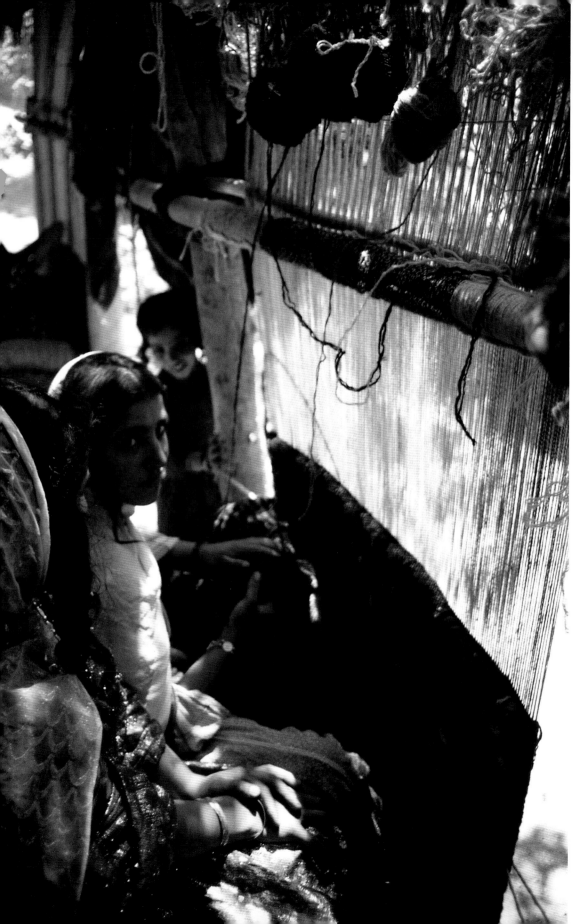

Apart from agricultural output, Kurdistan – not just Iraqi Kurdistan – has been famous through the centuries for its carpets. What can be seen here is weaving as it used to be, in 1973 in Nawperdan. The dark red colour is typically Kurdish, so are the geometrical patterns. Working the way these women do, without any pattern on paper to copy from, they are able to create perfect symmetry along the vertical axis but not along the horizontal one. Most regrettably, images like this one can no longer be taken, the art has almost disappeared. The destruction of almost all villages – including the sheep for the wool and the plants for making the dyes – by Saddam's government is partly responsible. Of course, handmade carpets, some of them very old, could still be found in tens of thousands of Kurdish households when the art of making them started being lost. In 1992 and after, when everybody was short of every-thing, a wave of traders from Turkey went from village to village and bought up all the carpets they could lay their hands on, took them to Turkey and sold them. To see real Kurdish carpets in Southern Kurdistan, you have to go to really affluent families or to the excellent Kurdish Textile Museum on top of Erbil's citadel.

Making carpets in Ble, Barzan, in 2002. In this workshop several carpets were being made at the same time. The women worked six days a week from 9 till 5. They were all widows or children of men killed by the enemy, including the 8,000 Barzanis rounded up and executed by Saddam's men in 1983. Normally the women don't wear headscarves when at work, but all that changes when a foreigner with a camera gets close.

Here a printed scheme is being used, and the resulting carpet, measuring 3 x 4 metres, will be symmetrical along both axes. Production of this carpet will take these five women six months. The painted wool is imported from Iran.

There is plenty of oil in Kurdistan, but no refineries. There are refineries in Iraq outside the IKR. So the idea is: why not build refineries here? Right now there are about two dozen small refineries, like this one near Koya that processes oil from the DNO field near Zakho, brought here by lorry. The men who run the refinery are Turkish Kurds. Their diesel is quite good, kerosene not so good, and the petrol won't keep an engine running unless mixed with ninety percent of quality petrol.

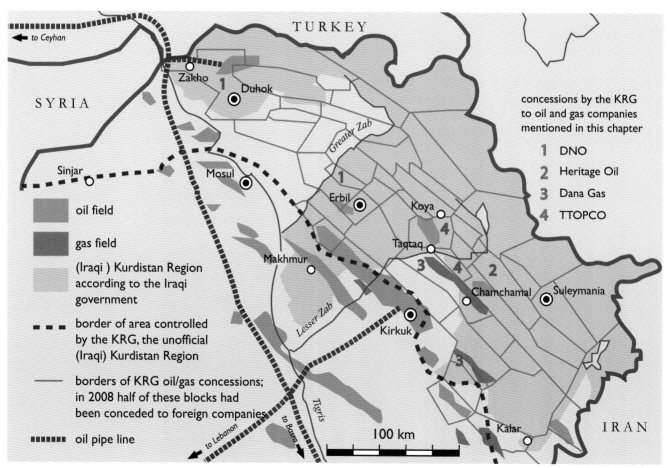

concessions by the KRG to oil and gas companies mentioned in this chapter

1 DNO

2 Heritage Oil

3 Dana Gas

4 TTOPCO

oil field

gas field

(Iraqi) Kurdistan Region according to the Iraqi government

- - - border of area controlled by the KRG, the unofficial (Iraqi) Kurdistan Region

—— borders of KRG oil/gas concessions; in 2008 half of these blocks had been conceded to foreign companies

▪▪▪▪▪▪▪ oil pipe line

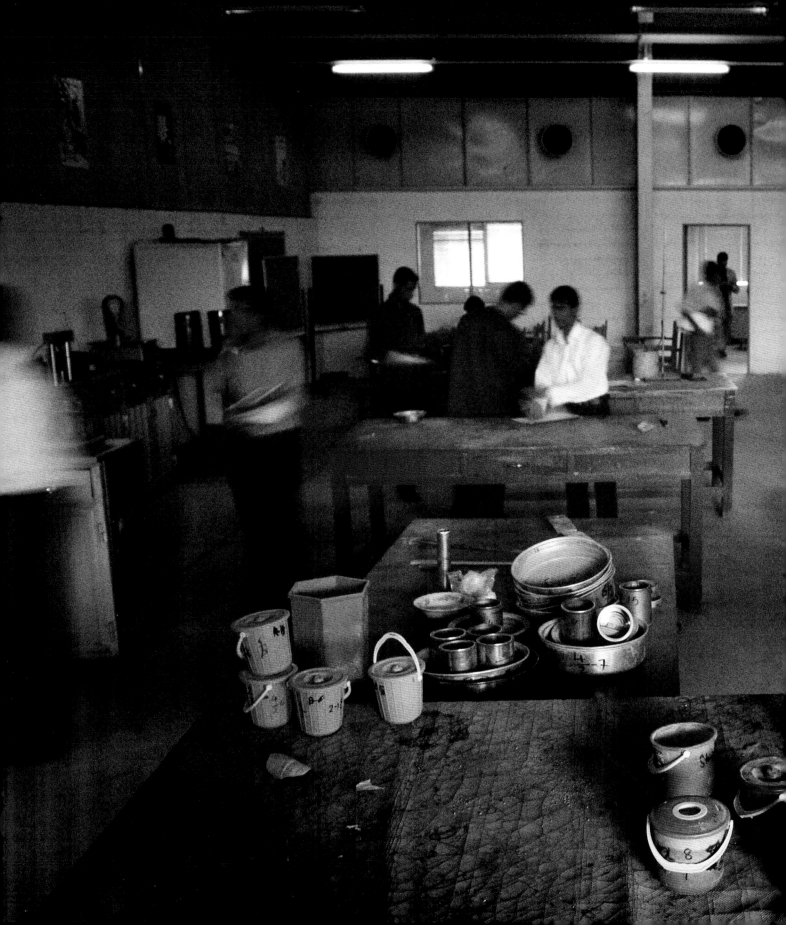

Students The department of
Civil Engineering at Salahuddin
University (see also next page).

Students

The IKR has some flourishing universities and tens of thousands of students. The Salahuddin University in Erbil and the University of Suleymania were established in 1968. Duhok followed in 1992, right after the de facto independence, and in 2003 came the University of Koya. In 2006 a second university in Erbil began giving courses, the University of Hawler, where all teaching is done in English. That will also be the case at the new American University of Iraq, which isn't being built in Iraq's capital, with all its abductions and killings, but on the outskirts of Suleymania. Education, including housing, is free. There are no scholarships, and students don't have to take on jobs to foot their bills.

> Students at the rapidly growing campus of the new university of Koya, founded by PUK chairman Jalal Talabani in 2003.

Oil engineering students at Koya university.

The Suleymania public library during a book fair. Books may not be as common in Kurdistan as in the West, on the whole the sector is doing well. According to writer Ferhad Pirbal (see page 209) it has become quite normal for a book to sell 2,500 copies, under a population of four million that is. Pirbal: "In Iran two thousand copies is often the limit and then we are talking about well known, important writers." An example of successful Kurdish literature, according to Pirbal, is The City of the White Musicians (2006) by Bakhtiar Ali: a novel about society in both Kurdistan and Denmark – where the author has been living – reflecting influences of Albert Camus, Guy de Maupassant and the Iranian writer Sadegh Hadayet. The book sold 7,000 copies. Encouraging too, says Pirbal, is the growing number of women writing poetry and literature, especially since 1991 and the beginnings of autonomy. Pirbal: "Marian Halabji wrote a book about sex, islam and women – six impressions, ten thousand copies! That really makes me happy." What the Iraqi Kurds lack is a well-developed and independent publishing sector. Most books are published by the Ministry of Media. In addition, some affluent individuals finance specific book projects, and there are also some foreign publishers active in this area.

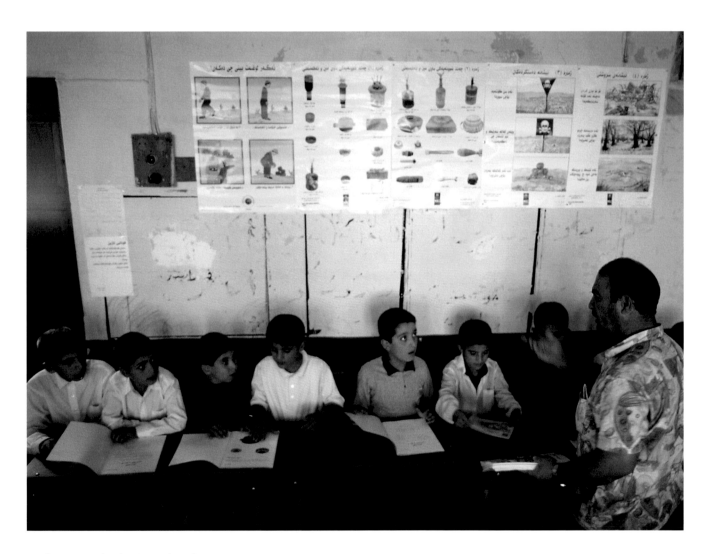

An elementary school in Rawanduz, where
lessons about recognizing mines and how
to avoid injury feature prominently on
the curriculum.

Mr Abdul Salam Barzani teaching English to some of the 170 boys at the oldest primary school in Rawanduz, founded in 1923. Learning Arabic, Iraq's first language, is not compulsory and the vast majority of pupils and students in the IKR prefer to skip it, focussing on English instead. Three out of four pupils at this school will go on to secondary school. All education in the IKR is free.

Communicators A newsstand
in Erbil selling dozens of dailies
and weeklies.

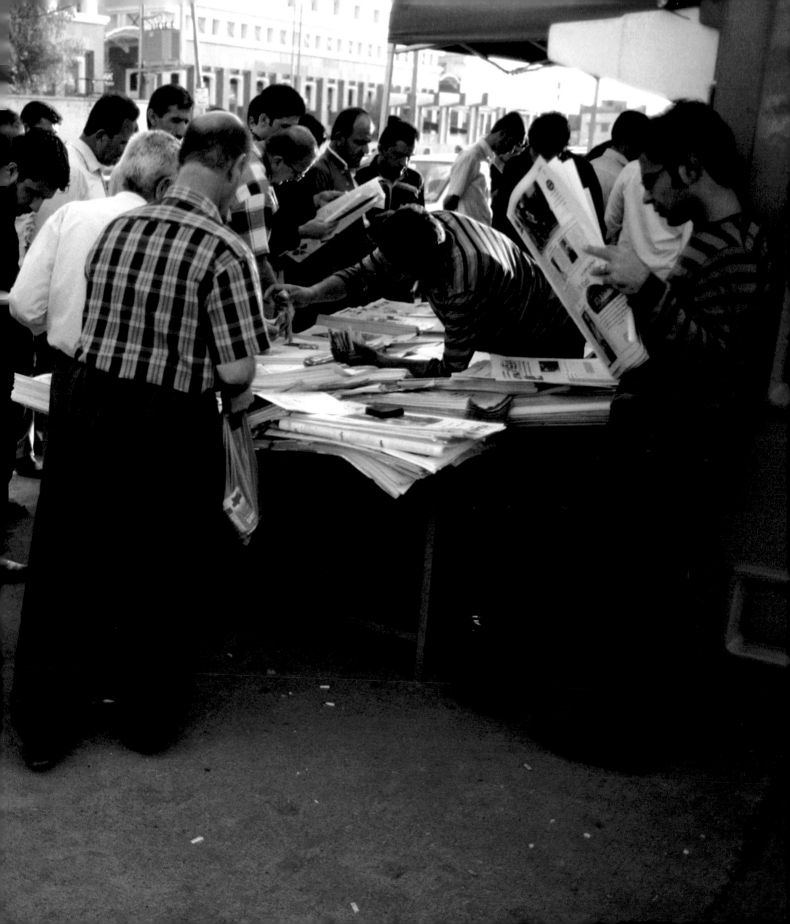

Communicators

During the terror campaigns of Saddam and his predecessors, the Kurds and the minorities in Northern Iraq came to realize the importance of telecommunications, with the outside world and between themselves. The Anfal went largely unnoticed in the rest of the world because the Kurds lacked the means to broadcast messages. The gas attack on Halabja, on the other hand, got worldwide attention because two days after it happened the horrendous images were flashing around the globe and were hitting front pages everywhere. In addition to this, the booming economy calls for a robust and dense telecommunications network.

To achieve these goals, a lot of energy was spent by the KRG and even more so by private companies. The world's oldest international organisation, the Geneva-based International Telecommunication Union, also helped by financing projects and providing technical support in the 1990s. The result is definitely dense, but not very robust. The problem is the absence of strong backbones. There are no cables or strings of microwave transmitters between Southern Kurdistan and the outside world, except the rest of Iraq, where they cross vast stretches of empty land where terrorists roam freely. Digging up and cutting cables is easy, and so is blowing up microwave towers. On February 8, 2008 eight mobile telephony towers were set ablaze in Mosul – and that was in an urban landscape. With an eye to the future: it's not a very attractive idea to have telecom trunk lines (cables in the ground, cables in the air following the electricity grid, or microwave transmitters) running through Iraq if the

IKR ever breaks away from the rest of Iraq amidst lots of animosity. The same applies to telecom lines running though Turkey or Iran, or maybe even Syria. For years, Turkey has done all it could to prevent air traffic between the IKR and the rest of the world; and they wouldn't be keen on allowing ten gigabits-per-second fibre optic cable from Kurdistan via Turkey to, for instance, SEA-ME-WE (the submarine fibre optic trunk line linking South-East Asia, the Middle East and Western Europe) that runs through the Mediterranean Sea. But the Kurds aren't very interested either as Turkey could cut such a lifeline in times of crisis, just as they threatened to cut the Faish Habur border crossing in the autumn of 2007. Similar problems apply to Iran. In fact, Syria might be the best and safest route for the much-needed fibre optic connection between the IKR and the Mediterranean.
The answer to all this was, and continues to be, heavy reliance on telecommunication satellites, and it's a mixed blessing. "Huge dependency on satellites and lack of trunk cables is the big problem of the IKR's telecommunications," says Hamad Saeed of Korek Telecom, one of the major mobile phone operators in the IKR.

The telecom network inside the IKR has three main components: cellular networks, TV networks, and the old cable networks from the Saddam era and before, mainly in the towns. All three rely on satellites. There are telephone cable networks in towns, but a lot of communication between Kurdish towns goes via satellite – and quite often it's double hop, a technicality that needs some attention. The bottom line is that there are two satellites at work, which is

expensive and inconvenient. For instance: from Suleymania to satellite A which sends the signal down to a satellite ground station in the West. From there the signal goes up again, to satellite B, which can be received in Erbil. As telecommunication satellites are very high up (35,786.4 kilometers above the equator) the signal suffers a time delay of one quarter of a second, and half a second if there are two satellites in between. In terms of a dialogue, that adds up to a one-second delay: hugely annoying when trying to conduct a telephone conversation. It also means a one-second delay between a mouse click and getting a response. The satellite delay, whether single hop or double hop, is also responsible for slow downloading from the net (for the reason, see: www.isoc.org/oti/articles/0997/hegener.html).

Cables are the answer, but the fixed line network is hardly expanding anymore because mobile is doing so well and bringing in so much profit. In the rest of Iraq, the Iraqi Telecommunication and Post Company is still the sole fixed line operator; after huge amounts of financial and technical support, especially from US AID, the network was considered up and running again in 2006 with 70 percent of all Iraqi households enjoying a fixed connection. But in Iraqi Kurdistan the fixed network was sold in 2006 to a private company, Newroztel, while the government kept a 30 or 45 percent share. Newroztel lacked the means to install many new lines. New subscribers now get fixed wireless.

As far as voice communications are concerned, the lack of backbones is not a big

problem. Mobile phones are cheap, and the networks are really dense. But mobile is no good for fast and cheap internet. For that you need ADSL, which requires a high-quality fixed telephone line – or a TV cable network (which is totally absent, courtesy of satellite TV).

Sounds technical and therefore maybe irrelevant? Sit down in any of the internet cafés, check out any website, and the problem becomes clear, with pictures descending on the screen with a sluggishness that is part of history now in more developed countries.

The best solution for the end user is an internet provider with a really fast (and therefore expensive) single hop satellite link to the cable backbones in the West, and dissemination of the signal by fixed wireless connections. This means that the ISP has a big pole with a set of antennae reaching an entire neighbourhood, and each customer has a small dish antenna on their roof trained on the ISP's central antenna. It works, and it's for sale here and there. TarinNet, one of the providers using this technology, offers a 96 kilobit/second link for 30 US dollars a month – far too expensive for any ordinary citizen, and far too slow for most.

A far better solution, but so costly that only well-to-do companies and foreign agencies, luxury hotels, bigger NGOs etc. can afford it: a dedicated satellite link. A dish on the roof or balcony provides a direct connection to a satellite which is connected to the internet via a ground station in the West. Usually the downlink is lot faster than the uplink. The more you pay, the better your speed. Several companies that sell and install these systems are based in Ainkawa,

the Christian suburb of Erbil, where many of their customers – typically oil companies – can be found. Many foreign businesses, especially Western ones, have their headquarters in Ainkawa.

Despite the absence of fixed backbones, the cellular networks still need satellite backhaul for communications outside Iraq. So, at the hub of AsiaCell, Korek or MTS Asia, the three largest providers, there are satellite dishes to get the signals to Western Europe, in some cases a Middle Eastern ground station, to link to the wired world.

For Kurdish TV, satellite is all. There simply aren't any alternatives like cable networks. But then, for TV, satellite is the solution of choice anyway because of the Kurdish diaspora. From well-guarded dishes inside the IKR (which I was not allowed to see) the TV signal goes to, for instance, the Eutelsat W2 satellite (positioned 35,786.4 km above the Congo river) which sees all of Europe and most of the Middle East. Forget the technicalities, the point is that every Kurd within that huge area can watch Kurdistan TV, the station of the KDP, which is actually using the W2. KurdSat of the PUK uses another satellite, another Eutelsat satellite that is (the Hotbird 3). In addition, they broadcast via five other satellites as well in order to reach Australia, the US, and Northern Africa.

The printed media are doing just as well as Kurdish TV – just a bit less high tech, not as capital-intensive as TV, and therefore an easier-to-reach platform for self-styled journalists and others who want to raise their voices. Right now there are more than fifty newspapers, available to all readers

Kurdish stamps are only used for mail within the IKR. Letters to or from the rest of the world? The manager of the Batufa Post Office had to make a number of calls to superiors, this was a difficult question. In the end he produced the address of a mailbox in Silopi, in Turkey, right near the border, which the Kurdish PTT uses for incoming mail. The number of incoming letters at the Batufa Post Office? "About one per month." Outgoing international letters need a Turkish stamp, available at the Batufa Post Office. Staff will make sure the letter gets to the Zakho post office, which will send outgoing mail to Turkey and beyond.

who can get to a distribution point, i.e. a town centre.

While pluralism abounds, the papers suffer from a lack of journalistic quality. Hearing the other side of a story, double-checking facts, and keeping comments and factual reporting separate from each other are still part of a slow learning process. Press freedom doesn't mean you can write everything you wish, it has to be factually correct as well as balanced. Right now, writing candidly about the wrongdoings of A or the corrupt ways of B is too often seen as a mark of good reporting. Among A, B and others there is of course a tendency to blame the new freedom of the media. Far worse is the recent trend to exact bloody revenge on authors of critical pieces. Here are some excerpts from a letter dated

Manager of the Batufa Post Office in front of his workplace and under a microwave transmitter for the telephony network. The sign says Batofa, rubber stamps indoors say Batifa. For 40 USD a month the local KDP office rents a permanently open line for their internet connection. The KDP office and not the Post Office is the place to go for offline Batufians wanting to send or to receive email. When they want to make a phone call, the Post Office staff is ready to make it happen, courtesy of the microwave transmitter. "But most people have their own mobile phone," the manager explains.

August 4, 2008 to president Barzani from Reporters Without Borders:

"The Committee to Protect Journalists is deeply concerned about the wave of threats against journalists in northern Iraq in the last few weeks. CPJ has documented an alarming number of cases recently, ranging from the murder of a journalist to an attack on another by a mob to at least three death threats directed at journalists in less than a month. The Kurdistan Journalists Syndicate, which has begun issuing periodic reports on threats against the press, noted that in the first six months of 2008 there were around 60 cases of killings, attacks, threats, and lawsuits against journalists in the region. In addition, at least one journalist has disappeared since March 2008, they said.
CPJ conducted a two-week fact-finding mission to Erbil and Suleymania in October and November 2007 and found that the increasing assertiveness of the independent press has triggered a spike in repression over the last three years.
[...] On July 30, Amanj Khalil, 28, a journalist with Rudaw, an Erbil-based newspaper, escaped an assassination attempt near his home, he told CPJ. On July 28, Khalil had received an anonymous phone call warning him to 'either to write an apology' for an article he had written on July 28 about the emergence of Ansar al-Islam, or he will 'face serious consequences,' he told CPJ. [...] On July 25, Soran Omar, 30, a contributor to Livin magazine and editor-in-chief of the Web site Kurdistan News Daily, received around a dozen phone calls from four different numbers threatening him to quit working for Livin or he 'will face the same fate as Soran Mama Hama,' Omar told CPJ. On July 14, soon after an issue of Livin hit the newsstand, editor-in-chief Ahmed Mira received a phone call from an unknown person threatening, 'You will pay the price

for what you are publishing,' Mira told CPJ. The magazine had published a story about one of the main Kurdish parties in that issue, he said. He said he has also received several messages calling him a traitor or a spy. Mira told CPJ that since 2006 Livin has received at least one threat after publishing each issue of its magazine.
Not one suspect has been prosecuted for killing or harassing these journalists, according to our research."

On 25 October, 2005 a Kurd living in Austria, Kamal Sayid Qadir, was arrested inside the IKR by the Parastin, the security service of the KDP, headed by Masoud's son Masrour Barzani. Two months later, Qadir was sentenced to thirty years in prison for having libelled the president. According to various sources, Masoud Barzani had had no hand in this. Like many others, Barzani was outraged, according to the same sources, but he could not reverse the decision of the court. Parliament had to issue a special law for that. The judge had based his verdict on an obsolete law dating from Saddam's time, when open criticism of the head of state was a very serious offence. The case backfired, resulting in Barzani and the IKR gaining more negative publicity than Qadir could have caused on his own. Amnesty International spoke out, the US State Department expressed concern, many foreign media reported the case. Reporters Without Borders wrote to Barzani: "This incident bodes ill for freedom of expression in Iraq's Kurdish region. We condemn the use of prison sentences to punish press offences and we are especially shocked by the length of this sentence, even if Qadir really did libel you. We therefore hope you will intervene to obtain his release and thereby show you intend to establish a fair judicial system in your region that complies with international standards."

And so, Qadir's case was reviewed, he got an eighteen-month sentence instead, and was released after just three months behind bars. At any rate, the problem at large hadn't gone away. From an editorial by the Assyrian International News Agency on 16 January 2008: "Although there are two independent newspapers in Iraqi Kurdistan – Awene and Hawlati – they are increasingly constrained. Both parties [KDP and PUK, mh] use their control over law courts to intimidate, bankrupt, and even imprison journalists who criticize ruling parties and officials. The PUK, for example, prosecuted Hawlati editors after the paper [on 12 October 2005] accused the PUK prime minister [Omer Fathah] of abuse of power. Necirwan Barzani's office has even threatened frivolous lawsuits against foreign writers and analysts who fail to adhere to his party's line." Many newspapers are being funded by political parties. While pretending to be impartial, they are airing the ideas of their sponsors. A case in point might be The Kurdish Globe, a weekly written in perfect English (text editors in the US see to that), circulation one thousand copies, retail price 0.40 USD, and freely available on the internet. I'd recommend The Kurdish Globe to any reader of this book who likes being kept posted on Iraqi Kurdistan, and also kurdistanobserver.com. But how independent is The Kurdish Globe? All the funding comes from the KDP and the paper, focused on informing non-Kurds about the situation in the IKR, was conceived by former KDP Media Center chief Jawad Qadir.

In the paper's office on the dusty outskirts of Erbil, assistant editor Ako Muhammad says: "We are eighty percent independent from the KDP. They sometimes have some comment on an article afterwards, that is all." Maybe self-censorship fills that void... At any rate, Muhammad thinks that lack of journalistic craftsmanship is a far bigger problem than any control by the KDP.

"Journalists here don't know about the principles of journalism. I call it: Kurdish journalism. We at The Globe are the only ones who know just a little bit about journalistic principles." Visiting foreign journalists – from France, from the Puerto Rico-based WIPR TV station, Dutch journalist Judit Neurink – taught some journalists, including the staff of The Globe, to some extent. The universities of Erbil and Suleymania now offer journalism as a discipline, but Muhammed complains the teachers lack real experience, "it is very theoretical." "It is good to have criticism," Muhammad asserts, "but not extremist. A good journalist finds a balance. But many papers here are biased against the government, they aren't neutral, they always focus on what goes wrong." And about the Kamal Sayid Qadir case: "The government was unhappy that he was arrested. But the government also wants to make sure no one corrupts our experiment till we have achieved what we want."

In the meantime there is a lot of corruption going on in the IKR, one of the vices scrutinized by Kamal Sayid Kadir. Ako Muhammad confirms it, Siamand Banaa does too, and according to Muhammad "no one denies it and even the prime minister and the president have spoken out against corruption. But no one knows the solution." For sure, incisive, well-documented reporting might help.

In 2006 Judit Neurink gave a two-week seminar for Kurdish journalists. Later on, during a lecture about her Kurdish experience, she mentioned the disproportionate amount of attention Kurdish media pay to authorities. What president Masoud Barzani did yesterday, what prime minister Necirwan Barzani said at the opening of this or that – it all gets huge amounts of uncritical coverage. Neurink: "There is no freedom of the press. Democracy is an

illusion in Kurdistan." She further reported: "Kurdish journalists need permission all the time from the Asayish, the secret service." Add to that the human rights record of the Asayish, and the sorry state of journalism in Kurdistan becomes a bit more comprehensible. Check out an online report by Human Rights Watch, Caught in the Whirlwind: Torture and Denial of Due Process by the Kurdistan Security Forces (2007), about the treatment of some of the 158 prisoners of the Asayish who were interviewed by Human Rights Watch.

In 2008 Judit Neurink began teaching journalism at the Independent Media Centre in Kurdistan, in Suleymania, founded in April 2008 by Press Now and the Dutch foundation Democratie en Media. Most students are already working as journalists. The root problem of Kurdish journalism, according to Neurink, is mutual distrust between reporters and their subjects, most of them politicians of course. "They see each other as enemies. As a result, journalists aren't getting their reports right and the politicians sometimes threaten the journalists. There is hardly any real censorship, party outlets excluded of course. But there is self-censorship and, from the other side, revenge and threats. I cannot say that either the KDP or the PUK is dealing with press freedom better than the other party." Improving the poor quality of the Kurdish media is key to giving democracy in the IKR a fair chance, Neurink says. "If no assistance is given to journalists, democracy in Kurdistan, and Iraq generally, will fail. That is why I felt I had to go to Suleymania. Hearing the other side of a story is a new concept here. Newspapers are being written by amateurs who hardly have a clue what they are doing. They boast that they are practising 'Kurdish journalism', which means fabricated stories, lies, unchecked facts and using just one source."

Here I have something to add from my own experience, after conducting between eight and ten months of journalistic activity in Southern Kurdistan. Rarely did any secret or other service or any authority seriously hamper my activities. My "hit and interview" approach may have helped: whenever possible I just go to a place, a house, an office, I say who I am and what I want, show a letter of introduction or two, and often I get an interview. Sometimes, but not often, doors were kept closed because I needed permission first, for instance to visit military barracks. In 2008 I wanted to visit the Harir Food Processing Plant, and do some interviews there, and wasn't allowed in, I needed permission first from someone important who happened to be unavailable. For reasons I never got to know, I did not get permission to visit any archaeological excavation. In November 2007 I was halted by the Asaiysh when I wanted to visit PKK camps in the Kandil mountains, but at that point in time no journalists were getting through, due to pressure on the KRG by the Turks and the US. On two occasions I did work with an interpreter who was on the KRG's payroll and I never heard him say: No, you can't go there, you are not allowed to do this. They never even suggested: Let's go here or there. The articles I wrote when back home were at times quite critical, for instance about torturing and corruption. I heard some grumbling at times but never any official rebuke, and I was always welcome when I returned to the area. But of course, Kurdish authorities hardly have any leverage over me, and that may have been helpful without me properly realizing it.

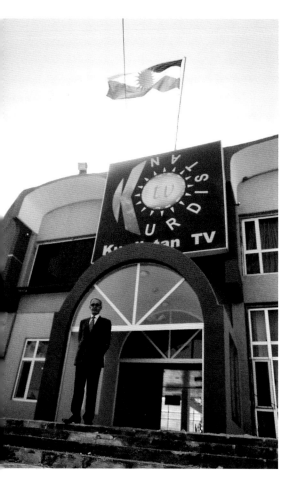

Chairman Mr. Karwan Akrawi of Kurdistan TV in front of the station's GHQ in Salahuddin.

Moments before going on air, a newsreader at the Kurdistan TV studio in Salahuddin checks her text. People on two-thirds of the globe will be able to see and hear her, provided they have a dish trained on a satellite carrying Kurdistan TV.

Ferhad Pirbal, writer, poet, philosopher, teacher of aesthetics at Salahuddin University and one of Kurdistan's best-known commentators, looks at the effigies of bearded men, covered in gold paint, on the wall next to where we are having a conversation. "They are famous Kurdish poets. But I don't like these images, they look too Islamic with these turbans and beards." That was just for starters, followed by far more profound criticism on the society he lives in, and which he loves even more profoundly. "In 1986 I fled my country. For years I lived in Paris, I studied literature at the Sorbonne. But in 1994 I decided to come back, in order to criticise, in order to change society. I am just doing my duty." He currently has a column in the magazine Aso (Horizons) and for years he wrote commentaries in The Kurdistan Globe. When he lectures, he addresses two hundred

students at a time, and not just about aesthetics.

Pirbal's shopping list is long, but some themes stand out. Like the dying villages and a government that isn't remotely doing enough to rescue them. "I like our prime minister Necirwan Barzani, he is open and he belongs to a new generation. But he is very much into new motorways, airports, the oil industry. I am saying that the government must add something to that package: reviving agriculture, reanimating villages, preserving our own culture, encouraging tourism in the countryside. Villages are essential carriers of Kurdish culture. Take carpet weaving, which is part of village life even though it has disappeared. Take the production of honey for which Kurdistan is famous. Take Kurdish yoghurt, the best in the world. We are

now eating imported yoghurt from Holland and Turkey and Iran! And where can I go to buy Kurdish clothing made in Kurdistan?" Decentralisation should be the core of a new approach, Pirbal says. The government is concentrating its efforts on Suleymania, Duhok and Erbil. "But schools, cultural centres, internet links, water and electricity in villages are just as important. Irrigation systems. Banks for farmers. Right now we have a huge migration of people from the villages to the towns, where many are drawing salaries from the government and where few are productive."

Another favourite topic of Pirbal's is the ineffective democracy. "Policies are now being made by the bureaus of the two big parties, the KDP and the PUK. Parliament is just saying hello to the government and it is voting yes or no. It is useless. My students know it and they aren't interested at all in the parliament."

Being critical of the IKR's government and society is a contested activity in itself. Many argue that it may damage unity, which would be highly appreciated by the enemies of the KRG. Pirbal: "Once you organise strikes or really criticise the government, they will say: Stop, think of the Islamists! Think of Turkey and Iran! And the government is right. The only solution is real independence, just like other countries – and including Kirkuk, Khanquin and other predominantly Kurdish places outside the KRG Region. Then we can really start reforming and create a genuine democracy." Wait a second – won't Turkey be dangerous, maybe even more dangerous than now, when Iraqi Kurdistan becomes really independent? "No", Pirbal asserts. "There are always dangers after a revolution. But when we become independent, everything will be different. All people will be united to defend our Kurdistan."

A shop for satellite phones. It's always very
costly to make a satphone call from one system
to another – while calls within one satellite
system are quite cheap. As a result, in most
regions worldwide, one system soon becomes
leader. Among the Kurds, it was Dubai-based
Thuraya, rather than Iridium or Globalstar.
While coverage of GSM-GPRS is remarkably
good in the IKR, there are gaps of course.
So everyone who can afford it buys or rents
a Thuraya phone.

> Wireless connections in a small public park
in Erbil.

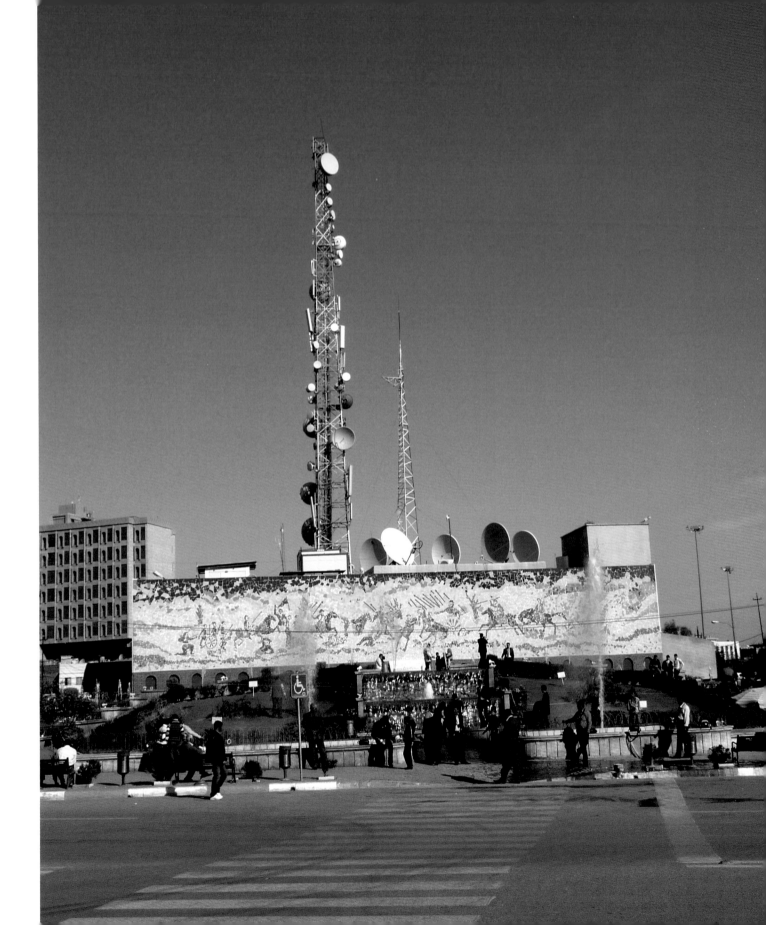

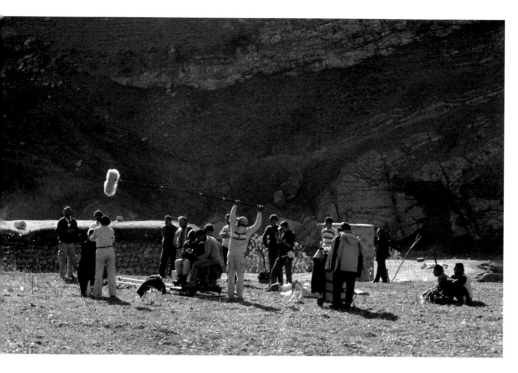

This picture was taken in December 2008 between Rawanduz and Choman, on the set of *Gift From the Mountain*, directed by Shahram Alidi, far left, produced by Walid Jaro and shot in 35-millimetre format for cinema projection. These are the final scenes, after four and a half years of filming. Production costs over-ran the budget considerably, and the KRG had to provide extra financing The film deals with the Anfal. But, says Alidi, unlike most films about the Anfal this film doesn't show a lot of cruelty and violence. It's about a man (with the black hat) who goes from house to house during the early nineties, when village reconstruction began, to record the stories of the survivors.

The GHQ of Korek Telecom in Sala-huddin. Korek of course needs an elevated position like Salahuddin (which lies hundreds of metres above the surrounding plains) for all its antennae and transmitters. But incidentally or purposely, the Korek GHQ lies a stone's throw from the GHQ of the Barzani's – as does the GHQ of Kurdistan TV, the KDP-dominated satellite TV station. The proximity of the three GHQs cannot be accidental.

Korek started in 2000 in the KRG-administered part of the IKR, was led by a Barzani and got a monopoly in order to build a network without having to bother about competition. The monopoly lasted till 2008, when Asiacell became available.
In 2007 Korek spent 1.25 billion USD on a frequency license covering all of Iraq. The number of Korek sub-scribers in the IKR is about 1.5 million of a population of four million.

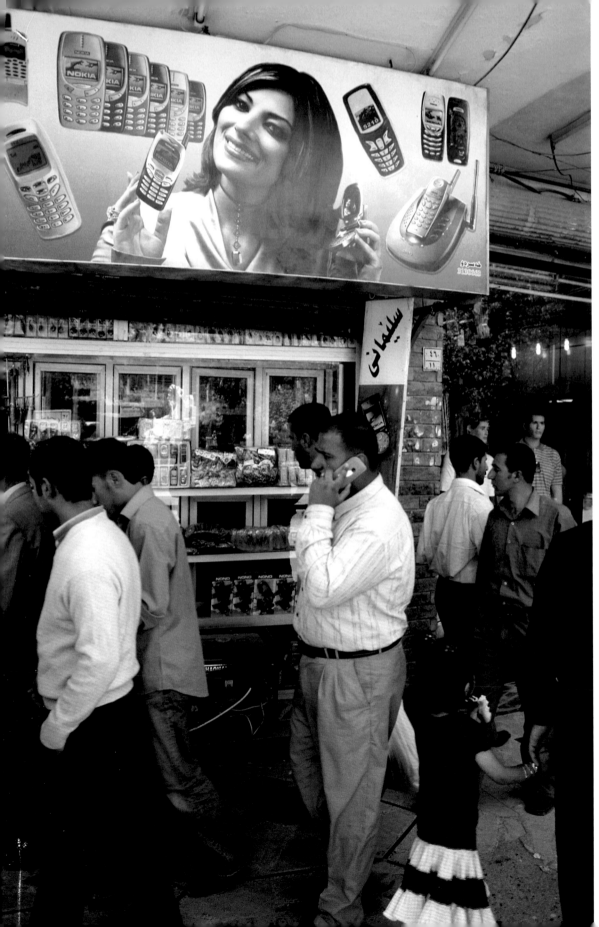

213

Suleymania calling. The man will definitely be using Asiacell, as this was before November 2007 when the two main providers, Korek in the North and Asiacell in the South, at long last got their roaming arrangement in place.

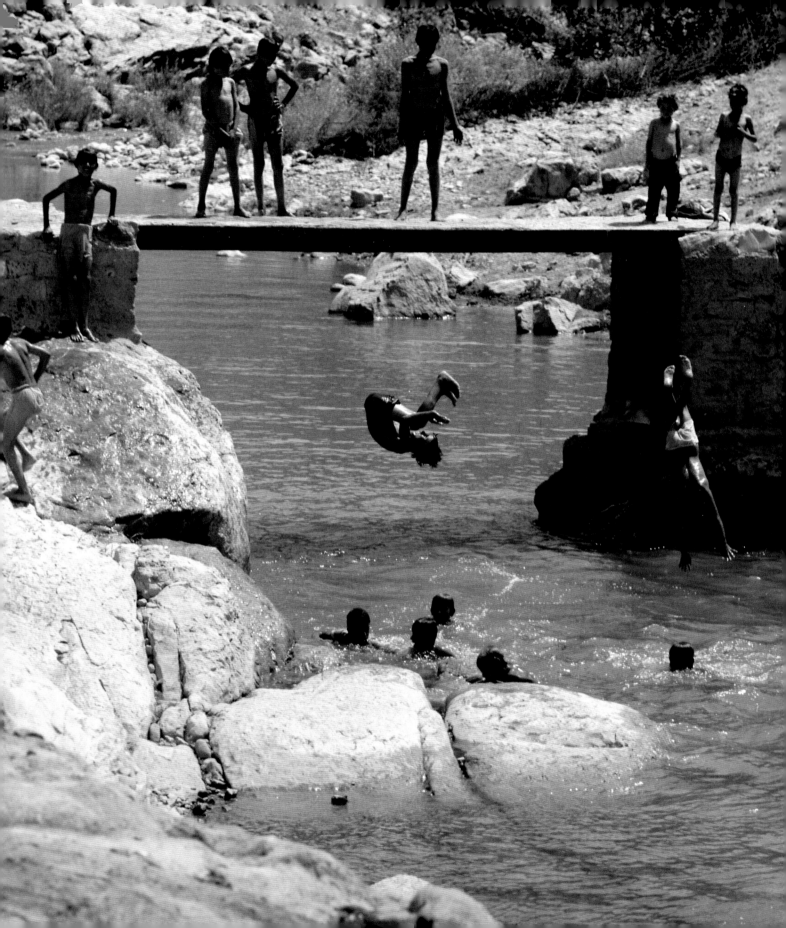

Partygoers Making splashes,
near Aqra.

Partygoers

Let's start with the bad news: Kurds hardly pay any attention to birthdays. No presents, no singing, no garlands. But there are plenty of festivities. Two major themes stand out: weddings and Fridays. On a Friday no one works except those in the local tourist industry, which includes zoos, fairs and lots of restaurants. Friday is also the day for a picnic – weather permitting: entire families head for the parks or, if they have the transport, the finest natural settings within reach, preferably near a brook, with a backdrop of mountains and on reasonably flat terrain so they can dance. If picnic world championships were ever to be held, the Kurds of Iraq would probably win. Despite all their sufferings – and maybe in response to them – the Kurds rarely miss a chance to throw a party, although they're not quite what you'd expect in the West.

Most weddings in the West pale into insignificance compared to Kurdish weddings, which, for starters, last for up to three days. Then there is a complex series of symbolic acts, each of which is essential for a successful marriage. Eating is important of course, especially because of the duration of it all. Amazingly, only the family of the bridegroom is present. The family of the bride can watch the twenty-plus hours of video of all the dancing and other activities, but they're not allowed to attend. Recently the eldest daughter of good friends of mine married and I watched the video. The father of the bride told me: "It's ridiculous that only the family of the bridegroom can be present. So I said to everybody: I am going to be the first father in Kurdistan who is going to attend the wedding of his daughter. I met with the family of the bridegroom and they under-

stood, they said: 'Fine, you can come.' But my own relatives asked me not to go, it would have brought shame on the family." The family of the bride may be banned from weddings – foreigners who are complete strangers are welcome, even if they bring a lot of cameras. In the course of my travels I attended at least half a dozen weddings. In most cases, I noticed the open-air festivities while passing by, and stopped the car. I could approach any of the men, and in most cases I would first be taken to another man, slightly more important, or even the father of the bridegroom. My request to walk around and take pictures was always honoured and, more than that, I was always encouraged to take any pictures and to join the dancing, etc.

In addition to Fridays and weddings, children playing should also be regarded as rather festive. Of course, boys playing soccer and boys jumping audaciously into ponds and rivers are recurring themes in all photography done in non-Western societies in hot climates. This book is no exception, if only because it's fun for the photographer too. The one annoying thing about this theme, notably in Kurdistan, is that you never see any girls making fun in public spaces.

> The monkey in the admission-free zoo in Erbil showing off on a Friday, the busiest day of the week for all entertainers. Behind the bars, a predominantly male crowd is captivated in amazement.

This 'wolf' (as the sign states) seems a bit less happy.

218 Mixed feelings being aroused during rides in
 Kurdish merry-go-rounds and related devices.

Not a Friday – and these people are not Kurds but Arabs, dancing on the lawn of the former Sheraton Hotel in Erbil, which is now run by a Kurdish company. Men and women dancing together in a public space, the girls without having to wear any headscarves and the prospect of having wine or beer afterwards – it was a temptation these Iraqis found hard to resist. Doing so in an Arab part of Iraq would have amounted to signing their own death warrants.

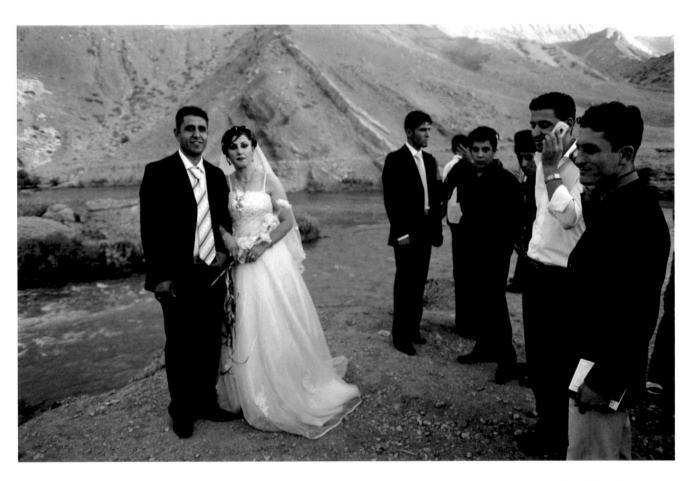

< Arabs splashing around in Kurdistan, at the Aqra waterfall. These tourists from a non-Kurdish part of Iraq belong to a vast crowd that heads for Iraq's mountains when their own turf gets too hot, meteorologically or otherwise. Each summer, tens of thousands of Iraqi Arabs converge on the IKR for a couple of weeks and many Kurds make money by letting their houses (and staying with relatives themselves).

In 2005, at the tourist resort of Sulav near Amadiya, I asked some Arabs about what had brought them there in terms of push and pull. They came from Falludja, they told me, where heavy fighting was going on at that time. It was great not to have bullets flying around and to spend some time without fear of being kidnapped and executed. And the pull? The fresh mountain air, the cool rivers and the lovely sights, of course. "This my country!", one of them said.

As I walked back, my interpreter whispered to me: "My country! An Arab. How dare he!"

A wedding in the garden of a big, luxurious hotel in Darbandykhan. The bridegroom lives in Sweden, he has just returned briefly to marry. While the partygoers in the next picture were dependent on good weather, this family could dash for the hotel if the weather turned grim.

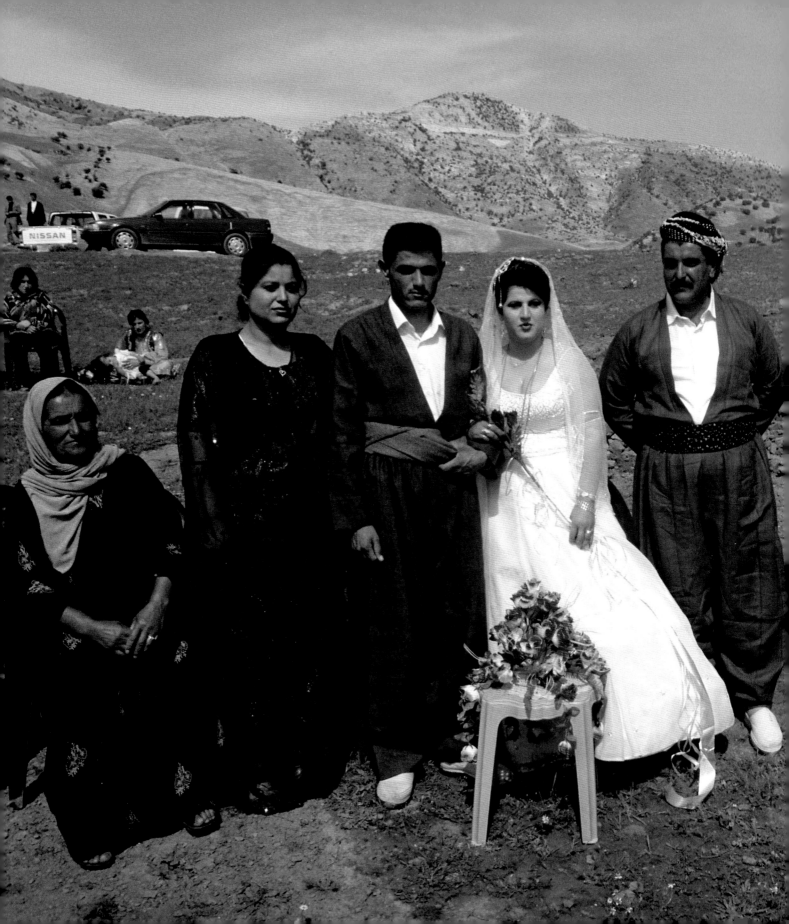

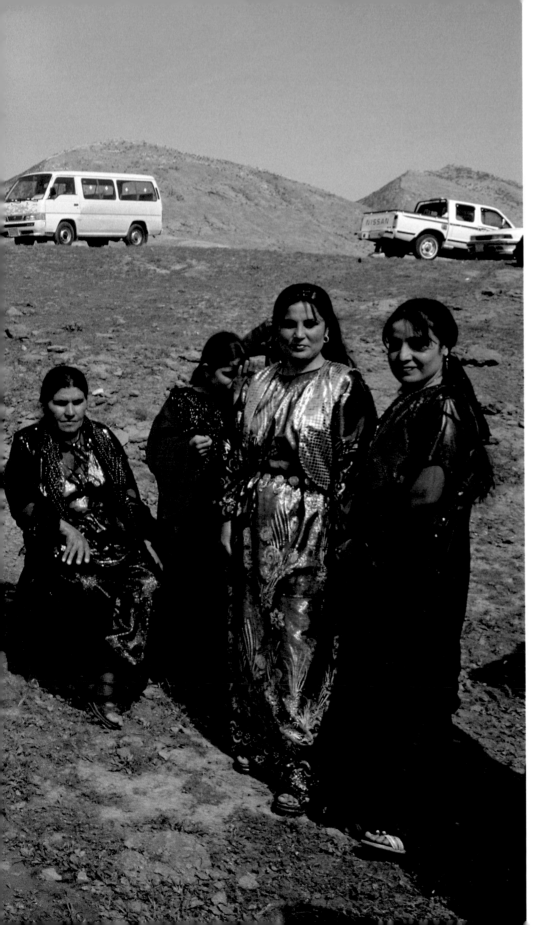

A wedding in the fields near the capital Erbil. A blazing sun has lifted all spirits while the bride's dress was lifted a bit by a breeze. After asking permission to join and take pictures, I had cautiously joined the party from the fringe of the hundreds of visitors. Soon someone came up to me and I was encouraged to take pictures of the newly-weds. Note the bride's white make-up. It is one way of telling she isn't the farmer's girl she might otherwise appear to be.

> A family from Suleymania picnicking on a beautiful April day near Qara Dag. Note the red generator, which is necessary to power the CD player and amplifier. While most family members danced and the children played, the older women were preparing an elaborate lunch on a wood fire.
All around there were other families engaged in similar activities.
These picnics also serve as opportunities for young men and women to meet. From the point of view of the girl's family, it's a safe idea when she meets her suitors while all her brothers, uncles and nephews are present. As much as a bond between two people, each marriage in Kurdistan is also a joint venture of sorts between two families, who may get to know each other during meetings such as these.

>> Soccer on the outskirts of Duhok and near Erbil.

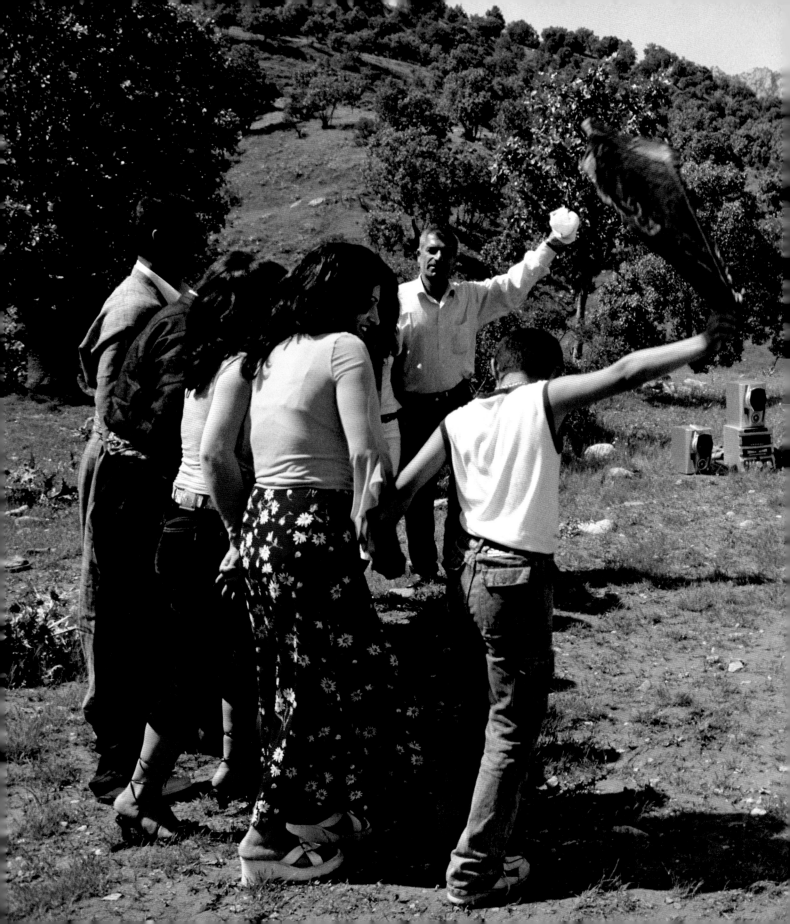

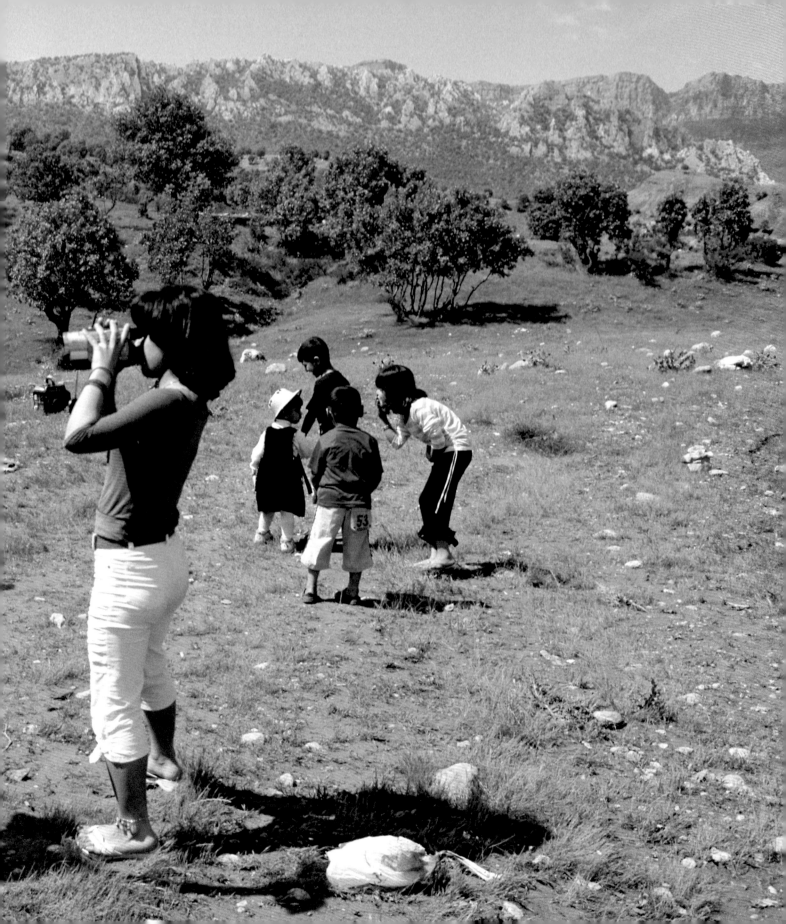

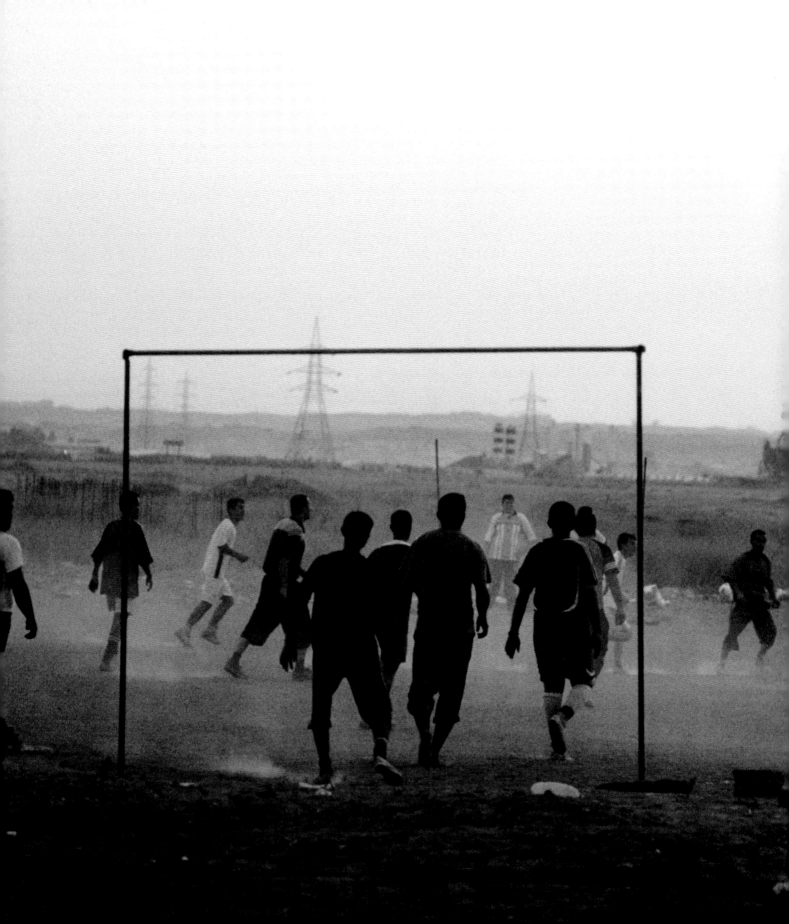

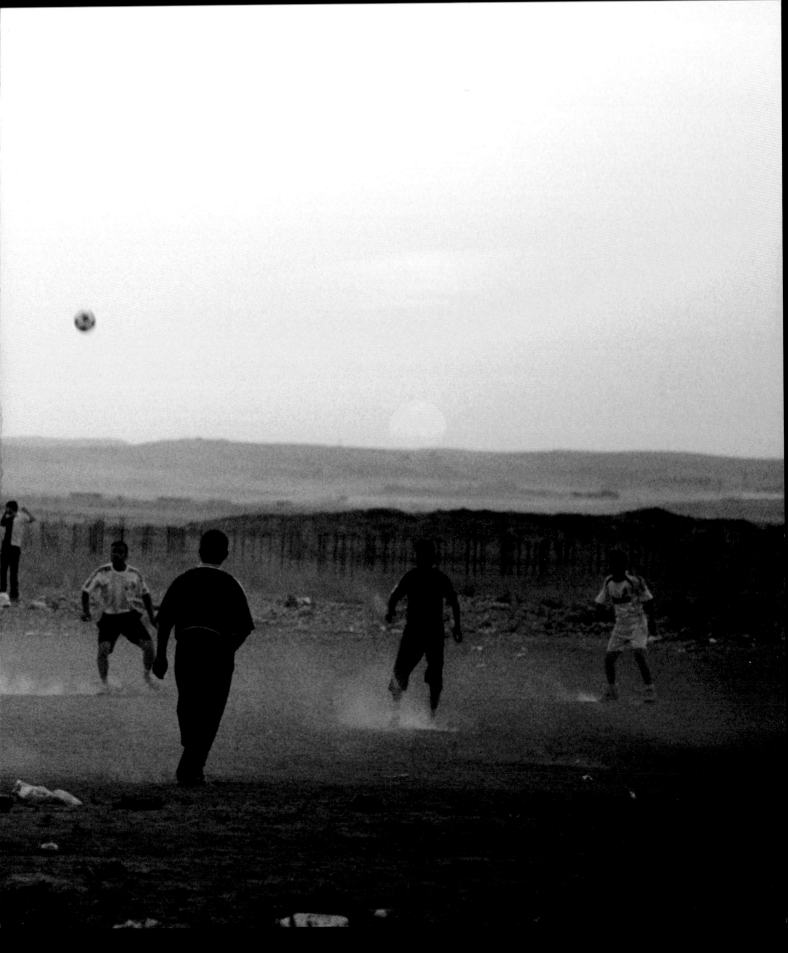

Acknowledgements

Credits

Hundreds of people were instrumental in the creation of this book, they are too numerous to mention individually. But a few really stand out. First and foremost: doctor Hashim Hameed and his wife Sabriah, who have supported me mentally and logistically throughout. They first put me up in April 1991, in their tent in a refugee camp seen on page 38/39 – and in their house on every trip since then.

Prime Minister Necirwan Barzani and his staff have been very helpful, especially in 2002 when, after an absence of ten years, I had to learn the Kurdish ropes again. At the start of each trip to Kurdistan since 2002, I called on Ibrahim Hassan of the KDP's Public Relations Office – to hear the latest news, to leave some recent English newspapers, to drink tea and to get some useful introductions. In 2003, in Suleymania, Sheelan Kanaka of the PUK offered me great assistance. Among my translators/fixers, I would like to offer my special thanks to Kheder Pishdery, Aref Omar Gul, Saef Hammad and Hana Jamal. In May 1991 and February 1992, I travelled across the area together with Rast Shaways, who showed me the impact of the Anfal – as well as educating me about it. In 2003 he helped me out while I was in a bad fix in Baghdad. My own personal hobby in Kurdistan, exploring its amazing archaeology, was even more fun when in the company of local archaeologists like Burhan Qaradagi, Carwen Omer, and Simko from Iran.

On the home front, thanks in the first place to my fellow travellers of 1973: my sister Ineke van Heemstra-Hegener and her husband Diederik van Heemstra, Elly Meriwani-van Waning, Freek Hasselaar, Bert Roelofsen (who is sadly no longer with us) and Piet Muller who, in 1972, first came up with the idea of going to meet the Kurds. Their cheerful support through the years kept me going, to Kurdistan in particular.

Siamand Banaa, who came to Holland as a refugee in 1975 and who is currently serving as Iraq's ambassador in the Netherlands, was helpful on countless occasions: by pulling strings in Iraqi Kurdistan, by translating and arranging interviews with Masoud and Necirwan Barzani, by being interviewed himself and by arranging logistical support when I was running out of funds. He told me more about the Kurds, their friends and their enemies than anyone else did. Others in Holland who were very helpful: archaeologist Kozad Ahmed, journalist Delshad Soran and Rosemary Tulett who told me about Kurdistan in the nineties, a time when she was able to cross the Turkish-Iraqi border as an NGO worker while I, as a journalist, could not.

Burhan Jaf, the Kurdistan Region's representative at the EU in Brussels, has been supportive year in year out, and helped me in Kurdistan in 1991 when we travelled together for a while and was kind enough to receive the first copy of this book. Thanks, finally, to my publisher Maarten Schilt who patiently supervised and coached this project since first discussing it in 2004, and to the Stichting voor de Beeldende Kunst whose grant to Mets & Schilt Publishers made the production of the book possible.

In the first place this book is dedicated to all Kurds, Assyrians, Chaldeans, Arabs, Turkmen and others living and working in the Iraqi Kurdistan Region.

It is also dedicated to the memory of Leopold Mannes (1899-1964) and Leopold Godowsky Jr. (1900-1983), inventors of Kodachrome, the adorable image carrier used for almost all the pictures in this book – and to all those helping Kodachrome survive in the digital age.

ISBN 978 90 5330 617 8
NUR 653

© 2009 Text, photos and maps:
Michiel Hegener, Den Haag
© 2009 Mets & Schilt publishers, Amsterdam

Text correction
Kumar Jamdagni, Zwolle
www.language-matters.nl

Design
MV LevievanderMeer, Amsterdam
www.levievandermeer.com

Lithography
Colorset, Amsterdam

Printing
Wachter GmbH, Bönnigheim (D)

www.metsenschilt.com
www.michielhegener.nl
www.thekurdsofiraq.com
www.sbk.nl